S0-AIT-912

WITHDRAWN

Biennial Ehsan Yarshater Lecture Series

School of Oriental and African Studies, University of London
(May 13–22, 1997)
No. 2
Supervised by Michael Rogers and Doris Abouseif

Yeshiva University Museum

IN SEARCH OF A CULTURAL IDENTITY

Monuments and Artifacts
of the Sasanian Near East,
3rd to 7th Century A.D.

by

Prudence O. Harper

Bibliotheca Persica
New York
2006

N
7283
.H345
2006

Biennial Ehsan Yarshater Lectures on Iranian Art and Archaeology
Prudence O. Harper, In Search of a Cultural Identity:
Monuments and Artifacts of the Sasanian Near East,
3rd to 7th Century A.D.

©2006 Bibliotheca Persica

All rights reserved. Except as permitted under current legislation, no part of this publication may be photocopied, stored in a retrieval system, published, performed in public, adapted, broadcast, transmitted, recorded or reproduced in any form by any means, without prior permission of the copyright owner.

Published by Bibliotheca Persica
450 Riverside Drive, No. 4
New York, NY 10027-6821

Distributed by:
Eisenbrauns, Inc.
P.O. Box 275
Winona Lake, Indiana 46590
Phone: (574) 269-2011
Fax: (574) 269-6788
www.eisenbrauns.com

Library of Congress Cataloging-in-Publication Data
Harper, Prudence Oliver.
 In search of a cultural identity : monuments and artifacts of the
 Sasanian Near East, 3rd to 7th century A.D. / by Prudence O. Harper.
 p. cm. — (Biennial Ehsan Yarshater lecture series ; no. 2)
 Includes bibliographical references and index.
 ISBN 0-933273-88-6 (alk. paper)
 1. Art, Sassanid. 2. Iran—Antiquities. 3. Iran—Civilization—
 to 640. 4. Iraq—Civilization—to 634. I. Title. II. Series.

 N7283.H345 2006
 709.35—dc22

 2006002138

Printed in the United States of America

Contents

Acknowledgments

The ideas expressed in this book were presented in four lectures at the School of Oriental and African Studies of the University of London. In the course of preparing the manuscript for publication, new material was added to reflect current developments in the field. I am indebted, primarily, to J. Michael Rogers and the School of Oriental and African Studies for the invitation to give these lectures and to devote some time to focusing on the thoughts and ideas expressed here. Michael Rogers's encouragement and patience made the completion of this work possible, and he has been, through most of my professional life in the field of Iranian studies, a source of inspiration to me. I also want to thank his successor at SOAS, Doris Abouseif, for her help and interest in the material as well as her concern to have the manuscript completed.

Many scholars in this country, Europe, Iran, and Russia have contributed through their work in museums and universities as well as their archaeological fieldwork to the ideas incorporated in this publication, and the present volume rests on the sure foundations they have laid. I want particularly to acknowledge my debt to friends and colleagues at the Hermitage Museum in St. Petersburg, the greatest repository of works from Sasanian lands. In my first visit to that great museum, I was fortunate to meet Kamilla Trever, whose interest in Sasanian works of art and archaeology was an inspiration for those who worked under her leadership in the Oriental Department. Among the scholars at the Hermitage Museum was Vladimir G. Lukonin, a close friend and most generous colleague who always delighted in discussing the directions in which his research was leading him. Meetings with him in his office at the Hermitage were memorable. Through him I came to

know other members of the department, Yevgeny Zeumal, Anna Ierusalimskaia, and Boris Marshak. I will always think of these good friends with pleasure as well as gratitude. They made available to me the collections of art and artifacts and shared their ideas, thereby enriching my own understanding and appreciation of the complex culture of the era.

My debt to my long-term institutional base, The Metropolitan Museum of Art, is tremendous. In the years in which I was a curator in the Department of Ancient Near Eastern Art, I received numerous grants and leaves of absence to complete research and was always supported in my efforts to develop and execute projects that helped to elucidate and define the art and cultures of the pre-Islamic Near Eastern world.

Friends and colleagues read this text before publication. Martha L. Carter, who has always stimulated me with her creative approach to the study and analysis of works of art, went over the manuscript and supplied comments. Christopher Brunner, a long-term colleague with a broad knowledge of the language and literature of early and medieval Iran, helped me to avoid errors and clarify statements. Thanks, too, go to my skillful and good-humored professional editor, Mary Gladue, who, with her colleague John Bernstein, took my typescript and photographs and made a handsome book of them.

Without Ehsan Yarshater's steady commitment to and support of Iranian studies, this book — and many others — would not have been written. His familiarity with and interest in every aspect of Iranian history and culture have kept students in the field active and productive during difficult years, stimulating and preserving among two generations of scholars a lasting interest in the Iranian world. To him I respectfully express my gratitude for and appreciation of a long friendship.

Introduction

The subject of this volume and of the third Ehsan Yarshater Lecture on Iranian Art and Archaeology given in London at the School of Oriental and African Studies is the art of the Sasanian era, a period of some four hundred years from the early third to the late seventh century A.D. The monuments and artifacts that have survived from these centuries range from court-controlled commissions to works made for common persons. Taken as a whole they provide illustrations of a stage in the history of Near Eastern art that is often considered to be an aberrant phenomenon and is narrowly viewed either as a precursor to the art of the Islamic era or as a form of oriental Hellenism. Sasanian artifacts and monuments unquestionably reflect in their appearance centuries of Greek influence, an influence already detectable in Achaemenid times, and, following the invasion of Alexander the Great, increasingly evident in the cultural remains, as colonists from the Hellenistic world settled in the land between the Tigris and Euphrates rivers and in Iran. But the art of the Sasanian kingdom is also part of a cultural continuum that is rooted in ancient Near Eastern traditions and has, by this period in the first half of the first millennium A.D., absorbed and adapted significant elements from the Late Antique West and the outer Iranian East.

The period of Sasanian rule fell at a time when cultural and political exchanges greatly expanded and increasingly transformed the face of the ancient world from Europe and the Mediterranean to India and China. The monuments of the Sasanian Near East are, however, products of a region rich in millennia-old remains (many still preserved and accessible) and cultural traditions. Sasanian society, multiethnic, linguistically and religiously diverse,

inherited a potent cultural legacy and at the same time continued to absorb and assimilate aspects of foreign cultures. The extent of the Sasanian empire at its height led, in turn, to the transmission of prestigious Sasanian icons, symbols of power, luxury and prestige, to the contemporary civilized world through trade, conquest and diplomacy.[1]

The chapters in this book have different titles but the subjects are not mutually exclusive. Continuity with the past is a factor in the discussions of diversity and diffusion and any definition of Sasanian culture draws on both ancient and contemporary traditions in a world where peoples, products and ideas moved over vast areas with remarkable ease and relative speed.

Geographically, the lands that formed the core of the Sasanian kingdom throughout the era were Iran and part of Mesopotamia or, to use the Middle Persian term for the latter, Asuristan (the heartland) between Arabistan in the north and Maishan in the south and the Gulf coasts. The rulers and the homeland of this dynasty were Iranian but the center, economically and politically, was in southern Mesopotamia. There, the capital was Ctesiphon, south of modern Baghdad, in ancient Babylonia, a region that was an important trade center and market. For millennia the inhabitants of southern Mesopotamia had been ethnically diverse, as foreign peoples entered the fertile Tigris and Euphrates River valleys. Agriculturally rich, the southern Mesopotamian lands were, as well, a major developed urban area.

Northern Mesopotamia was also agriculturally important but much of the land is mountainous and the region lacked the many centers of urban life that existed in the south. The borders between Persia and Rome in the West changed frequently and the northern lands were, in a sense, a bridge between Rome and the heart of the Sasanian realm, between the Mediterranean and further Asia.

Also intermittently under Sasanian rule were other lands to the west and east of Mesopotamia and Iran: in the northwest in Syria, and in parts of Armenia and Georgia in the Caucasus mountain region and in the east in the eastern Iranian world (Merv, Balkh and Herat in present-day Turkmenistan and Afghanistan). Finally the Arab allies of the Persians, the Lakhmids, from their capital at Hira in the southwest, maintained the borders facing Arabia and the southern routes of trade. The cultural remains of the Arabs from this period are poorly investigated and the major monuments including elaborate, palatial architecture are known chiefly from literary sources.

The state religion of the Sasanian dynasty, Zoroastrianism, was an integral part of social, political and cultural life. With roots in the east Iranian world, the Zoroastrian faith first spread in Iran under the sponsorship of certain Achaemenid kings. By Parthian times the religion had obtained an official status as reflected in Zoroastrian calendrical references in the documents found at the early Parthian capital city of Nisa in Turkmenistan in the first century B.C. Zoroastrianism under the Sasanians was a religion in which two separate and eternal powers, Ohrmazd (Old Persian: Ahura Mazda) and Ahriman (Avestan: Angra Mainyu) existed, Good confronted by Evil. The representative of the great god Ohrmazd on earth was the king, defender of the faith, at the apex of a structured and ordered society, the superior of common man. It is generally accepted that in Sasanian times a variant form of Zoroastrianism existed – Zurvanism, a doctrine going back to Achaemenid times in which Good and Evil, Ohrmazd and Ahriman, are believed to be the product of a "supreme being" Zurvan, Time.

For Zoroastrians, two "notions" were present in all creations, the *menog*, the mental or spiritual state of existence and the *getig*,

the physical domain. Humans living in the material world were instructed to follow the path of good thoughts, good words and good deeds in the battle against evil. In this task they were supported by beneficent forces, the Amesha Spentas, abstract concepts and expressions of the powers of Ohrmazd including Truth, Good Purpose, Ideal Dominion and Immortal Bliss. Wisdom, prosperity and joy were all part of the Zoroastrian vision and the good life led to eternal bliss while evil deeds condemned man to an existence in hell. Ultimately, good will triumph and a final Saviour will redeem the world.

In contrast to most other regions in the ancient world and to earlier periods in the Near East where temples were a common feature of urban environments and divinities were regularly represented, often as sculptures in the round in human form, the Zoroastrian forces remain to a large extent spiritual rather than material conceptions.[2] Evidence of Zoroastrian practices survive chiefly in the remains of stuctures dedicated to the maintenance of the fire, "the supreme instrument of ritual." Exceptions are made in the art of the Sasanian era with representations of the great god, Ohrmazd, and a few ancient Iranian and Indo-Iranian divine beings, lesser forces on the side of Ohrmazd, such as Nahid (O. P. Anahita) and Mihr (Mithra), who are occasionally portrayed in human form, notably in royal rock reliefs depicting scenes of 'investiture' and victory. However, Zoroastrianism remained, essentially, a religion of ritual practice and ethical doctrine based on principles (truth, order, balance) that were not only wise but good to follow. In Sasanian material culture the Zoroastrian presence is ambiguous, hard to define and difficult to recognize with certainty but conceptually the tenets of the Zoroastrian religion, passed on as a part of an oral tradition, lie behind many Sasanian cultural creations and traditions: an adherence to

established formulae, balance and order, the absence of divine images in the round. There is some evidence that suggests diversity within the Zoroastrian community, variations in doctrine and actual practice in the Sasanian era, and traces of this diversity, as we shall see, are evident in the cultural remains in the representations of divinities and royalty, in burial practices and in the use of magical images and devices.

Among the limited contemporary written sources are Middle Persian inscriptions on rock faces, seals, coins, silver vessels and, more rarely, on parchment and papyrus. The script used for this Iranian language, a development of the Old Persian language of Achaemenid times, was a variation of the Semitic Aramaic script. For the most part religious and historical texts are not preserved in any Sasanian original form but are known through later copies compiled in the early Islamic era. This fact explains why so many questions remain concerning both religion and the secular life. Also lost is another form of cultural expression essential to an understanding of the period and particularly of continuity with the past. This source in pre-Sasanian and Sasanian Iran and Mesopotamia is the spoken and sung word. Oral traditions were maintained over generations by priests and singers and were, with the written texts, an integral part of Near Eastern and particularly Iranian culture.

In an art historical review it is the material remains that are the primary sources used to illustrate and give definition to a culture. The Sasanian works range from monumental to miniature, from art that is dynastic, court-centered and official to the simple private expressions of peoples and cultures within the Sasanian realm. Both classes of artifacts are important to consider in order the achieve a balanced picture of Sasanian culture. The remains that survive are, of course, only a fraction of the whole. While

Sasanian dynastic rock reliefs, carved on the rock faces of Iran and court, silver-gilt vessels, many found beyond the borders of Iran in the southern Ural Mountain region of Russia, have been known in the West for centuries from the records of early travelers and collectors, it is only in recent years that a more complete picture of Sasanian culture has emerged from in-depth studies of the various categories of monuments and materials (rock and stucco sculptures, metalwork, ceramics, glass, seals and coins) and through archaeological excavations.

The great excavations of the 1930s at Persepolis, Susa, Bishapur, Hissar, and Istakhr in Iran, at Ctesiphon, Kish, and Hira in Iraq, and at Dura Europos in Syria were followed by a lengthy period lasting until after the Second World War when little archaeological fieldwork at Sasanian sites in Mesopotamia and Iran was undertaken.[3] Moreover the results of the earlier excavations remained largely unpublished. This situation has been remedied by recent publications in which finds made decades earlier and recorded with varying degrees of detail have been reconsidered, whenever possible, in the context of modern techniques and methodology. Included in this category are the sites of Ctesiphon, Qasr-i Abu Nasr and Susa. New archaeological exploration has taken place in recent years at Hissar, Hajiabad, Firuzabad, Takht-i Suleiman and Siraf to name a few major sites.

This varied evidence of the material culture of the Sasanian era will be discussed in the chapters that follow. Viewed through different lenses, the works will first be considered in the context of continuity and then against a background of ethnic and cultural diversity and the increasing development and use of routes of trade and communication leading from the Mediterranean world to China. The spread of Sasanian culture abroad and subsequent modifications of Sasanian imagery and style in early medieval

Europe, in western Central Asia and in China are factors that clarify and give definition to a Sasanian cultural identity.

1. Relevant references and bibliography can be found in: Oates 1968; Mango 1982; Whitcomb 1985; Boyce 1990; Shaked 1971, 1994.
2. Schwartz 2000, p. 13.
3. For a review of early excavations, see Whitcomb 1985, pp. 12–13.

CONTINUITY

In art historical surveys of the pre-Islamic Near East the material culture of the Seleucid, Parthian, and Sasanian periods is often ignored or only superficially treated as a shadowy and imperfect reflection of a particular historical event, the conquest of Mesopotamia and Iran by the Macedonian Greek army of Alexander the Great. Certainly the invasion and destruction of the Achaemenid Persian empire by Alexander's army at the end of the fourth century B.C. and the settlement of Greek colonists in Asia had significant impact on Near Eastern artifacts and architectural remains. But the appearance of the monuments has mistakenly led some modern historians of ancient Near Eastern art and archaeology to place the cultures of the so-called Hellenized East, Mesopotamia, Iran, and Bactria, in a modernly constructed vacuum between the pre-Islamic and Islamic eras. Visibly transformed by artisans and influences from the Hellenistic and Roman West, the Seleucid, Parthian, and Sasanian artifacts and monuments may appear on the surface to be unrelated to the remains of earlier Semitic Mesopotamian kingdoms and Elamite and Achaemenid dynasties in Iran. However, a closer study of the art illustrates the fallacy of this view and provides evidence of the presence of traditional Near Eastern themes, significant motifs, persistent compositions or designs, and ancient techniques of manufacture.[1]

For a long time, the art of the first Persian dynasty in the history of the Near Eastern lands, the Achaemenid, was also viewed in art historical surveys as a separate, if not totally distinct, chapter. The entrance into the Near East of an Indo-European, specifically Iranian, people in the form of the Medes and Persians in the second millennium B.C. was followed by the gradual assumption

of power by an Iranian political entity in the middle of the first millennium B.C. The foundation of the Achaemenid dynasty and the spread of a new Zoroastrian religion at this time was understood by modern scholars to represent a definitive historical and cultural break with a Semitic Mesopotamian-centered past. This categorization of Achaemenid art and architecture as something 'non-Mesopotamian' was strengthened by the focus placed on the undeniable Greek influences and cultural interchanges evident in Achaemenid forms and designs.

Recent studies of Achaemenid culture, stimulated by the Achaemenid History Workshops, have finally provided a better perspective from which to view the art of the period. The extent to which the Achaemenids adopted and adapted significant imagery and followed precepts derived from the Assyro-Babylonian past has become increasingly apparent. But this recognition of continuity with the past has only recently led to a broader sensitivity to the dangers of academic periodization insofar as they affect our understanding of later Near Eastern art in the periods following the invasion of Alexander the Great and preceding the coming of Islam.

Some years ago, the anthropologist Norman Yoffee defined Mesopotamian civilization as "that fragile, but reproducible, set of cultural boundaries that encompass a variety of peoples, political and social systems and geographies marked as Mesopotamian and that, importantly, include the ideal of a political center."[2] This civilization ended in a political sense, he suggested, with the conquest of Babylon by the Achaemenid king Cyrus in 539 B.C., after which a Mesopotamian political system was never again "autonomous and dominant." The collapse of cultural traditions he set at the time of the last known use of the cuneiform script, believed at that time to be in the second half of the first century A.D.

Such a clear-cut end to Mesopotamian traditions is not evident in the material remains. Ancient Mesopotamian culture was a resource upon which post-Achaemenid cultures drew, a powerful presence in the Near East through the Sasanian period. Mesopotamia was a center—political, economic, and cultural—of the Iranian dynasties, Achaemenid, Parthian, and Sasanian. The capital cities of Seleucia and Ctesiphon lay in the same region as the earlier state centers, Akkad and Babylon. The tenacity and influence of artistic, literary, and oral traditions in both Mesopotamia and Iran was considerable.

Continuity in the arts is a complex and imprecise subject of study, as the absence of contemporary documentation leads to the risk of mistaking chance similarities for real and meaningful statements. Continuity in form and continuity in content are separate phenomena. The same image may take on, in time, a different meaning; the same concept may be expressed through different images. There is also the danger of applying modern (chiefly western) concepts to the interpretation of the material remains, and misinterpreting or overlooking significant data. An illustration of the complexities inherent in the analysis of ancient monuments is provided by a building constructed over the ruins of an earlier temple of Ningirsu at Tello (ancient Girsu) in southern Mesopotamia during the early Parthian period.[3] The palatial architectural foundation of Adad-nadin-ahi, a Hellenized ruler of this small southern Mesopotamian domain in the second century B.C., incorporates ancient bricks stamped with the name Gudea, ruler of Girsu in the late third millennium B.C. But new bricks are used as well, stamped with the name of Adad-nadin-ahi in Aramaic and Greek and modeled in size and shape on the older examples. In the later structure, a little over one meter above the third millennium B.C. sanctuary of Gudea, fragmentary reliefs of

the earlier period were also preserved, sealed in unused doorways and placed face down in a passage. The scenes on these relief fragments are iconographically significant ones: the goddess Inanna from the so-called Stela of the Vultures and the bull harp from a stela of Gudea. In the great courtyard of the palace of Adad-nadin-ahi sculptures of Gudea were preserved in two separate groups, standing figures and seated figures. These poses have been convincingly shown to be individual and significant expressions of royalty in the third millennium B.C. The standing, worshiping figure faced the god in perpetual prayer and was inscribed on the back so that other worshipers could see the inscription. The seated figure, the more prestigious form, was itself an object of cult facing the approaching worshipers.[4]

What memory of the distinct roles of these traditional forms of images persisted at the later date, and did some knowledge of the past cause the separation of the two types of sculptures in the arrangement of Adad-nadin-ahi? In the reuse and imitation of the earlier bricks and in the preservation of complete and fragmentary significant sculptures was there still a sense of the importance of traditional imagery relating to the exercise of meaningful dominion and rule? The primary focus of this chapter is continuity in the art of the Sasanian era as illustrated by the material remains that survive. Supporting and providing a setting or context for the analysis of the monuments are contemporary Sasanian and slightly later written sources that have to do with dynastic origins and the expression of royal authority and identity. The ancestors and early history of the first king of the Sasanian dynasty, Ardashir I (r. 226–241), as recounted in the *Karnamag i Ardashir i Papagan*, a text preserved in a later rescension, follows in its structure a traditional formula first employed in the Near East by scribes in the third millennium B.C. to document the rise of

Sargon of Akkad (ca. 2300 B.C.). The formula follows certain stages: a royal child is cast out and abandoned by his parents, is raised in humble circumstances, comes finally to the attention of the ruler, and peaceably or violently assumes his royal position.[5] Subsequently adopted by the Persian Achaemenids, this formula was used as the framework in which the events leading to the birth and rise to authority of Cyrus I (ca. 640–600 B.C.) are described. Both the Akkadian and Achaemenid dynastic legends were widely known. Copies of the Akkadian tale are recorded on tablets found in regions as distant as Amarna in Egypt and Hattusha, the second millennium B.C. Hittite capital in Anatolia. The Achaemenid tale was transmitted to the West by Ctesias, the Greek physician to the Persian Achaemenid queen (409–392 B.C.) in Babylon. Because of the significance of the subject matter, the founding of a new dynasty, the literary formula persisted and remained relevant in Sasanian times.

The subject of dynastic origins is not the only subject in which texts provide evidence of continuity in the use of literary formulae. As early as 1953 Sprengling compared the great 'historical' text of the inscription of Shapur I on the so-called Ka'ba of Zoroaster at Naqsh-i Rustam to the format of the inscription of the Achaemenid king Darius at Bisitun.[6] In this case shared formulae are used in the texts separated in date by almost eight hundred years to express qualities of the good king, the state of the land, the description of the empire, and the restoration of the true religion. Skjaervø has argued in favor of "an early Sasanian literary corpus, written or oral, with roots perhaps reaching back to pre-Achaemenian times."[7]

The Achaemenid kings and the Achaemenid era have no significant place in Firdausi's eleventh-century *Book of Kings*, which drew on "ancient books," but the presence and accessibility of

Achaemenid remains, palaces, rock reliefs, and inscriptions influenced the Sasanian dynastic language of images in its formative stages. While the earlier monuments were poorly understood by the Sasanians in a modern historical sense, they were nevertheless part of a national Iranian heritage with which the later rulers deliberately chose to associate themselves. Persepolis, known to the Sasanians first as *sad stun* (hundred-columned palace), in the late Sasanian period finally became Takht-i Jamshid, the Throne of Jamshid, the first king in the national Iranian epic poem, the *Book of Kings,* and the legendary ancestor of the Sasanian rulers. The presence of a member of the Sasanian royal family at this site is recorded in an inscription placed in A.D. 311 in a doorway of the Palace of Darius. Shapur, the Saka king, a son of Hormizd II (r. 302–309), "travelled on this road, the road from Istakhr to Sakastan, and graciously came here to *sad-stun* [100 columns = Persepolis]"; he "ate bread in this building...," a significant and solemn Zoroastrian ritual act.[8] Moreover, eighteen years later this same Shapur sent Seleucus, a judge, to examine the earlier inscription, an event that is duly recorded by that personage in a second inscription at the site.

Also preserved at Persepolis are the works of Sasanian artisans who sat on the floor of the 'harem' of Xerxes and drew images of the elite on the Achaemenid stones. No inscriptions provide a context for these early dynastic works, but in their form and composition the drawings, cut lightly into the stone, foreshadow the earliest Sasanian monumental reliefs (Fig. 1).

Persepolis was not the only site where Achaemenid remains were known and reused by the Sasanians. At Susa Sasanian builders reused Achaemenid column bases, as earlier Parthian builders had at Bard-i Nishandeh,[9] and an awareness of the significance of some Achaemenid architectural forms is also evident at Shapur's

royal city of Bishapur, where a bull-protome impost block[10] is an adaptation of an Achaemenid architectural element (Fig. 2). It is interesting to read the record of the early Islamic historian Muqaddasi, who states that in the Friday mosque in Istakhr (Persepolis) "on the top of each collumn is a cow" and at Qazvin the Friday mosque of the eighth century was known as the "Bull Mosque."[11] This significant architectural element used in prestigious court structures in Iran before and during the period in which Zoroastrianism was the official state religion apparently remained in early Islamic times an acceptable feature in religious architecture.

The Sasanian image of the winged human-headed bull (Fig. 3), perhaps the legendary Gopatshah of Avestan texts, a figure described as part bull and part man, is iconographically derived from the great guardian figure of Assyrian palatial doorways (Fig. 4) and of Achaemenid gateways at Persepolis. At Hajiabad in southern Iran, the archaeologist Massoud Azarnoush found in a substantial villa of early Sasanian date stucco plaques decorated with the forepart of a winged human-headed bull (Fig. 5).[12] The plaques were found in a hall leading to a room he associated with the fire cult, a hypothesis recently supported by the presence of badly damaged figures of the same fantastic creatures above columns carved on an early Sasanian fire altar found near Shiraz.[13] The foreparts of the creatures on the altar are battered and difficult to interpret in the photographs, but the headdresses and the bent forelegs are visible. An inscription on this fire altar states that it commemorates the foundation of a fire by Abnun, master of the harem, and celebrates the Roman defeats by Shapur I in the third century. The fire is named "Abnun whose refuge is in Shapur."[14] The human-headed bull in the relief carving is rendered as an architectural element in a Zoroastrian cult building,

an arched structure in which the Sasanian monarch also appears. Oktor Skjaervø has written that the name of the donor, Abnun, is Semitic and that the inscription is from a different tradition than the roughly contemporary inscriptions of the Zoroastrian priest, Kirder. He supposes that Abnun may have been a Christian who could have belonged to one of the many Christian sects that existed at the time within the Sasanian realm and were to become the focus later of Kirder's wrath and his persecutions. If so, the diversity, as well as the continuity, of early Sasanian culture is illustrated by this monument with an image of pre-Zoroastrian origin incorporated into a Zoroastrian cult context and dedicated by a member of the Sasanian Christian community.

Certainly the most dramatic evidence of continuity at the level of dynastic art is the placement and deliberate association of Sasanian relief carvings with sculptures of earlier periods in Iran. At Naqsh-i Rustam there are carvings of the Middle and Neo-Elamite periods, second and early first millennia B.C., at the site of the relief of the Sasanian king Bahram II (r. 276–293) (Fig. 6). The Sasanian scuptures are carved onto the surface of a Middle Elamite relief, which remains partly visible, and the Neo-Elamite figures of a king and queen bracket the later relief appearing on either side of the Sasanian scene. Margaret Root has written that the "Elamite king and queen [are] brought into the Sasanian scene.... [They] anchor Bahram's court [and] give its members a sense of ancestral history."[15] There is no evidence that the historical identity of the earlier dynasties or personages was known to the Sasanians, but their significance undoubtedly was. The Neo-Elamite queen wears a crenellated crown of a type worn later in representations of Achaemenid, Parthian, and Sasanian royalty and divinities. The earlier sculptures were apparently valued as evidence of ancient and prestigious dynasties in Iran. Much later,

the Qajar rulers in the eighteenth and nineteenth centuries incorporated Sasanian reliefs into their own monuments and selected sites of prestigious Sasanian reliefs for their own dynastic monuments without apparently knowing or understanding much about the ancient historical context. Fath ali Shah's son, Muhammad ⁽Ali Mirza Dawlatshah (d. 1822), in his relief and inscription at Taq-i Bostan, the great rock cut iwan of Khusrau II, places his image at the same height as Khusrau so that the latter appears as his "door keeper," while on a second Qajar relief at Shiraz a file of figures—all that remains of an otherwise obliterated Sasanian relief—appears to support the throne of Fath Ali Shah (1798–1834) (Fig. 7).[16]

The rock reliefs are among the best documented Sasanian works of art, in large part because of the superb scaled photographs and the drawings rendered from them by Georgina Herrmann and her colleague Rosalind Howell. There are few inscriptions associated directly with the relief scenes. The trilingual inscriptions on the investiture relief of Ardashir I at Naqsh-i Rustam simply name the equestrian figures in Greek, Parthian, and Middle Persian: the god Ohrmazd (Zeus) and the Mazda-worshiping god Ardashir, king of Iran, who is the scion of the gods, son of Papak the king (Fig. 8). Beside the reliefs of Kirder, where the priest is represented as a half figure, there are inscriptions giving the history of his career, a list of the positions he held, and the kings he served. Only at Sar Meshed is there a more elaborate text recounting the dream journey to the other world of Kirder and of persons and events on the way (Fig. 9). Convincing arguments have been advanced in recent years that the relief here is an illustration of this text. The "noble prince" wears the crown of the king, Bahram II, under whom Kirder was serving, and the beautiful *den* is identical to some images of the Sasanian queen as they appear on coins of

Bahram II. The slaying of leonine prey is a royal and significant feat of prowess frequently depicted in Iranian art, most notably on Sasanian silver-gilt plates. Here it has additional significance as an illustration of the "defense of the cosmic travellers from the fierce animal guardians of the bridge."[17] Earlier interpretations of the relief scene were based on the identification of the figures as historical personages—king, queen, crown prince, and the powerful priest and king-maker Kirder. In a Zoroastrian context it is conceivable that there were, in fact, two levels of meaning and that a revelation from the spiritual realm is given form by the use of images associated with the earthly domain, the two realms meeting in this single monument.

Another extensive inscription stands by itself in the vicinity of the relief carvings, on the tower at Naqsh-i Rustam, the so-called Ka' ba of Zoroaster. It is a record of the Roman wars of Shapur I in which three defeated Roman emperors are named; Gordion who was killed, Philip the Arab who sued for peace; and Valerian who "was taken by my hand," a prisoner of the Sasanian king. One relief at Naqsh-i Rustam and three reliefs at Bishapur present this narrative in similarly schematic form. In the most elaborate compositions, at Bishapur, the central focus of the scenes nevertheless remains the same, a panel showing the victorious equestrian ruler with his dead and defeated Roman foes. The rows of Iranian nobles on one side of this panel and of tribute bearers on the other side are embellishments that are not intended to distract the viewer from the central message of invincibility (Fig. 10).

From the beginning of the Sasanian period, the reign of Ardashir I, the reliefs illustrate two themes: investiture with kingship by the god Ohrmazd and occasionally by other ancient Iranian divinities, Nahid and Mihr, a subject more correctly understood as the celebration of god-endowed royal authority and invincibility;

and historical events, dynastic scenes, and battles presented in an abbreviated iconic fashion. On Ardashir's relief at Firuzabad, three individual combats represent the battle of Hormizdagan when the new Sasanian army defeated the forces of the Parthian ruler, Ardavan, and brought the Arsacid dynasty to an end (Fig. 11). The battle scene follows earlier Iranian traditions in this utilization of the individual combat theme with pairs of battling antagonists arranged in a linear sequence. On a Parthian relief (probably 1st century A.D.) at Bisitun inscribed with the name of Gotarzes, one equestrian figure pursues another, and on a first to second century A.D. silver, Sarmatian vessel excavated at Kosika in Georgia there is a single-combat battle scene (Figs. 12a,b).[18] Somewhat later in date but similar in theme and composition is a third-century painted rendering of the same theme at Dura Europos.[19] This articulation of a historical event in the guise of individual heroic combats is a feature that persists in the written Iranian epic the *Shahnameh,* or *Book of Kings,* of Firdausi.

Later reliefs at Naqsh-i Rustam are similarly schematic and iconic, a single combat standing for the battle between two forces, an historical event at one level and at another level an expression of the triumph of Good over Evil (Fig. 8). In the reliefs, as in the *Book of Kings,* history is envisaged as a tale of heroes and individuals. There is no apparent concern in the Sasanian sculptures to depict real topographical settings, a prominent element in the Assyrian palace reliefs on the one hand and in Hellenistic and Roman art on the other. Realism of setting and historicity give place to national and religious ideals. Whether carved in stone, inscribed on a rock face, or sung by court minstrels, the deeds of Iranian heroes and kings were viewed as part of a continuum and were articulated in familiar terms that referred to the national culture and identity.

There are probably many levels of meaning in the Sasanian reliefs that remain unrecognized in modern times, but one notable image on Sasanian reliefs is the presence of a heavy horse, the mount of god and king. The Nisaean steed of Achaemenid times, known from Persian sculptures and the writings of the Greek historian Herodotus in the fifth century B.C., was associated with royalty and royal processions, and on the early Sasanian reliefs a massive horse is the royal and divine mount (Fig. 8).[20] In late Sasanian art on the seal stones of some of the highest officials and in the rock relief at Taq-i Bostan, the powerful horse wearing heavy body armor and supporting an armored warrior is a most prestigious icon.[21] On the seal stones the inscriptions refer to the *spahbed*, the title of four generals of the Sasanian empire who held control of the different regions—north, south, east, and west—of the Sasanian kingdom (Fig. 13).[22] In Assyrian and Achaemenid times the "four corners of the world" is a significant and persistent concept in Mesopotamian royal ideology.[23] But the most striking image of the heavy armored horse is the over-life-size sculpture, almost in the round, in the large iwan attributed to Khusrau II at Taq-i Bostan (Fig. 14). This over-life-size sculpture of an armored horse and rider provides a perfect illustration of the often-quoted text of the Greek historian Ammianus Marcellinus, who in the fourth century A.D. traveled with the army of Emperor Julian in the Near East. In one chapter he describes the armored cavalry of the Persian enemy: "mail-clad horsemen in such close order that the gleam of moving bodies covered with closely fitting plates of iron dazzled the eyes of those who looked upon them" (XXIV 6, 8), "and the forms of human faces were so skillfully fitted to their heads that . . . arrows that fell upon them could lodge only where they could see a little through tiny openings fitted to the circle of the eye, or where

through the tips of their noses they were able to get a little breath"
(XXV, 1, 12).

The awesome sculpture at Taq-i Bostan may have been the
prototype for the unique image of a horseman holding a spear
who is described as surmounting the palace of the eighth-
century Abbasid caliph Abu Ja'far al-Mansur and the gates of his
new capital at Baghdad.[24] The early Islamic images were com-
missioned by the new ruler from Khorasan, who was as con-
cerned as his Sasanian predecessor had been to establish his
legitimacy. The innovative use of this particular image by the
Abbasid caliph is reminiscent of the use of ancient imagery by
earlier Sasanian rulers in their reliefs illustrating the mighty
Nisaean steeds.

The motif of a horseman and dead enemy, the latter placed
beneath the hooves of the horse, is another ancient and presti-
gious motif in the ancient Near East, one that is represented on
many Sasanian reliefs and has precursors in the art of earlier peri-
ods. In contrast to contemporary Roman imagery, the enemy in
Sasanian art and earlier in Assyrian and Achaemenid art is not
only shown struggling or in the throes of death but more com-
monly lies inert and lifeless under the hooves of the horse or the
feet of the victor. The impact of the scene at Naqsh-i Rustam
where the equestrian god and king are depicted above the bodies
of their lifeless foes, Ahriman and Ardavan, perfectly reflects the
Order and Balance of ideal Zoroastrian rule and the certainty of
the outcome of the battle of Good and Evil forces (Fig. 8). The
earthly victory over a historical enemy is a metaphor for the larger
spiritual victory, a theme expressed much earlier on an Achae-
menid seal (Fig. 15) by the presence of the Ahura Mazda icon. In
his choice of this subject matter at Naqsh-i Rustam, Ardeshir
brings together the worldly and the spiritual.

Comparable scenes of equestrian battles were carved on pre-Achaemenid and Achaemenid cylinder seals, one of them naming the grandfather of Cyrus the Great, a contemporary of the Assyrian king Ashurbanipal (669–626 B.C.) (Fig. 16).[25] This seal apparently remained in use for a century after it was carved since it was finally impressed on some of the Persepolis fortification tablets. In the carving a central mounted spearman rides over a dead enemy, but the emphasis is not on a specific historical event. The inscription on the seal stone simply reads: "Cyrus the Anshanite, son of Teispes." The enemy is not identified and the mounted spearman is, rather, a potent image of Persian might. The earlier Persian king as the vanquisher of foes is the royal icon used a millennium later by the first Sasanian king, Ardashir I, at Naqsh-i Rustam, as a canonical expression of royal prowess.

In neighboring Georgia—in the Transcaucasus, a region frequently under Iranian rule—the west door tympanum sculptures of the Church of St. George and St. Theodore at Nicorzminda carved in the eleventh century illustrate the same theme as the early Sasanian relief, the victory of Good over Evil in this world and the next. Two horsemen trample their enemies. Saint George throws down Diocletian and Saint Theodore overcomes a dragon, images in the tradition of Ardashir and the defeated Artabanus, of Ohrmazd and Ahriman.[26] The same significant theme and composition is utilized elsewhere in the Christian West, notably in Coptic monastery paintings of the seventh to the thirteenth centuries in Egypt.[27]

The relief celebrating the kingship of Ardashir I at Naqsh-i Rustam is only one illustration of continuity and traditionalism in this medium of Sasanian dynastic art. On other reliefs of the third century at Darabgird and Bishapur, the grouping of loyal followers on the king's right and of tribute bearers or foreigners

on the left, is a pictorial arrangement already employed by Elamite and Achaemenid artisans at Kurangun near Persepolis (Fig. 17), at Kul-i Farah near Susa and at Persepolis. The effect of the Elamite, Achaemenid and Sasanian scenes in which figures grouped at the sides bracket a central or main image is visually more effective, in a didactic sense, than a composition including additional historical and realistic details.

In contrast to the low relief and attention to surface detail apparent on the victory relief at Firuzabad and evident too on some of the less expert reliefs carved in the south during the preceding Arsacid era, the figures represented in the celebration of Ardashir's kingship at Naqsh-i Rustam are fully sculptural (Fig. 8). On the earlier Firuzabad relief close inspection reveals carefully modulated surfaces and the traces of polishing that also characterize Ardashir's later rock reliefs as observed by Georgina Herrmann.[28] The early Sasanian sculptors, presumably influenced in their craft by the presence of the neighboring Achaemenid monuments at Persepolis, carefully finished some of the monumental carvings by polishing the surfaces. This finish, which gives a luxurious appearance to the smaller wall sculptures of the Achaemenid palaces, was less effective on the monumental reliefs and in the later Sasanian period the procedure was abandoned.

In the north of Iran the fourth- and sixth-century reliefs at Taq-i Bostan provide a contrast in style, composition, and significance to the sculptures carved in the south. At this site near the Khorasan road, the millennia-old route connecting East and West, Asia, Mesopotamia, and the Mediterranean world, artisans were employed who were less influenced by either the earlier Achaemenid sculptures at Persepolis or by contemporary Roman designs. The rich linear stylization of the drapery of the fourth-century kings depicted (Fig. 18) is reminiscent of the drawn

images of the early Sasanian nobility on the walls of Persepolis (Fig. 1), where a wealth of linear details is incorporated into the design, and it is possible that the Sasanian sculptors in the north were following two-dimensional patterns. Similarly in the Achaemenid era the relief of Darius at nearby Bisitun is a distinctive regional monument carved in a style influenced by Assyria in northern Mesopotamia and is noticeably different from the slightly later sculptures at Persepolis in the south.

The large iwan at Taq-i Bostan, probably but not certainly attributable in its final form to Khusrau II (r. 591–628), is considerably more than a celebration of an historical event, the regaining of the throne, and the initiation of a particular Sasanian monarch's reign (Fig. 19). What remains at the site is only part of an immense monument, including a flattened area above the arch on which appear traces of a horse's hooves and, below, a badly damaged and worn standing royal figure in the round as well as column capitals which must also be part of the central architectural monument.

This richly embellished late Sasanian monument faces out over a spring-fed pool to a huge enclosed park or *paradeisos,* a setting that is comparable to the Assyrian and Achaemenid palace gardens. David Stronach, in reconstructing the buildings and gardens at early Achaemenid Pasargadae, turns for a prototype to the porticoed garden enclosure or pavilion of Sargon II (742–705 B.C.) of Assyria, a pavilion in *bit hilani* form newly adopted in Assyria in the eighth century B.C.[29] Stronach refers to a garden as a potent vehicle for royal or dynastic propaganda and cites certain features as traditions persisting into the Sasanian/early Islamic era: "the assymetrical manipulation of water, the frequent presence of stone water channels, and the fourfold division of the available garden space." The use of this architecture by an Assyrian king and its

appearance in the palace reliefs, he suggests, may be a form of political propaganda celebrating the defeat of Assyrian enemies in the west, the source of the *bit hilani* form. The significant royal role of gardens and orchards in Assyria is underscored in the inscription of Ashurnasirpal II on a stela found at Nimrud. The three main subjects of the text—the gardens, the hunt, and the banquet—are carved on this stela below an image of the ninth-century Assyrian king.[30] In Iran, the palatial pavilion garden setting at Achaemenid Pasargadae is followed chronologically by the villa garden setting of late Parthian date excavated at Qaleh-i Yazdgird and finally by this Sasanian iwan and garden at Taq-i Bostan. Through the centuries in the Near East, gardens were a symbol of royalty, of monarch and empire, of the fruitfulness and prosperity that comes with effective rule, and of the role of the Oriental monarch as protector of a larger world whose extent was expressed in the many varieties of plants and animals.

There are many concepts incorporated into the wonderfully complex palatial structure at Taq-i Bostan and the monument illustrates diversity in form and design as well as continuity. The large iwan has been described as an ancient Iranian throne building with formal parallels in the podium thrones illustrated in Achaemenid and Parthian art. In a broader view it is possible to think of Taq-i Bostan in the context of the mobile court centers described in ancient texts concerned with the annual travels of the Achaemenid king through his empire. These settings are royal camps in the countryside, the occasional residences of the kings on their yearly travels through the kingdom.

In neighboring Arsacid Armenia in the Sasanian era similar mobile court centers are described. They included impermanent structures, tents and pavilions, as well as more lasting and permanent structures, such as hippodromes and game parks.[31] Writing

about the Achaemenid traveling court, Briant observed that the practice was designed to make the royal presence known through-out the vast kingdom and to underscore the king's control of his empire.[32] In modern times the erection of a lavish tent city at Persepolis by the Shah in 1971 was a similarly significant political expression to the world of his power and dominion.

In the Sasanian period the Iranian ruler followed the same cus-tom of annual progresses through his state, and certain coins from the fifth through the early seventh century bear the mint mark *BB' dar*, a movable mint operating not from a single site but from the place where the king and his court were currently in residence. A description written in the early nineteenth century of the en-trance of the Qajar ruler into his capital in Tehran gives a sense of what was involved in such a royal passage and provides a verbal illustration of the imagery on the large iwan at Taq-i Bostan and the events one can imagine took place at that royal setting.

> Here we learnt that the King was preparing to return and
> that arrangements were making for his reception, as it was
> his intention to dismiss his troups and pass ten days among
> the rocks of Sawachi, for the purpose of hunting the wild
> goat....
>
> His Majesty was gaily dressed.... His sword, his dagger,
> and other ornaments were entirely inlaid with precious
> stones. The bridle, crupper, breast-plate, were all either
> rubies, diamonds or emeralds, whilst a long tassel of pearls
> was suspended under the horse's throat, by a *cordon* that went
> around his neck.[33]

It is in the decorative program of the sculpture on the great iwan at Taq-i Bostan that continuity with past traditions is most

evident. Studies of the Assyrian palaces of the first millennium B.C. have given definition to these royal foundations and to the function of their relief programs. The origins of Assyrian pala-tial ideology have been traced back to monuments of the third and second millennia B.C. in Mesopotamia and the Assyrian relief programs have been interpreted as essential expressions of the role of the king: as a ruler enthroned under the aegis of the gods; as the maintainer of order through the prosperity and fertility of the realm; as the vanquisher of animals; and as heroic warrior, defeater of the enemies of the empire. The Assyrian palace reliefs are symbols of royal power that define and establish the iconog-raphy of rule.[34]

It can be argued that these same concepts of kingship and authority persist and are similarly apparent in the sculptural pro-gram laid out and preserved in part at Taq-i Bostan. The subjects of the sculptures on the large iwan include, on the facade, two immense trees at ground level and supernatural beings above on the spandrels of the arch, expressions of fertility and abundance at both the earthly and the supernatural level. The main figural motifs on the back wall are royal and divine presences, again arranged at two levels. The armored horseman at ground level is a reference to war and the scenes on both side walls are hunts, millennia-old themes in Mesopotamian palatial imagery and expressions of a Mesopotamian concept of kingship.[35]

The absence of any inscription contemporary with the reliefs that might identify the king and recount specific historical events has led to continuing discussions over the past century concern-ing the date or dates at which the monument was executed. This uncertainty is in large part due to the focus and purpose of the monument which, in contrast to the reliefs in the south, was to provide an ideal expression, using traditional formulae, of a uni-

versal concept of kingship here associated with the dynasty of Sasan. The crown of the king is that of a number of late Sasanian monarchs. Originally unique and individualized, the Sasanian royal crown after the fifth century A.D. becomes repetitive in form and images of the rulers are for all practical purpose indistinguishable, the crowns being symbols of dynasty rather than marks of individual identity.

Other questions exist concerning the explicit identity of the armored horseman, possibly a reference to the royal earthly warrior, a counterpart to the divinities and the spiritual realm represented above. These figures carved in high relief are icons that do not move in real space or come free of the architectural setting. There is no attempt to draw the viewer into a natural scene. The frontal imagery of the upper scene is broken only by the slight turn of the heads of the divinities toward the central royal figure and by the placement of Ohrmazd's feet.

There are few Sasanian architectural remains with which to compare the palatial monument at Taq-i Bostan.[36] Bishapur is the site of a third-century Sasanian palace but only a tiny percentage of the whole was excavated and has been published. The audience iwan was not part of the excavations and the function of the buildings uncovered remains enigmatic. The closest parallels for the imagery appearing at Taq-i Bostan are provided by fragmentary architectural stucco sculptures from Ctesiphon, Nizamabad, and Chal Tarkhan-Eshqabad. These reliefs offer evidence of some of the same subjects in a palatial or villa setting: winged entrance figures, elaborate plant or tree designs, and hunting scenes.

At Taq-i Bostan the Iranian social identity is overlaid with "a subscription to Mesopotamian cultural norms"[37] in order to give expression to the ideology of a ruler whose primary concern was to establish the legitimacy of his rule and place himself in the

role of his predecessors, the great kings who had ruled over Meso-
potamia and Iran. The king is the divine representative, protector
of the realm, royal hunter, and overlord of a peaceful and well-
ordered state. In the ninth-century B.C. palace of Ashurnasirpal
II at Kalhu (Nimrud), the visiting dignitary looked through the
entrance to the opposite wall in the throne room where the
images of the king framed a tree and were supported by winged
guardian figures.[38] At Taq-i Bostan the facade bears motifs stress-
ing both the fecundity of the realm and the presence of supernat-
ural beneficent beings. In contrast to the Mesopotamian, Assyrian
monuments, the Iranian iwan reliefs lack historical specificity as
well as any reference to conquest and subjugation. As at Achae-
menid Persepolis, nothing distracts the viewer from an ideal and
essential theme.

An analysis of the decorative programs of earlier palatial
buildings in Iran is hampered by the fact that there is insufficient
evidence from some periods. The images appearing on the palace
reliefs at Persepolis and on the Achaemenid glazed bricks found
at Susa and Babylon have been the subject of much scholarly study,
and one widely accepted hypothesis is that a court style existed
illustrating an

> intercultural synthesis in Achaemenid workshops, part of
> a deliberate expression focussing on unity, the world view
> of the Achaemenid rulers.... All of this was accomplished
> by a program that partook of essential qualities of artistic
> traditions that were not moribund but which had active and
> immediate associations.[39]

Other evidence of continuity in the sculptural program carved
on the walls of the large iwan at Taq-i Bostan can be found in

images that refer to the supernatural world, a realm that had considerable importance for all classes of Sasanian society. The introduction of a new monstrous image in the late Sasanian period at Taq-i Bostan is associated with the royal personage and the elite armored horseman. On the reliefs the new supernatural creation, the so-called *senmurw*, appears in the decoration of royal garments and in the caparison of the royal mount (Fig. 20).[40] The monster incorporates a number of significant features, but the basic form consists of a winged animal protome having a feline head and griffin ears, as well as feline legs and paws. Joined to this body is a peacock's tail. Earlier stages in the development of this image in Sasanian art are not preserved, and it is impossible to know whether the late Sasanian form seen in the reliefs at Taq-i Bostan had forerunners or whether this creature, as the evidence now suggests, was an entirely new phenomenon.

The appearance of the *senmurw* in a royal context at Taq-i Bostan is interesting to consider against the background of events in the sixth and seventh centuries within the Sasanian realm. The last two centuries of Sasanian rule in the Near East were a time of internal conflicts, foreign wars, and the massive displacements of peoples within the Sasanian realm. Throughout the Late Antique lands there was an atmosphere of uncertainty and fear as well. Political disruptions contributed to the vulnerability and suffering of populations who turned to the supernatural for protection. The need for an escape from known and unknown horrors was felt across the boundaries of class and religion. Christian bishops in Byzantium warned the faithful to turn their backs on magic, but the artifacts that remain suggest that the Church leaders had only a limited success. The cross became a charm against demons as much as an expression of adherence to a particular faith, and inscriptions on crosses that survive regularly include

both prayers and curses. In this context the appearance of the new Sasanian monster on the garment of the Sasanian king is understandable. The garments of lesser persons in the Eastern Mediterranean world were often decorated with biblical scenes not, apparently, to instruct the faithful but to protect the innocent. Scenes of the travels of the magi guarded travelers in the Late Antique world against mishaps.[41]

This is the environment in which the *senmurw* appears in the decoration of royal garments and equipment: on the caftan of the king on the side wall, and on the horse's body armor at Taq-i Bostan. The subject—a fantastic, composite, feline-bird creature— has a long history in the art of Mesopotamia and Iran and takes on various forms, at first as a lion-headed eagle, the Anzu-bird, a weather beast in Sumerian times, later as a four-legged creature, feline, and bird. A bird and feline monster also appears in the art of neighboring Bronze Age Bactria in the second millennium B.C., where it is thought to have been associated with spring waters and seasonality. In Mesopotamia through the mid-first millennium B.C. the composite feline-bird monster remains a weather beast associated with divinities who control the raging storms. At Parthian Hatra lion griffins decorate a doorway in the temple of the Semitic sun-god, Shamash (Fig. 21).[42] While no contemporary Middle Persian inscriptions offer an identification of the specific creature depicted at Taq-i Bostan, the concept of a great benevolent bird, the *Saena*, is present in Avestan texts and provides a plausible context for the appearance of this image in Sasanian times. The *Saena* comes to be associated with "the fortunes of man and the fertility of the world which depends on rain."[43]

Nowhere is continuity and tradition more evident and more important than in the realm of the supernatural, where the antiquity of images and practices added to their potency. Throughout

the Sasanian era magic was practiced by all levels of society and by adherents of all the religions within the realm: Zoroastrianism, Christianity, Judaism, and Manichaeism. The latter sect, led by Mani, a Parthian of Mesopotamian birth, emphasized the fact that he was a "doctor from Babylon," a heritage that explained and supported his claim to special prophetic powers.

One view into the world of the supernatural is provided by a class of magical artifacts from the Sasanian era preserved in large numbers in Semitic Mesopotamia and commissioned by members of various religions and most levels of society. These artifacts are simple, ceramic, ink-inscribed incantation bowls and lead amulet scrolls found in Sasanian levels in excavations in southern Mesopotamia and, occasionally, in northern Mesopotamia at sites such as Assur and Kalhu (Nimrud). The ceramic bowls date from the fifth to the seventh century and are inscribed in Judaeo-Aramaic (Hebrew script), Syriac, Mandaic, and, more rarely, Middle Persian. One hundred and fifty specimens excavated at Nippur in southern Mesopotamia were published in 1913 by Montgomery. Placed face down in buildings, the bowls were deposited beneath thresholds and in the four corners of rooms, areas in which earlier Babylonian apotropaic figures were also buried. One text in a bowl found at Nippur states explicitly that the bowl is to contain the evil demons. "Covers to hold in sacred Angels and all evil Spirits and the tongue of impious Amulet spirits. Now you are conquered, you are charmed...and sealed in each one of the four corners of his house."[44] Other inscriptions define specific techniques for overcoming demonic control and various ritual acts to be performed. The images frequently include shackled or bound demons (Fig. 22). Only rarely are the practitioners of the magic portrayed. On one bowl from Nippur a standing frontal figure, a powerful, apotropaic pose in

the ancient Near East, holds a palm frond aloft, a gesture Mont-
gomery compares to the ancient Babylonian practice of holding
aloft a tamarisk branch or a date palm to ward off demons
(Fig. 23). In his study of the Nippur bowls, Montgomery (p. 47)
also notes the correspondence between the way the exorcist pre-
sents his acts in the accompanying inscriptions on the bowls as
commissioned by the deities, and ancient Babylonian formulae,
the *maklu* (magical incantation) texts employed by the *asipu*
(priest-exorcist).

The texts and images on the incantation bowls relate them, as
a class of magical artifacts, to a group of seal-amulets of Sasanian
date.[45] On some examples a male figure holds a branch or mace
and grasps a monster. On one particularly elaborate and presti-
gious seal-amulet, in the collection of The Metropolitan Museum
of Art, another unique demonic image appears (Fig. 24).[46] The
rectangular obsidian stone on which the figure is carved is, how-
ever, an ancient amulet form in the Near East, the same approxi-
mate shape and size as many of the Mesopotamian amulets, the
so-called *lamashtu* plaques of the first millennium B.C. (Fig. 25).
Lamashtu, a female demon who primarily attacked women in child-
birth, was depicted on amulets as an upright striding form, the
sometimes hairy body surmounted by the head of a lion-griffin,
and talons on her bird feet.

The image on the Sasanian, obsidian amulet appears in an ex-
tremely schematic and iconic form, a cruciform body surmounted
by an oval head adorned with wild curling locks that almost
appear to be scorpion pincers. Surrounding and enclosing this
image on the obverse is a lengthy Middle Persian inscription, an
incantation against powers that might harm a woman named
Perozduxt. The reverse is uncarved. Because of the use of Middle
Persian and the inclusion of the name of Jesus in the incantation,

Skjaervø has postulated that the owner was a Christian living in the fourth or fifth century A.D.

The imagery on the Sasanian amulet shares certain features with the iconography of the incantation bowls and with representations on the *lamashtu* plaques. On the bowls the demons, as noted above, are shackled or bound; on the *lamashtu* plaques, spear points are customarily aimed at the demon's body. On the Sasanian amulet spears also point at the legs of the demonic abstraction. The purpose in every case was to control or contain a force while at the same time utilizing the potency of the monstrous creature to serve as a protection against lesser evils.

If continuity over such a span of time seems hardly credible, records from modern times give some support to the role of traditionalism in the practice of magic. In "A Tammuz Ritual in Kurdistan (?)," an article published in *Iraq*, the great Near Eastern archaeologist and art historian Henri Frankfort gives an interesting account of a modern cult practice in northern Mesopotamia:

> While excavating the Palace of Sargon at Khorsabad, for the Oriental Institute of the University of Chicago, we were called from our house one night (March 20th, 1930) by the sound of singing and the clapping of hands which accompanies the dances of that country-side. In front of our gate we found the villagers squatting and standing around an open space in which two figures performed. One was dressed as a woman, in a black garment with anklets, bracelets and veil. In her we recognized later one of our workmen. The other personage was wearing a high pointed basket as head-gear, a goatskin round his shoulders, and a bell tied to his girdle; he carried a heavy stick, and both had their faces blackened. . . .

After a little preliminary action...the man lay down on the ground, the "woman" at once showing signs of distress, beating her breast, throwing earth over her hair, while she continued to dance round the prostrate body. The "woman" finally knelt down beside the corpse with an increased display of sorrow. At this moment one of our men rushed out of the house and threw a bucket of water over the prostrate figure. At once both performers leapt to their feet the man demonstrating in the most convincing manner how he had recovered his vitality.

It was averred on all sides that the dance was made "for rain." The winter had been very dry till then (two days later our excavations were interrupted by a spell of wet weather lasting for twelve days!).[47]

Frankfort then proceeds to give a translation of the songs that continued throughout the performance, noting that as the "whole tradition is oral, there is no set version of the songs, which are composed of a series of motives presented as they occur in the singer's mind" (p. 140). He then notes similarities—in the songs and in the actions of the dancers—with "the cult of the god of fertility whose best known name is Tammuz, and of the Mother-goddess, with whom he is associated in ancient ritual as well as in our rain dance" (p. 145).

Continuity is not a feature particularly evident in another class of dynastic art associated through the millennia with the courts of the Near East. Silver vessels, the luxury ware of Near Eastern monarchs and a symbol of their majesty, were made in some quantity throughout the Sasanian era, as they had been in the immediately preceding Achaemenid, Seleucid, and Parthian periods. Gold vessels have not survived in any number from Achaemenid and Parthian times and are practically unknown in the

Sasanian period. The forms of Sasanian silver vessels reflect contemporary local and foreign influences rather then continuity with the past (Fig. 26). There are almost no parallels with the shapes of luxury vessels made at the Achaemenid, Seleucid, and early Parthian courts. To find continuity with these earlier Iranian vessels one must look to the borders and frontiers of the Sasanian state, to works made in contemporary Georgia in the west and Sogd in the east where modified Achaemenid and Seleucid forms and designs persisted. The selection of the hunter king as the primary and—for a time after the initiation of this production by Shapur II—the exclusive royal dynastic motif on the court silver demonstrates continuity only in the selection of an ancient prestigious theme (Fig. 27).[48] In earlier times this meaningful symbol of royalty had appeared on palatial and dynastic reliefs as well as on prestigious, official sealstones but it was not represented on silver and gold vessels in Mesopotamia or Iran in the preceding millennia. The utilization of a single royal theme to decorate the official court production of Sasanian silver plates suggests that the works of art were, rather, instruments of dynastic policy, icons of kingship.

A striking illustration of discontinuity with earlier silver productions is the lack of evidence in the Sasanian Near East for an ancient and prestigious form of luxury vessel: the horn rhyton. Only one example is known and that piece is probably an east Iranian work of art (Fig. 28). The omission of this familiar form from the known Sasanian corpus can be interpreted as a matter of chance or coincidence, as precious objects never survive in great quantity. But it is as likely that the variety of cult activities with which the shape was widely associated in the Late Antique world made its use at a Zoroastrian court inappropriate. A different form of rhyton known from Achaemenid and Parthian examples

continued to be produced and is known from late Sasanian examples made of ceramic and glass (Fig. 29) as well as of gilded silver. This is the vase rhyton, a shape represented by a late Sasanian gilded silver example in Tehran and another comparable, slightly earlier vessel in the Cleveland Museum of Art.

The limited typology of early Sasanian silver vessels and the significant images that decorate them—at first historical images of the royal family and of the high court nobility (Fig. 30) and, later, exclusively the symbolic royal hunter (Fig. 27)—underscore the role of the early Sasanian works in this medium as significant dynastic icons. Only the royal inscriptions naming the king and his forebears that appear on a few of the Achaemenid gold and silver vessels indicate that some of these earlier works may belong in the category of a significant court propaganda production comparable to the royal hunt vessels of the Sasanian era.[49]

In the second half of the Sasanian period there is an increase in the number of shapes of Sasanian silver vessels (Fig. 26) and the types of designs that decorate them, and some evidence suggests that there may have been a class of table silver, wine sets like those of the Achaemenid era, and groupings in which pairs or multiples of identical pieces existed, as they did in the Hellenistic and Roman world.

If the production of Sasanian silver vessels is a subject better discussed in the contexts of diversity and diffusion than continuity, it is nevertheless true that in one important respect Sasanian silver production was traditional. This is in the techniques used for the manufacture of the vessels. The single shell of the vessel is consistently hammered into the final shape and not cast; parts are added to the designs to produce relief by fitting the pieces into a lip cut up from the background shell; gilding is frequently used to enliven the designs. Although the ancient form of leaf

gilding is replaced early in the Sasanian period by amalgam gild-
ing, the solution of gold in mercury being a practice that may
have come to Iran from China, the effect in terms of the appear-
ance of the final product is traditional.[50]

The unusual technique of adding separate pieces to a precious
vessel to create relief elements of the design has been traced back
to the construction of objects and vessels in the Achaemenid era.[51]
Silver vessels made in that period incorporate into their decora-
tion significant images—royal figures and fantastic creatures—
executed in gold foil and slotted into a cut channel or area on the
vessel's surface. The history of high relief decoration on vessels is
a long one in Iran, going back to the third millennium B.C., but
evidence at this early time for the specific technique used on the
Achaemenid and Sasanian pieces does not exist. An interesting
parallel for this technique of adding elements in high relief to the
vessel background exists in Anatolia in the early second millen-
nium B.C., where, on elaborate ceramic cult vessels, high relief fig-
ures are placed into a cut-out and hatched space in the vessel wall.[52]
It is possible that in the use of this technique, an unnatural one
for ceramic artisans, the craftsmen who made these prestigious
ceramic pieces followed a metal-working tradition at present un-
known to us.

Perhaps the greatest challenge in attempting to identify conti-
nuity with the past in the arts is the question of how themes and
concepts persisted over the millennia. Craft traditions handed
down through families of artisans, the presence of extensive re-
mains, both monumental and minor works, and shared ideologies
and memories passed on through written and oral texts all con-
tribute to this phenomenon. The Sasanians were familiar with
works from earlier eras, not only rock reliefs and architectural
monuments but also innumerable minor works, artifacts of small

size, that they came upon in their occupation of ancient sites. Ancient seals were reused and at times recut in the Sasanian era, and in some cases the motifs and icons of earlier eras must have had an almost magical quality. An Achaemenid seal found at the late Sasanian and early Islamic site of Qasr-i Abu Nasr in southern Iran was carved again in Sasanian times with a magical theme and must have been used as an amulet.[53] At Barghuthiat near Kish in southern Mesopotamia a Babylonian stamp seal was impressed in the clay sealing one end of a Sasanian amulet case.[54]

While a familiarity with creations of earlier eras and preceding generations can often be documented, continuity in the realm of ideology and in the perception and interpretation of events is a more difficult subject to address. Written texts and oral tales are essential elements in understanding continuity at this level. The legendary birth stories of Sargon, Cyrus, and Ardashir demonstrate that rulers in Sasanian times shared with their predecessors a particular way of viewing and expressing significant dynastic events, and the similar phraseology used in official dynastic inscriptions in the Achaemenid and Sasanian periods illustrates a need or a preference for traditional modes of expression at the highest levels of society.

How well-known and well-understood were the earlier expressions of authority and ideology? If it is true that the cuneiform script could still be read by even a limited number of persons as late as the third century A.D., this fact would suggest that the transmission of complex ideologies and dynastic tales was possible.[55] Some texts from antiquity were also carefully preserved and copied.[56] In the third century B.C. Berossus, a priest of Marduk living in Babylon, wrote the *Babyloniaka*, dedicating it to the Seleucid ruler Antiochus I (281–261 B.C.). Only a part of the text, which attempts to explain Babylonian origins and ideology to

the new Hellenistic rulers in the Orient, is preserved, but it is evident from what survives that Berossus was drawing on ancient sources, including a version of the ancient Mesopotamian Creation story, the *Enuma elish*, to describe the defeat of Chaos by Marduk, the great god of Babylon, and the establishment of order in the universe.[57] Similarly, the *Physiologus* (ca. second century A.D.), a widely known collection of ancient animal fables reinterpreted in a Christian context, preserved oriental stories in a moralizing and allegorical form.[58]

Important as these and other sources known to us were in the transfer of ideas and images, there is a larger and significant but more elusive presence in the Sasanian world that must have contributed, as it had over the millennia in the Near East, to the transmission of ancient wisdom and ideology. This is the oral tradition. An Iranian *Book of Kings*, a compilation of national epics, legends, and historical data, was written down only late in the Sasanian period, but undoubtedly it was sung in the courts of kings and in the gathering places of common men long before any traditional text was compiled.[59] Firdausi's version, the *Shahnameh* of the eleventh century, is still an integral part of modern Iranian life and culture. On September 23, 1998, at the United Nations General Assembly in New York, President Khatami of Iran gave a speech directed to Iranians living in this country. It was described in *The New York Times* as having "said little about Islam but appealed to his audience's sense of Iranian nationalism instead. He told the story of two of the heroes in the eleventh-century Persian epic poem, the *Shahnameh*, adding that in battle Iranians treated each other with respect." "Nationhood is not a piece of land," he said. "It is in your blood."

The significance of oral sources lies not in historical or chronological accuracy but in the fact that the sources preserve signifi-

cant aspects of a culture—religious beliefs and moral concepts as well as 'historical' events.[60] Any definition of Sasanian culture must include the prominent role of the 'singer of songs,' and this subject will be returned to often in the following chapters, to point the way to an understanding of Sasanian identity.

1. The subject of cultural as well as literary continuity in the pre-Islamic Near East has been treated by many scholars. For references and bibliography, see particularly Yarshater 1971, pp. 517–531; Root 1994, pp. 9–37; Dalley 1998, pp. 163–181.

2. Yoffee 1988, pp. 44–45. For the opinion that cuneiform could still be read as late as the third century A.D., see Geller 1997, pp. 43–95.

3. Parrot 1948, pp. 150–155, 309–313; Downey 1988, p. 48; André-Salvini 2003, pp. 424–425.

4. Winter 1992, p. 25.

5. Sancisi-Weerdenburg 1985, pp. 459–471; Kuhrt 1990, p. 185.

6. Sprengling 1953.

7. Skjaervø 1985, pp. 593–603; Huyse 1990, pp. 177–181; Wiesehöfer 2002, pp. 430–431.

8. Shabazi 1977, pp. 200–204; Wiesehöfer 1996, p. 223; Back 1978, pp. 492, 495.

9. Ghirshman 1976, pl. XLI 6.

10. Ghirshman 1962, fig. 190.

11. Creswell 1989, p. 7.

12. Azarnoush 1994, pp. 132–134, 163, 164.

13. Tavoosi 1989, pp. 25–38.

14. Skjaervø 1992, p. 158.

15. Root 1990, p. 24.

16. Luschey 1979, p. 401; von Gall 1979, pp. 617–618; Luft 2001, pp. 31–49; Lerner 1991, pp. 31–43. Lionel Bier brought my attention to the fact that the remains of a Sasanian relief exist at the base of the Qajar monument at Shiraz.

17. Skjaervø 1983, pp. 269–306; Skjaervø 1993, pp. 697–698.

18. Kawami 1987a, pp. 157–159, pl. 3; Treister 1994, pp. 172–203; Treister 1997, figs. 24, 28.

19. von Gall 1990, pl. 18.

20. Herodotus bk. 6, ch. 40; Anderson 1961, pp. 18, 82; Shabazi 1987, pp. 724–730.

21. Michalak 1987, pp. 73–86.

22. Gyselen 2001.

23. Daryaee 2002, p. 290.

24. Rabbat 1993, p. 208.

25. Garrison 1991, pp. 3–4; Stronach 1997, pp. 40–41.

26. Baltrusaitis 1929, p. 55.

27. Gabra 2002, pp. 80–81, figs. 6.10, 6.11.

28. Herrmann 1981, pp. 151–160.

29. Stronach 1989, pp. 475–502; Stronach 1994, pp. 3–12.

30. Wiseman 1952, pp. 24–39.

31. Garsoïan 1988–1989, pp. 263, 267.

32. Briant 1988, pp. 253–273.

33. Morier 1818, pp. 385, 387.

34. Winter 1993, pp. 27–55.

35. For a similar two-level arrangement of sculptures, which separates the private and sumptuous images from the symbolic ones, at early-Islamic Khirbat al-Mafjar, see Soucek 1993, p. 124.

36. L. Bier 1993, pp. 57–66.

37. Yoffee 1988, p. 67.

38. Harper 1996, pp. 124–125.

39. Root, p. 134.

40. Schmidt 1980, pp. 1–64; some scholars believe that this fantastic creature should be identified as a personification of the concept of *xvarena* (heavenly fortune). See, e.g., Belenitskii and Marshak in Azarpay 1981, pp. 70–73; Marshak 2002, p. 37.

41. Kitzinger 1954, pp. 83–150; Maguire 1990, p. 223.

42. Schmidt 1980; Wiggerman 1992, pp. 185, 188; Aro 1976, pp. 25–29; Brisch 1967, pp. 237–249.

43. Schmidt 1980, p. 5.

44. Montgomery 1913, p. 133.

45. Gyselen 1995, fig 43a.

46. Harper, Skjaervø, Gorelick, Gwinnett 1992, pp. 43–58.

47. Frankfort 1934, pp. 137–138.

48. For bibliography, see Gignoux 1983; Rashid 1996.

49. Gunter, Root 1998, p. 27.

50. Moorey 1988, pp. 231–246.

51. Moorey 1993, pp. 131–139.

52. Özgüç 1988, p. 85.

53. Wilkinson 1965, pp. 341–345.

54. Langdon 1934, p. 123.

55. Geller 1997, pp. 43–95.
56. Dalley 1991; Dalley 1998a, b, pp. 45–49, 163–181.
57. Burstein 1978; Kuhrt 1987, pp. 32–56.
58. Wittkower 1938–39, pp. 293–325.
59. Shabazi 1990, pp. 208–229.
60. Culley 1972, pp. 102–116.

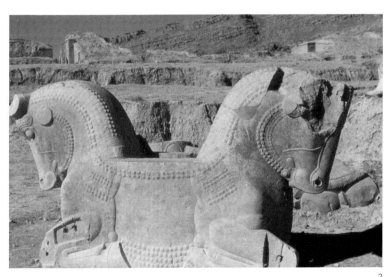

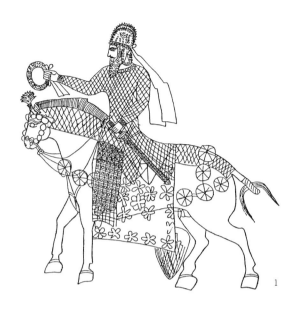

Fig. 1 Drawing of horseman, Persepolis, Iran. Sasanian, 3rd century A.D.
P. Calmeyer, in *Archaeologische Mitteilungen aus Iran* 9, 1976, abb. 3 (opp. p. 64).

Fig. 2 Bull protome on impost block, Persepolis, Iran. Achaemenid, 6th – 5th
century B.C. Photo: V. E. Crawford.

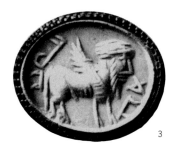

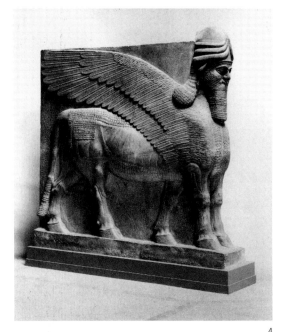

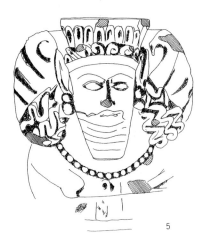

3

4

5

Fig. 3 Modern impression of stamp seal. Sasanian, ca. 6th century A.D. The British Museum, London, acc. no. 119859.

Fig. 4 Limestone sculpture of winged human-headed bull, Nimrud, Iraq. Assyrian, 9th century B.C. The Metropolitan Museum of Art, acc. no. 32.143.1. Gift of John D. Rockefeller Jr., 1932.

Fig. 5 Drawing of stucco human-headed winged bull, Hajiabad, Iran. Sasanian, 4th–5th century A.D. Azarnoush 1994, fig. 141.

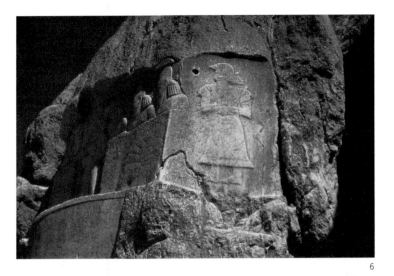

6

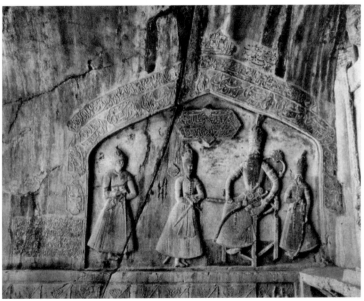

7

Fig. 6 Rock relief of Bahram II (A.D. 276–293) and Neo-Elamite king, Naqsh-i Rustam, Iran. Sasanian, 3rd century A.D.; Neo-Elamite, early first millennium B.C. Photo: L. and C. Bier.

Fig. 7 Rock relief of Fath Ali Shah (A.D. 1798–1834), Taq-i Bostan, Iran. Qajar. Photo: V. E. Crawford.

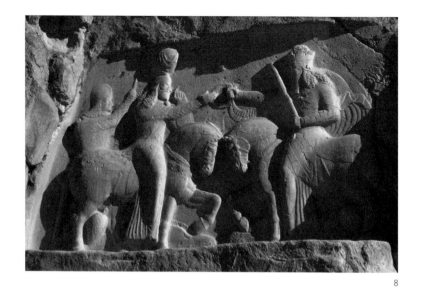

8

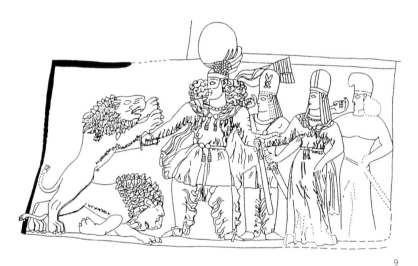

9

Fig. 8 Rock relief of Ardeshir I (A.D. 226–241), Naqsh-i Rustam, Iran. Sasanian, 3rd century A.D. Photo: L. and C. Bier.

Fig. 9 Drawing of rock relief of Bahram II (A.D. 276–293). Sar Meshed, Iran. Sasanian. K. Tanabe, in *The Art and Archaeology of Ancient Persia* 1998, p. 96, fig. 28.

Fig. 10 Drawing of rock relief of Shapur I (A.D. 241–272), Bishapur, Iran. Sasanian, 3rd century A.D. Herrmann, in *The Art and Archaeology of Ancient Persia* 1998. p. 43; fig. 1.

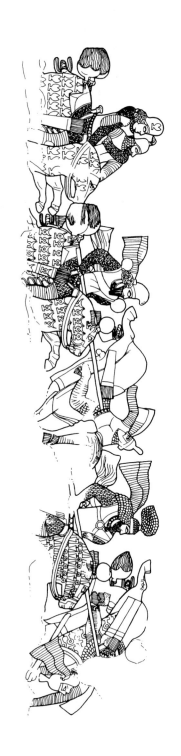

Fig. 11 Drawing of rock relief of Ardeshir I (A.D. 224–241), Firuzabad, Iran. Sasanian, 3rd century A.D. L. vanden Berghe, *Reliefs rupestres de l'Iran ancien*, Brussels 1983, fig. 8.

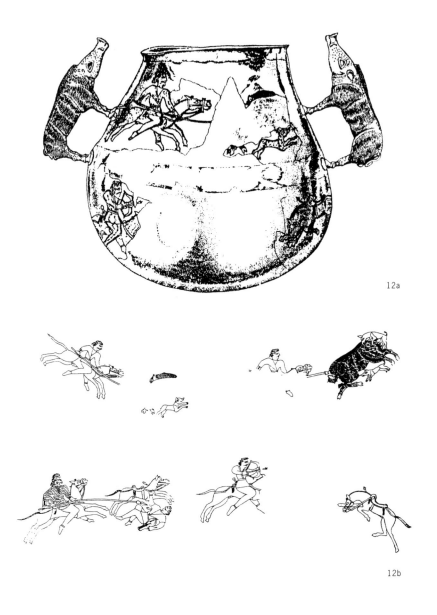

Fig. 12 a,b Drawing of silver cup, Kosika, Caucasus. Sarmatian, 1st–2nd century A.D.
Treister 1994, figs. 1, 7.

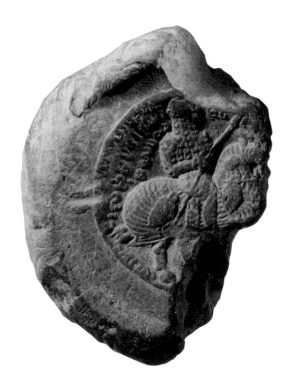

Fig. 13 Clay sealing with impression showing an armored horseman. Sasanian, 6th–7th century A.D. Mr. and Mrs. Jonathan P. Rosen Collection.

Fig. 14 (OPPOSITE) Iwan sculptures, Taq-i Bostan, Iran. Khosro II (A.D. 591–628). Sasanian, 6th–7th century A.D. Photo: L. and C. Bier.

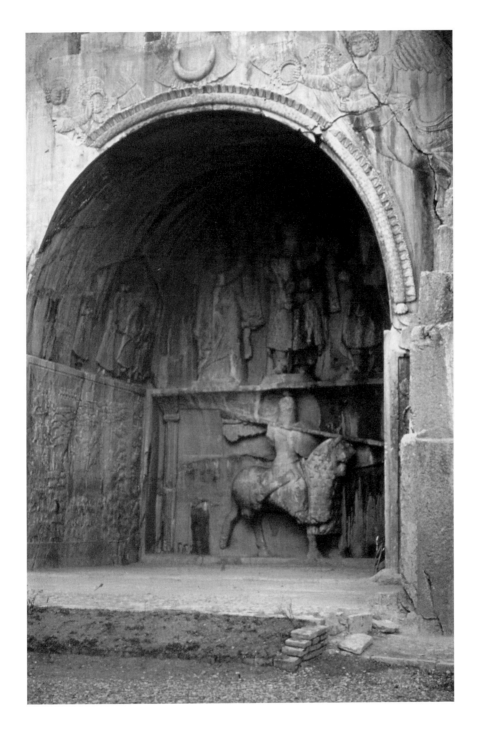

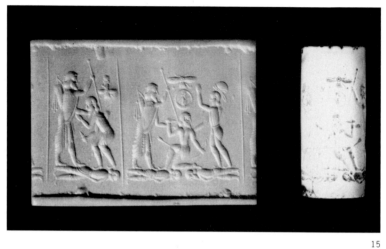

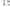

15

16

Fig. 15 Modern impression of cylinder seal. Achaemenid, 6th–5th century B.C. The British Museum, London, acc. no. 124015.

Fig. 16 Drawing of impression of cylinder seal of Cyrus on clay sealing, Persepolis, Iran. 7th century B.C. Stronach 1997, fig. 15.

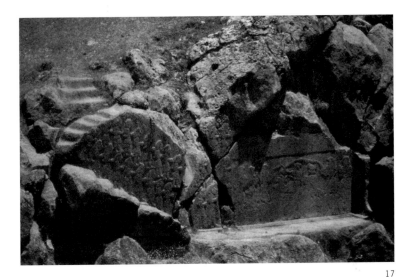

17

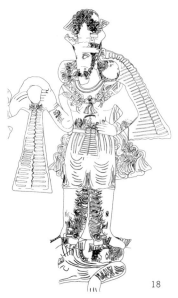

18

Fig. 17 Rock reliefs, Kurangun, Iran. Elamite: side panels, 8th–7th century B.C.; central panel, 17th century B.C. Photo: L. and C. Bier.

Fig. 18 Drawing of rock relief of Ardeshir II (A.D. 379–383), Taq-i Bostan, Iran. Sasanian, 4th century A.D. S. Fukai et al., *Taq-i Bustan III.* The Institute of Oriental Culture, University of Tokyo, Tokyo, 1983, pl. XXVI.

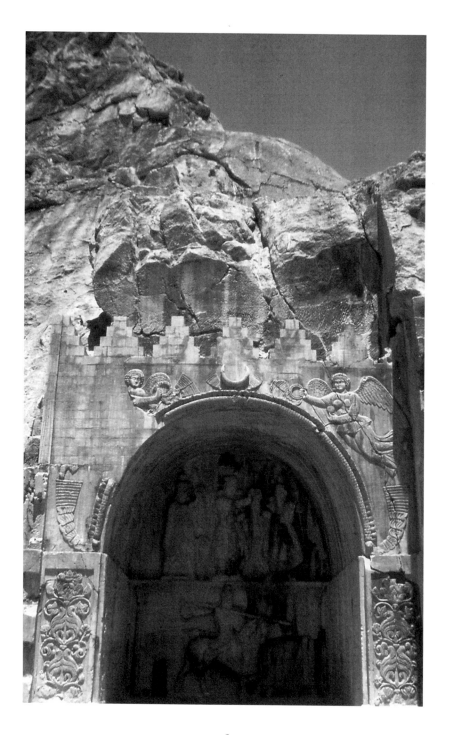

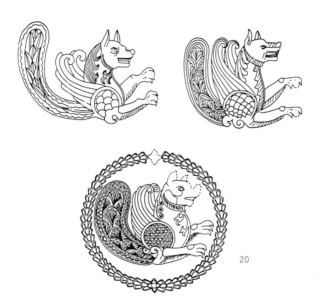

20

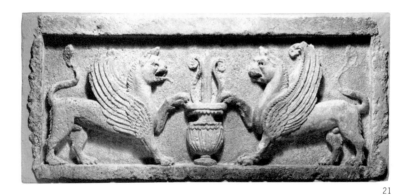

21

Fig. 19 (OPPOSITE) Iwan of Khosro II (A.D. 591–628). Taq-i Bostan, Iran. Sasanian, 6th–7th century A.D. Photo: L. and C. Bier.

Fig. 20 Drawings of *senmurw* figures, Taq-i Bostan, Iran. Sasanian, 6th–7th century A.D. S.Fukai et al., *Taq-i Bustan IV,* Tokyo 1984, figs. 60, 62.

Fig. 21 Lintel stone, Temple of Shamash, Hatra, Iraq. Parthian, 2nd–3rd century A.D. The Metropolitan Museum of Art, acc. no.32.145 a, b. Joseph Pulitzer Bequest, Purchase, 1932.

49

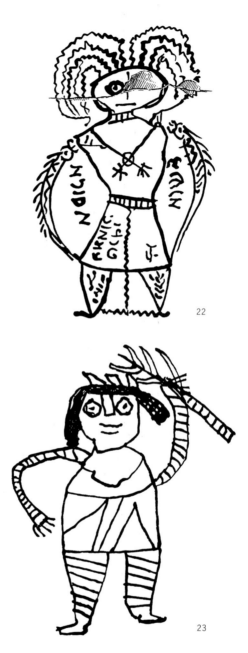

22

23

Fig. 22 Drawing of demonic figure on incantation bowl, Nippur, Iraq. Sasanian, 5th–6th century A.D. Montgomery 1913, pl. XXI.

Fig. 23 Drawing of figure on incantation bowl, Nippur, Iraq. Sasanian, 5th–6th century A.D. Montgomery 1913, pl. IV, figure for Text 4.

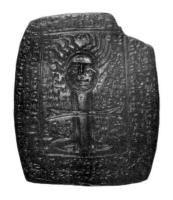

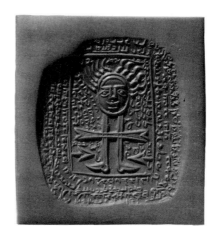

24

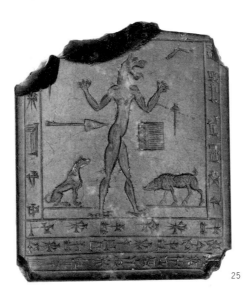

25

Fig. 24 Stone amulet. Sasanian, 4th century A.D. The Metropolitan Museum of
Art, acc. no. 1989.123. Purchase, Rogers Fund, 1989.

Fig. 25 Obsidian *lamashtu* plaque. Neo-Assyrian, 9th–7th century B.C.
The Metropolitan Museum of Art, acc. no. 1984.348. Purchase, James N. Spear
Gift, 1984.

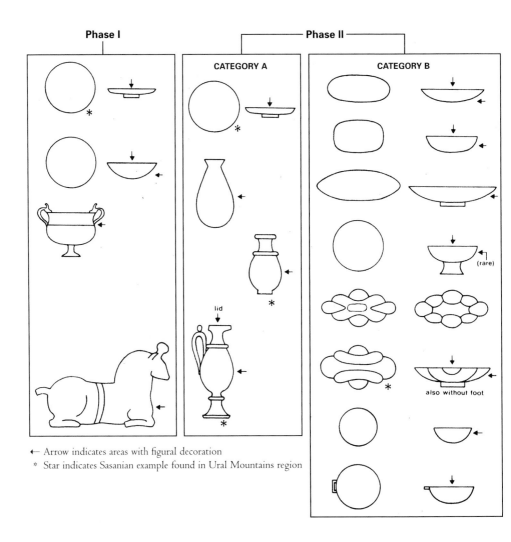

Phase I

Phase II

CATEGORY A

CATEGORY B

lid

(rare)

also without foot

← Arrow indicates areas with figural decoration
* Star indicates Sasanian example found in Ural Mountains region

Fig. 26 Sasanian silver vessel shapes. Harper, in *Argenterie romaine et byzantine,* ed. F. Baratte. Paris, CNRS 1988, p. 155, fig. 1.

52

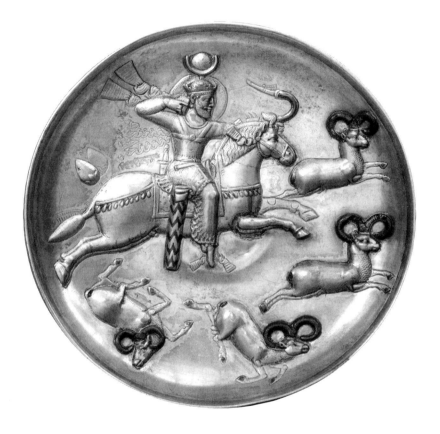

Fig. 27 Silver-gilt plate with Peroz or Kavad I hunting rams. Sasanian, 5th or early 6th century A.D. The Metropolitan Museum of Art, acc. no. 34.33. Fletcher Fund, 1934.

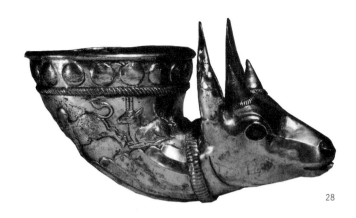

28

29

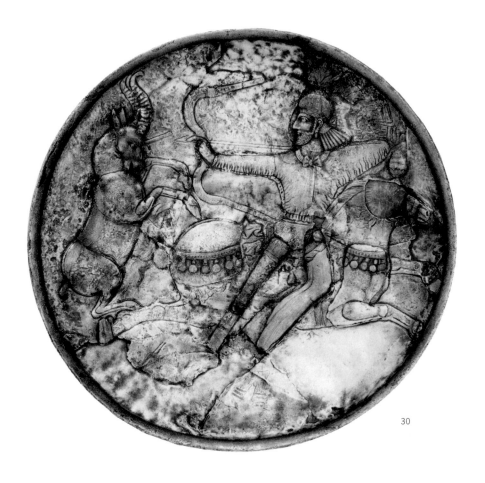

30

Fig. 28 (OPPOSITE) Silver-gilt rhyton. Sasanian, ca. 4th century A.D. Arthur M. Sackler Gallery, Washington D.C., acc. no. S1987.33. Gift of Arthur M. Sackler, 1982.

Fig. 29 (OPPOSITE) Glass vase-rhyton. Sasanian, ca. 6th century A.D. The Metropolitan Museum of Art, acc. no. 64.60.1. Fletcher Fund, 1964.

Fig. 30 Silver plate. Shemakha, Azerbaijan, Sasanian, 3rd century A.D. Museum of the History of Azerbaijan, Baku. Harper, Meyers 1981, pl. 8.

DIVERSITY

Peoples from the lands bordering the Near East had periodically entered Mesopotamia and Iran from the east and the west in the millennia before the Islamic era, and their gradual assimilation into existing urban societies led, over time, to the growth of rich and diverse cultures in the region. During the Achaemenid period cultural diversity, as it was expressed in the court and dynastic arts, became a symbol of empire, the foreign presence a support and affirmation of the Persian center. Herodotus observed simply that Persians readily adopted foreign ways, and it is true that if one looks at the court luxury objects— Achaemenid, Parthian, and Sasanian gold and silver vessels—one forms the immediate impression that such luxury works of art, spanning a millennium, reflect the influence of contemporary foreign, chiefly western, forms and styles as much as continuity with past traditions.[1]

At one level, local internal factors led, as they had in the past, to cultural diversity within Sasanian Mesopotamia and Iran. Natural barriers—mountains, deserts, and rivers—in Mesopotamia and, more substantially, in Iran created an environment where distinct traditions developed and were maintained by geographically separated populations. These traditions are apparent in the material culture of all levels of society, from the ceramics used in everyday life to the court-commissioned rock reliefs produced in different parts of Iran.

Cultural and religious diversity in the Near Eastern lands in the Sasanian era is also a reflection of historical events. The Sasanian policy of transporting foreign prisoners to various places within the kingdom follows age-old precedents established by the

Assyrian and Babylonian rulers of Mesopotamia in the first millennium B.C. But population displacements also occurred as a result of economic conditions and religious policies in the Late Antique world. Silk merchants from the West came to Persia after the imposition of a state monopoly by Justinian (r. A.D. 527–565) ruined the market in the Byzantine realm, and Christian Nestorian refugees fled to the Sasanian kingdom from religious persecution in Orthodox Byzantium. With the influx of refugees and prisoner populations from Syria and Byzantium and with the official establishment in the early fifth century of a Nestorian Church in the Sasanian East, independent of the Orthodox Church in Byzantium, the Christian population of the Sasanian kingdom became an increasingly significant element in Sasanian society and culture. The closing of the School of Edessa in the late fifth century and the flight of Nestorian scholars to the East contributed to the development of the hospital and medical school at Gundeshapur near Susa in southwestern Iran, a major center established by Shapur I (r. A.D. 242/3–273) to settle his Roman prisoners. By the sixth century this city was one of the primary intellectual centers in the ancient world, a place where teachings drawn from many sources, the Greek world as well as India, were expounded. The office of royal physician at Ctesiphon was regularly held by Christians,[2] and there are Syriac records of the role of Christians, weavers from Amida, transported to Khuzistan by Shapur II (r. 309–379). In the fourth century the career of Posi, a weaver whose father was a prisoner resettled at Bishapur, can be followed as he moved from a position as head of a textile workshop near the palace of Shapur to become head of artisans at Karkha de Ledan (Ērānshahr-Shāpūr), and subsequently head of artisans in other regions. Finally, as *karougbedh* he was chief of all artisans and inspector of ateliers throughout the empire.[3]

Nina Garsoïan has observed that the borders between Christian Byzantium and Zoroastrian Mesopotamia and Iran were generally open in spite of ongoing hostilities and political disagreements. The two empires shared important market cities at Callinicum and Nisibis in Mesopotamia and Artaxata in Armenia, where Persian and east Roman merchants met and traded their wares. The Sasanian king was titular head of the Nestorian Church and later of the Armenian Church, and there are politically motivated tales of conversion to Christianity associated with a number of late Sasanian rulers—Khusrau I (r. 531–579), Khusrau II (r. 591–628), and Shahrvaraz. The fifth-century Sasanian ruler Yezdgird I (r. A.D. 399–421) agreed to stand as guardian for Theodosius II, the son of the Byzantine emperor Arcadius, and under Khusrau II and Kavad II (r. 628). Christians enjoyed considerable religious freedom. By the late Sasanian period the Christian churches and oratories in the Sasanian capital city of Ctesiphon were so numerous, according to literary sources, that Khusrau II could hear the chimes (Fr.: simandres) from his palace in that city. A Christian community at Bishapur actually minted coins inscribed in Middle Persian displaying a frontal bust and a cross on a base. The period to which these coins belong is uncertain but one suggestion is that they were minted in the pre-Islamic period, around A.D. 591, when relations between Khusrau II and the Byzantine emperor Maurice were close.[4]

The ancient Jewish communities in Mesopotamia and Iran, whose origins go back to the Babylonian deportations of the first millennium B.C., were also a significant and historically well-documented segment of Sasanian society. This is the era in which the Babylonian *Talmud* was produced and some evidence of the Jewish presence in Sasanian material culture exists in the minor arts, notably in the carvings on stamp seals. Paintings at third-century

Dura Europus in Syria provide evidence of a Persian-Jewish artistic *koine* that is relevant to any discussion of Sasanian Persian and Jewish art, although comparable remains are regrettably not preserved in Mesopotamia or Iran. It has been reasonably argued that it is through Jewish art that some Parthian and Sasanian artistic modes became known in the West.[5]

To illustrate the different aspects of diversity in Sasanian culture, whether caused by ethnic, religious, or geographical factors, is a challenging prospect since the material remains are not extensive and do not constitute in any sense a representative whole. Nevertheless analyses of the various remains, ranging from luxury objects to the artifacts of daily life, provide a clear indication of the coexistence within Sasanian culture of two equally important but distinct phenomena. On the one hand there developed early in the Sasanian period a standardized and canonical language of images, the official expression of the new Zoroastrian state. This official language of dynastic images, evident in coins, seals, rock reliefs, and silver vessels, developed and changed over the centuries but remained regulated and distinctive. In contrast are the works of art and artifacts created by and for other levels of society. These works illustrate a freedom from the restrictions and conventions of the official art and provide evidence both of continuity with the pre-Sasanian past and of a culture that was broad and inclusive, incorporating and preserving features drawn from diverse sources. To identify one of these classes of artifact as more 'Sasanian' than the other is to mistake the character of the times and the nature of Sasanian culture in its totality. While the official Sasanian court arts include the most prominent and well-studied monuments, the restrictions and conventions that they display are best understood in the context of the minor arts produced for a culturally rich and diverse society.

A good illustration of the nature of this society and of the artifacts that fall outside the realm of official court arts is provided by Donald Whitcomb in his detailed publication of the excavations in the 1930s by The Metropolitan Museum of Art at Qasr-i Abu Nasr near Shiraz in southern Iran.[6] Qasr-i Abu Nasr is a small site near Persepolis in Fars province located on routes leading from the Persian Gulf to the north and on roads between the eastern and western parts of the Sasanian empire. Whitcomb remarks on regional continuity over time in the resemblances that can be noted between the Qasr-i Abu Nasr late Sasanian ceramics and much earlier Iron Age materials from western Iran (Baba Jan, Nushijan, and Godin). Whitcomb comments as well on the considerable diversity apparent in the cultural complex. Artifacts comparable to the finds made at Qasr-i Abu Nasr come from a variety of regions, ranging from Corinth in Greece to Piandjikent in western Central Asia. Weights, buckles, lamp stands, eating implements, and crosses are all indistinguishable from Byzantine types. A buckle found at Qasr-i Abu Nasr has a curvilinear meander design and is a type generally believed to have been distributed from a Byzantine center (Fig. 31). At Malyan, near Qasr-i Abu Nasr in Fars, an unlined burial pit of late Sasanian date contained another buckle of this precise type.[7] The burial was an inhumation, contrary to Zoroastrian practice, and the person interred in the grave was probably not a Zoroastrian. Nevertheless the deceased was a personage of some means and importance as the grave contained, in addition to the buckle, a number of iron daggers, a short sword, a silver bowl, and some weapon that once had a hilt decorated with seed pearls.[8] The bronze buckles and other minor artifacts excavated at Qasr-i Abu Nasr, whether they were the creations or possessions of Persian nationals, foreign merchants, or colonists, provide documentation of an extensive

multi-cultural presence in material complexes from the heart of the Sasanian kingdom.

Unlike Qasr-i Abu Nasr, most excavations of Sasanian remains in Mesopotamia and Iran have focused on major urban centers, residences of the nobility and religious foundations. Major artifacts found in these excavations expand our knowledge of Sasanian court art, and recent studies of materials excavated in earlier decades as well as new archaeological fieldwork have focused increasingly on minor artifacts, notably ceramics.[9] This latter class of artifact reveals the impact of geographical divisions and regionalism, phenomena that are less easy to identify in the official art. Remy Boucharlat writing about the ceramics found at Susa in southwestern Iran and at Turang Tepe in the north of the country, concludes that the regional diversity apparent in ceramics made in the preceding Parthian period continues in the succeeding Sasanian era. As in past centuries, the ties of Susa in the Sasanian period were with the southern Mesopotamian lowland and the Gulf rather than with neighboring Fars to the south or more distant areas in the east of Iran. Glazed ceramics, rare in northern Mesopotamia and most of Iran, are found commonly at sites in southern Mesopotamia and are present in Susiana—although Boucharlat claims that they are not so common as the literature suggests. One fabric described as "coarse, brittle ware" is a local production in northern Mesopotamia that does not extend to southern or central Mesopotamia. In contrast, the practice of stamping vessels with figural and abstract designs is documented over a wide area in Mesopotamia, Iran, and western Central Asia in Sasanian times.

At Turang Tepe, on the Gurgan plain in northeastern Iran, the ceramics are related to materials excavated at sites farther east, in Khwarazm and Kazakhstan. There are no points of comparison,

on the one hand, with ceramics from Khuzistan in southwestern Iran or, on the other hand, with the ceramics of Margiana and the Merv oasis. Thanks to the recent work of the Turkmen/British expedition to Merv, we will soon have a corpus of ceramics of Sasanian date from this region long under sporadic Sasanian rule. One unique, late Sasanian, ceramic type found at Merv is a class of ceramic vessels painted with rich polychrome figural designs, a distinctive fabric otherwise undocumented in the Sasanian world (Fig. 32).

The ceramics used within the Sasanian realm underscore the continuing presence of regional cultural diversity. Less well documented in terms of provenance or source but as large and varied a body of material as the ceramic corpus are the stamp seals produced during the Sasanian era. These tiny artifacts are largely of unknown provenance. However, the artistic imagery used by the various religious minorities in the Sasanian realm is apparent in the motifs chosen for some of the seal stones. Among the small group of seals belonging probably to prominent members of the Jewish community there are two types: those seals having a Hebrew legend but carved with images identical to those found commonly on seals having Middle Persian inscriptions; and those in which specifically Jewish motifs appear, the *lulav* (base and sprouting branch), *etrog* (citrus fruit), and the temple incense shovel (Fig. 33). In the eastern Mediterranean world in the early centuries A.D. these same symbols are prominent on coins and in the minor arts at times of national revival, and it is possible that the choice of these subjects as a seal motif may also be related to the rise of Jewish political aspirations within the Sasanian kingdom at certain times. The Jewish motifs on the Sasanian seals are only generally similar in appearance to the same subjects represented in the arts of the eastern Mediterranean world, notably on

coins. On Sasanian seals both the *lulav* and *etrog* display some variations in their form and are, apparently, local developments in a region where the standard Jewish icons were no longer familiar.[10]

Seals that can be identified as having belonged to Christians in the Sasanian realm constitute a larger group.[11] The establishment of the Nestorian Church in the East followed the Council of Chalcedon (A.D. 437) and the creation of an Orthodox Church in Byzantium. Christians in the East, no longer allied to or part of this 'orthodoxy,' created their own church which adhered to the teachings of Nestorius. In the second half of the fifth century a Nestorian Church hierarchy developed. A *catholicos* residing in Veh Ardeshir in the region of Ctesiphon was placed over all Christians in the Orient. Below this official, a Metropolitan headed the clergy who were scattered through ecclesiastical provinces that were under the control of bishops. This pyramidal arrangement of authority is similar to administrative divisions within the Sasanian state administration, where officials were placed over a group of provinces, a single province, and, at the lowest level of authority, the subdivision of a province. Some seals of Christian authorities—as well as of persons of lesser or unknown rank— have survived, and, like the seals of the Jewish community, they illustrate some distinctly Christian subjects, notably the cross, as well as motifs that are also commonly found on ordinary Sasanian seals. The inscriptions are in Syriac or, alternatively, in Middle Persian. One Christian seal impression showing two profile human busts confronting a hill topped by a cross appears on a sealing excavated at Takht-i Sulaiman, the site of the Zoroastrian Fire Temple of the King and the Warriors (Atur Gushnasp) in northern Iran.[12]

While there is a fairly extensive corpus of recognizable Christian seals identifiable by the presence of a Syriac inscription or a

Christian cross, some motifs on seals are ambiguous. Old Testament scenes such as the sacrifice of Isaac by Abraham and Daniel in the lion's den may be intended for either a Christian or Jewish patron, a determination that can sometimes be made on the basis of the inscription. Syriac inscriptions are an indication of a Christian owner, as the legends on Jewish seals are written in Hebrew. One unusual subject appearing on a Sasanian seal that has a Syriac inscription is the figure of a man wearing striated and irregularly defined clothing (Fig. 34). This seal, which is in the British Museum, may illustrate a form of dress worn by the wandering monks and ascetics who were clad, in humility, in ugly and diverse forms of rags of hair or wool.[13]

Other motifs on Sasanian seals can be assumed to be Christian because of their popularity in Christian art in the eastern Mediterranean world. This is true of the stag and snake combat, the focus of a tale recorded in the *Physiologus,* a compilation of ancient animal tales recast and given a Christian interpretation. The book is probably a work of the fourth century A.D. written in the Syro-Palestinian region, and the tales, widely translated and known in the fifth and sixth centuries A.D., include a story concerning a stag and snake.[14] The stag, his mouth filled with water, flushes the snake from its hole, grasping it and killing it—so "the Lord slew the great dragon with the heavenly waters of knowledge." This theme became popular for obvious reasons in the decoration of Christian baptisteries in the eastern Mediterranean world, and the same motif was included in the seventh-century mosaic decoration of a floor in the Great Palace at Constantinople. Although an uncommon subject in Sasanian art, the stag in combat with a snake is represented on a fine Sasanian seal (Fig. 35) and in a stamped design on a Sasanian vessel in the British Museum.[15] There is no inscription to indicate who commissioned the carving

on the seal stone, but the choice of this motif might be an indication of familiarity with the *Physiologus* tale and the owner might have been a Christian.

Related to the seal stones produced for Christians within the Sasanian realm is the Sasanian amulet described in the preceding chapter, a precious work of art probably made for a high-ranking member of a Christian family some time in the fifth century (Fig. 24).[16] Oktor Skjaervø has suggested that the inscription on this stone, which names Perozdukht, may reflect the activity of a Christian amulet writer. The image on the amulet, a tousled head surmounting an abstract cruciform body, is contemporary with some of the earliest representations of the Christian crucifixion in the fifth century A.D., images that also display a human head surmounting a cross. One other point of comparison between the Christian crucifixion scenes and the motif on the Sasanian amulet is the presence of a spear or spears aimed toward a central figure. As noted in the preceding chapter this detail has a long history in Near Eastern art, where spears similarly threaten or control the demonic *lamashtu* figures carved on Assyrian and Babylonian amulets of the first millennium B.C.

Another religious development, early in the Sasanian period, was the appearance of a new gnostic religion preached by Mani, a prophet born in A.D. 216 in Babylonia, whose parents seem to have been connected to the Arsacid clan. For a time Mani had the support of Shapur I (r. 242/3–273), to whom he dedicated his treatise, the *Shapurakan.* Mani is said to have been a painter and to have used books with paintings as didactic aids to propagate the tenets of his new religion. No evidence of Manichaean painting and scarcely any artifacts that can be classified as Manichaean art survive from Mesopotamia or Persia, but fragmentary Manichaean paintings dating from the eighth to tenth centuries were recovered

in the nineteenth century at sites along the Silk Roads in Central Asia where the religion for a time flourished.

The use by Mani of art as a means of making his religion accessible and the influence of this teacher for a brief time at the Sasanian court are factors that deserve consideration in the context of developments in early Zoroastrian art. In an extraordinary and unique rock relief at Sar Meshed in southern Iran (Fig. 9) and in inscriptions carved at that site and at Naqsh-i Rustam and Naqsh-i Radjab, Mani's chief antagonist, the Zoroastrian priest Kirder, describes and portrays a dream journey to the other world. This form of disembodied travel was also claimed by Mani and may well have been featured in his painted books. The utilization by the Zoroastrian religious leader of two forms of dynastic proclamatory art otherwise reserved for the king of kings, a major rock-carved inscription and a relief scene, is an unparalleled occurrence in Sasanian dynastic art and may be a response by the Zoroastrian religious hierarchy to the visual imagery and didactic successes of Manichaean art.

Questions about the nature of Manichaean imagery bring us back to the subject of seal stones. A unique rock crystal seal published as in the Bibliothèque Nationale in Paris is carved with three images and inscribed in Syriac "in a sort of Estrangelo script": "Mani, the Apostle of Jesus Christ" (Fig. 36).[17] Carved on the seal face are three bearded male heads in profile surmounting abstract forms. While the authenticity of this seal is unproven, the emphasis on the head and the abstraction of the body forms correspond to Manichaean beliefs that the head is the source of the good spirit and that the body and its desires are negative aspects of human life. The combination of figural and abstract forms is also comparable to the image on the amulet of Perozdukht, described above, where the head surmounts an abstract cruciform body.

Religious diversity within the Sasanian realm is also evident in burial practices. Regrettably, no undisturbed Sasanian burials of personages of wealth and rank have been excavated in Mesopotamia or Iran, a loss that is evident if one considers the burials of this period at Mtskheta in Georgia and farther abroad in Europe, where the artifacts recovered from graves of the elite provide a means of distinguishing ethnic and cultural groupings and of tracing population movements.

Remains of various types of burials dating to the Sasanian period exist in Iran.[18] Those burials that conform to Zoroastrian practices requiring exposure of the body and the enclosure of clean bones in stone boxes or containers to avoid contamination of the earth or water are identified in accompanying inscriptions as *dahmak*. Such enclosures or boxes cut into rock faces and originally covered with a lid exist at various sites in Iran. A considerable range of Sasanian burials from simple to elaborate has been identified and studied. Some rock-cut graves follow Achaemenid tomb forms, whereas other burials prepared for the clean bones are in the form of stone cists or clay pithoi mounted on columns. Later Islamic literary sources refer to the practice of embalming or mummifying the body of the Sasanian king, a practice also recorded for Achaemenid monarchs. Of this practice, which appears to run counter to Zoroastrian teaching, there is no evidence, although Roman Ghirshman proposed that Shapur I (r. 242/3–273) was buried in the cave in the river gorge at Bishapur where his monumental statue still stands. It was, perhaps, in response to some diversity in burial practices that an official Zoroastrian doctrine was eventually established defining the stages from death to burial and, finally, to judgment in the afterworld.

At variance with official Zoroastrian practices, and presumably reflecting regional traditions, are burials in which the bones

were interred after the exposure of the body but which also include other features unusual in a standard Zoroastrian context. A funerary chamber of the late sixth century A.D. that was excavated at Shahr-i Qumis in northeastern Iran held bones of a person whose body must have been previously exposed, a collection of textiles, and a horse's hoof. At the same site in a burial of bones dating to the preceding Parthian period equine skulls are present. Both of these burials seem to indicate some continuity with more ancient Iranian and steppe traditions. The presence of a coin of Hormizd IV (r. 579–590) in the Shahr-i Qumis Sasanian burial and of a first-century B.C. coin in the Shahr-i Qumis Parthian burial may also be an indication of some knowledge of the Greek practice of placing a coin in the mouth of the deceased, "Charon's obol," payment for the transportation of the deceased in the underworld.[19] Sir Aurel Stein found a coin in the mouth of a person buried at Astana in Central Asia, an indication that this originally Greek practice persisted east of Iran in a period contemporary with the era of Sasanian rule in the Near East.[20]

In west central Iran, in Luristan, Louis Vanden Berghe excavated a megalithic tomb chamber of the third millennium B.C. that had been reused in the early Sasanian period for an inhumation. In the burial was a glazed jar, a Mesopotamian and southwest Iranian ceramic type, a seal having a dolphin and fish motif carved on it, and bronze rolls with Manichaean inscriptions.[21] All of these artifacts point to a Babylonian origin for the deceased, who probably was not a Zoroastrian. Similarly, the person buried in the Sasanian unlined pit at Malyan in which a coin is present cannot have been a member of the Zoroastrian faith. Christian graves can sometimes be identified by the presence of a carving of a cross at the tomb site.[22]

While burial types and the basic artifacts of daily life, ceramics and seals, document regional, cultural, and religious diversity in the Sasanian kingdom, an examination of the official dynastic or court arts, sculpture and toreutic, illustrates the effects of cultural diversity in the Sasanian realm in a somewhat different fashion. It is true that the different styles in which the dynastic rock reliefs are carved are to some extent the result of geographical factors, natural regional divisions within Iran. Nearly contemporary rock sculptures found in different parts of Iran illustrate different sculptural styles. The high, modeled reliefs in late third- and early fourth-century Fars (Fig. 8) have little in common with the fourth-century reliefs at Taq-i Bostan in the north (Fig. 18), which are characterized by flatness and linear detail and, in one case, by the inclusion of a Buddhist icon, the lotus flower. Such regional differences in style and subject are harder to document at the level of the court arts other than the rock reliefs, as the places of manufacture of most other luxury works of art—silver and glass vessels—are unknown. An exception is provided by stucco architectural decoration, an example being the panels found in a fifth-century noble villa in northeastern Iran at Bandian, on the border of Turkmenistan.[23] At Bandian a distinctive style and iconography provide striking evidence of regional variations in this medium as well (Fig. 37). A close stylistic parallel is provided by the fragmentary stucco of the fifth or sixth century excavated nearby at Mele Hairam in Turkmenistan (Fig. 38).[24] The style and iconography, particularly the Zoroastrian cult scenes, of the stucco reliefs in northern Khorasan, at Bandian, have no parallels in the contemporary villa and palatial stucco decoration found in the heart of the Sasanian kingdom in southern Iran and Mesopotamia.

It is evident that the artisans who created the Sasanian dynastic rock reliefs drew upon diverse sources and were influenced in

form, style and content by the presence over the centuries of foreign artisans living in Iran. With the fall of Hatra in A.D. 240, the capture of Antioch in A.D. 253, and the defeat of the emperor Valerian in the mid-third century, east Roman and Hatrene craftsmen were transported to Sasanian centers. With these artisans came a Roman imperial language of images signifying conquest and victory and a distinctive sculptural style. At Bishapur a solitary column set up in A.D. 266/7 in honor of a visit by Shapur I to the city bears an inscription naming Abasa (Apasay) from Carrhae and stating that he had set up the image of the Sasanian king at his own cost.[25]

Continuity with pre-Sasanian traditions in the creation of the Sasanian dynastic reliefs was discussed in the preceding chapter, but it is also true that the composition and content of the Sasanian rock reliefs throughout the period illustrate new features that are the result of cultural diversity within Sasanian Iran. One source for Shapur's victory imagery, as Marjorie Mackintosh has illustrated, is the Roman theme of the submission of the barbarians, a type represented by a relief of Marcus Aurelius (r. 161–180) in the Palazzo dei Conservatori in Rome. The pyramidal compositions of the early Sasanian reliefs depicting the equestrian king confronting a kneeling and suppliant Roman closely follow such Roman models.[26]

Few sculptures in the round survive from the Sasanian era. One of the most remarkable is the monumental image of Shapur I in a cave above the river gorge at Bishapur, a work that is hieratic and immobile and that owes little to foreign prototypes. But another, much later sculpture in a humbler medium, stucco, follows more closely sculptural traditions ultimately derived from the Greco-Roman world. In what may be a Nestorian Christian church excavated in 1929 by the German expedition to Ctesiphon, a painted

stucco image of a headless male figure was found (Fig. 39).[27] This nearly life-size figure is clad not in Iranian but in western classicizing dress. It is probable that the creators of the sculpture deliberately chose to follow a Greco-Roman model rather than any Iranian prototype for the depiction of an image usually identified as a Christian saint. More surprising is the similar use of Greco-Roman models for the type of undergarment worn by the almost contemporary, over-life-size sculpture of the Zoroastrian goddess Nahid at Taq-i Bostan (Fig. 40). The drapery worn by the goddess is gathered and falls in heavy naturalistic folds over the body, reflecting western not Iranian fashions. Over this western garment Nahid wears a long-sleeved Persian caftan, and the image becomes, in this sense, a culturally composite one.[28]

The appearance on the image of Nahid of two forms of dress derived from different cultural sources is only one of many features in the artistic program of the great iwan at Taq-i Bostan that illustrate a trend in late Sasanian dynastic art toward the creation of a culturally inclusive language of images. The imagery was intended to be familiar (and therefore meaningful) to a diverse population ruled by a monarch who was the titular head of both the Zoroastrian and the Christian communities.

In chapter one, continuity with past palatial iconographic programs was noted in the subject matter of the relief decoration of the iwan at Taq-i Bostan, but scholars have also demonstrated that the composition and design of the sculptural program share many elements with Byzantine church apse decoration and, presumably, Byzantine palace design. The sculptures on the back wall of the iwan, carved almost in the round, are abstract and frontal images, comparable in this respect to contemporary Byzantine images. Other important details are also entirely foreign to Sasanian artistic traditions. Just as the undergarment worn by Nahid is

distinctively western in design so the long, pointed beard of the supreme god Ohrmazd standing on the other side of the king of kings on the back wall of the iwan is not a Sasanian type but resembles the beards of Christian saints in contemporary early Christian art in Syria and the West.[29]

Another image appearing in the relief sculptures at Taq-i Bostan illustrates a further awareness and assimilation of contemporary foreign imagery. An entirely new, fantastic, composite creature, the so-called *senmurv*, appears in Sasanian art first at Taq-i Bostan, where it decorates the garments of the Sasanian king and the armored horseman (Fig. 20). In the preceding chapter the form of the protome of this fantastic being was traced back to ancient Mesopotamian models, depictions of the great weather beast having the shape of a lion-dragon.[30] In this respect the creature demonstrates traditionalism and continuity with the past. But the rear half of the Sasanian monster's body represents a new iconographic development. This part of the supernatural being is in the form of an upturned peacock's tail, the feathers depicted, as is customary in Sasanian art, without 'eyes.' The upturned display position has a characteristic Sasanian appearance and is identical to the feathered tails of peacocks as they are depicted quite commonly on Sasanian seal stones (Fig. 41).

In the late Roman and early Christian worlds the peacock was a widespread motif in the arts, an exotic bird whose plumage, shed and grown anew each year, led to the association of the bird with rebirth and immortality. No texts explain the popularity of the bird on Sasanian seal stones or the relative infrequency of the motif in other court media such as silver vessels. In the art of fifth-century Greece, Cyprus, Armenia, and Egypt, peacock feathers appear for the first time in the wings of the archangels and they are incorporated as well into the earliest images, part animal

and part bird, created at this time in the art of the Byzantine West as symbols of the Evangelists. On a mid-fifth-century representation of the Vision of the prophet Ezekiel (sixth century B.C.) in the apse mosaic of the Church of Blessed David in Thessalonika, peacock tail feathers enrich the bodies of two of the 'living creatures,' the bull and the lion, symbols of the Evangelists (Fig. 42). The appearance of the early Christian symbolic beings and the *senmurw* is evident.[31]

At Taq-i Bostan, this new Sasanian supernatural creature, the *senmurw*, appears only as textile decoration, and in this context the new apotropaic motif is related to phenomena in the Christian West. As noted in chapter one, this was a time in the eastern Mediterranean world when, to the growing horror of Christian bishops, elaborate garments increasingly incorporated in their design significant images, including biblical scenes. The images were not intended to serve a didactic purpose but rather to act as magical devices to protect the wearer. In the Sasanian Near East, textile workshops were major intercultural centers, where weavers from Syria and elsewhere in the West worked under Persian court direction and control. It is in this environment that common trends and the development of multicultural, magical images such as the *senmurw* appear to have first developed. Such images, having aspects that were potent or meaningful in more than one culture, may have contributed to the rise of iconoclasm in later Byzantium and Islam.

Much more difficult to trace and assess than the evidence for cultural interaction between the Sasanian Near East and the Roman and Byzantine worlds, as seen in sculptural and architectural developments, is the role of the Arab population in Mesopotamia and farther afield in northern Arabia.[32] The material remains from these regions are meager and the developments

of the arts still poorly documented and understood, as they are for the earlier period in the mid-first millennium B.C. when Nabonidus compared his now-lost palace in northeastern Arabia at Tayma to Babylon. The remains of the first millennium A.D. at Petra and Palmyra illustrate a bold multicultural style that flourished in these centers of trade west of Mesopotamia at a later period, and that probably characterized the lost idols seen by the Prophet when he entered Mecca.[33] We know that the interaction between the Arab Lakhmid tribes and the heart of the Sasanian kingdom in Mesopotamia and Iran was continuous and that relations were close. The Lakhmids at Hira, their capital in central Mesopotamia, were allies of the Sasanians and protected the western borders of the kingdom. Hira was a culturally diverse center of art, an active trading center in Sasanian times. The Christian presence at Hira is documented by records of Monophysite and Nestorian bishops as well as by a small number of artifacts. Churches excavated there have ground plans comparable, in the absence of a rounded apse, to church buildings in the eastern Mediterranean world. Palatial architecture in the region of Hira is known from literary sources that describe a palace built at Khavarnaq by the ruler al Nu'man I and the architect Sinimmar as a residence for the Lakhmid king's contemporary, the Sasanian crown prince and future king Bahram V (r. 421–439). Herzfeld speculated that the naming of Sinimmar as the architect of the Hira palace represented an attempt in Islamic times to create a symbolic tie between Khavarnaq and Taq-i Bostan, where Qattus, the son of Sinimmar, was said to be the sculptor of the great armored horse and rider. The luxurious palace of Khavarnaq entered the literature as one of the wonders of the world, but nothing remains. The sojourn of the Sasanian prince, later king of kings, at Hira with the Lakhmids is an historical fact and must

have led to an awareness at the highest levels of Sasanian society of the mixed oriental and hellenizing culture and the skilled artisans in the Arab lands in western Mesopotamia and northern Arabia.[34]

Early Sasanian control in southeastern Arabia, Oman, is evident in artifacts found in burials at Shamad ash-Shan but, again, the Sasanian remains recovered in this region are few.[35] From the time of Shapur II (r. 309–379), a Sasanian presence had secured important trade routes that led from central Mesopotamia to the region of modern Yemen in the South Arabian peninsula and by the sixth century the Persians established their authority in Yemen. A limited number of sculptural monuments have been found in South Arabia that display themes and motifs iconographically comparable to works made for the late Sasanian courts in Mesopotamia and Iran. Architrave blocks decorated with stylized vine trees carved in relief, sometimes growing from a floral vase or base (Fig. 43), combine western and oriental features, and a capital from Husn al-Urr in the Hadramawt is decorated with elaborate hunting scenes that suggest a familiarity with a common language of palatial imagery in parts of South Arabia, Mesopotamia, and Iran (Fig. 44). Another architectural 'wonder' known from texts and from meager remains incorporated into later Islamic buildings was the palace of the Himyarite king at Ghumban near San'a, constructed in the Sasanian era. Records also exist of elaborately decorated and embellished Christian churches in sixth-century South Arabia, where sculptures and mosaics as well as silk brocades and gold existed. It is only to be regretted that so little remains of the palatial art and architecture of Arabia and that it is, therefore, impossible to trace the interaction between the rich and diverse cultures of the region and late Sasanian Iran.

The presence and utilization of foreign artisans and materials, particularly for the construction and embellishment of palaces and capital cities, is recorded from earlier times in the Iranian world, and under the Achaemenids in the first millennium B.C. it became an apparent metaphor for world rule and a dynastic policy of inclusiveness. The specialities of Babylonians, Ionians, Scythians, and others who came to work for the Achaemenid king Darius in the construction of his royal palace at Susa are recorded in foundation charters that have thematic parallels in literary references to the men from 'Rum' who came to build Sasanian Ctesiphon. The evidence of cultural diversity apparent in the monumental structure at Taq-i Bostan may, therefore, be viewed as part of a traditional expression of world rule and inclusiveness. Klaus Brisch, writing of the creation in the early eighth century of the Great Mosque at Damascus, suggests that that monument was intended to speak as well to Jews and Christians, and Oleg Grabar, in his recent study of the early Islamic decoration in the Dome of the Rock, sees the design and iconography incorporated into that building not as a confrontational statement but as an intercultural expression intended to be meaningful to many peoples.[36]

Another prestigious medium of art, the luxury silver-gilt vessels, is similarly an expression of dynastic and court policy that illustrates influences coming from a variety of sources. Because the silver vessels are numerous and cover a broad chronological span, they are particularly valuable as evidence of cultural, social, and political trends and developments at the highest levels of Sasanian society. As noted above, no gold vessels—the treasured possessions reserved in all probability for the table of the king alone—are preserved from the Sasanian kingdom, but a wealth of gilded silver made in the Sasanian period has survived. During the

centuries of Sasanian rule the forms of these vessels, as well as the images appearing on them and the style in which the images were depicted, changed as a result of new social and political factors within Iran and of expanding trade activities along the famed Silk Routes connecting the Mediterranean world and China.[37]

From the time of the initiation of Sasanian production at the beginning of the period in the early third century A.D. until the end of the Sasanian era, court luxury vessels made within the Sasanian realm illustrate, in form and decoration, significant influences from the eastern Mediterranean world—Byzantium, Armenia, Georgia, and Syria—rather than continuity with pre-Sasanian Near Eastern productions (Fig. 26). The influence of contemporary Hellenistic and Roman toreutics is similarly apparent in Seleucid and Parthian metalwork, but only a few of the Parthian shapes and designs persist in the early Sasanian silver corpus, notably the deep bowl, and the animal-shaped rhyton and the use of the medallion 'portrait' image (Figs. 26, 45). These vessel shapes and the medallion portrait icon fall out of general use in Mesopotamia and Iran sometime after the early fourth century and by the middle of this century the evidence suggests that a new Greco-Roman type, the picture plate, has become the primary court luxury vessel produced within the Sasanian realm. The production of this class of vessel, which was a form of proclamatory art in the Persian East as it was in the Roman West, appears to have been for a time a royal prerogative. The subject selected for the decoration of the vessels is the image of the Sasanian king, dressed in full royal regalia, hunting wild animals.

This development in the early fourth century is preceded by an earlier stage in which royal and court silver vessels are decorated with two different types of images: 'portrait' busts not only of

the king but of members of his family and court enclosed within a roundel (*imago clipeata*) (Fig. 45), and equestrian hunting scenes with representations of members of the same elite levels of society (Fig. 30). In the use of the medallion portrait bust as an official icon on silver vessels, the Sasanian elite were following their Parthian predecessors who had adopted and used this western icon in a variety of media including silver vessels. Stucco medallion 'portrait' busts decorated the architecture of a late Parthian pavilion excavated by Edward Keall at Qaleh-i Yazdgird in central western Iran, and medallion images appear on occasional silver vessels. Missing from the late Parthian representations and from early Sasanian stucco and painted medallion portraits excavated in a third-century villa by Azarnoush at Hajiabad in southern Iran (Fig. 46) is the leaf base upon which the bust rests on Sasanian silver vessels and on Sasanian seal images (Fig. 47).[38] This iconographic detail has a funerary significance in the art of the eastern Mediterranean world, a meaning that is absent on the Sasanian works where the plant motif probably has beneficent, life-giving significance.

One example of the early Sasanian official medallion 'portrait' appears on a silver plate found in a third-century tomb of a female at Armazis Khevi (Mtskheta) the burial place of the *eristavi*, or high nobility in eastern Georgia (Iberia). On the interior of a large (24 cm) silver dish is a central roundel enclosing the image of Papak, a Persian governor or *bitiaxš*, identified in a long inscription encircling the vessel beneath the rim on the exterior (Fig. 48). This personage, portrayed as a bust surmounting a split acanthus leaf base, is clad in Sasanian dress. The folds of the drapery are naturalistically rendered, but the frontal bust and profile head have a hieratic appearance that is characteristic of all early Sasanian figural images.

More elaborate and slightly later in date than this plate is a two-handled cup found at Sargveshi, a site in western Georgia. On the cup the Sasanian king Bahram II (r. 276–293) is portrayed in a fashion resembling the images appearing on his coinage. The busts of the king, a prince, and a female (who has been variously identified as the king's wife, Shapurduktak, or, less probably, as the goddess Nahid) are depicted (Fig. 49). Each of the images is enclosed within a circular frame and is placed above a split acanthus-leaf base. Between the roundels are naturalistic plant designs, and an inhabited vine scroll decorates the band beneath the vessel's rim. The bodies of the figures within the medallions are naturalistically modeled and the drapery reflects the form of the body beneath so that the images have a marked resemblance to Greco-Roman figural images. Nevertheless the early Sasanian icons are hieratic, formalized expressions of authority, and many details of the dress and appearance of the figures are characteristically Sasanian. The frontal bust and profile head of each figure, the respectful gesture of a raised fist with extended forefinger, and the circlet held by the royal son are significant and persistent features in Sasanian dynastic art and the images are comparable to the early Sasanian rock reliefs in Fars.

It is not the medallion portrait bust, however, that becomes the most familiar Sasanian royal or official image on court silver in the following centuries but the equestrian hunter, the second of the two motifs appearing on the earliest Sasanian luxury vessels of the third and early fourth centuries. Only on a few later Sasanian silver vessels of unknown provenance is the earlier icon, the royal portrait bust, again utilized. One vessel, in a Japanese collection, displays the image of the Sasanian king Khusrau I as a bust resting on a stylized plant base and enclosed within a central medallion (Fig. 50). It is likely that this deviation from what

was by this time the canonical royal type on Sasanian silver plates, the hunter king motif, is probably to be explained by historical events during the reign of this king.[39] The extension of Persian authority once again in the sixth century into Georgia may be responsible for the renaissance of a no longer current Sasanian royal icon, still familiar in this region, as a reference to an earlier period of Sasanian rule. Khusrau I reestablished Sasanian authority in Georgia and the plate in the Japanese museum collection may celebrate and commemorate this historical event. On the reverse of the plate, rippling fluted lines in alternately gilded groups radiate out from the foot ring, an uncommon treatment of the exterior surface on Sasanian silver plates. However, examples of Byzantine silver vessels with such decorated exteriors exist and in this respect the Sasanian plate demonstrates the influence of western modes.

The silver vessels that are preserved indicate that in the middle of the fourth century A.D., at the end of the minority of Shapur II (r. 309–379), the exclusive royal icon on Sasanian silver-gilt plates became the hunter king, and the production of these silver plates within the Sasanian realm became the sole prerogative of the king of kings (Fig. 27). Access to the ore sources used for the manufacture of the vessels as well as the form and decoration of the plates appear to have been strictly controlled. For over a century there is no evidence of silver vessels decorated with images of high officials or other members of the royal family. The restriction in the use of figural imagery on silver plates to the king alone, and the selection of an age-old Persian motif (the hunter king) as the icon of the state-controlled production, coincides with the initiation of a powerful, centralized government structure in the Sasanian kingdom under Shapur II. The official, canonical production of a class of silver vessels having royal

images wearing crowns similar to those appearing on the official coinage continued from the fourth century throughout the Sasanian period, and the vessels decorated with such royal images are one of the hallmarks of Sasanian culture, and of dynastic identity.

As time passed and political and social conditions within the Sasanian kingdom changed, the plates having royal images became only one of many types in a varied and growing corpus of decorated silver and silver-gilt vessels (Fig. 26). This expanded silver production included works made not only to royal or court commission but for a broader class of social elite who had access to silver sources differing from the mines that produced the metal for the royal production. The extent to which the artisans who made these vessels were subject to state regulation is unclear, but the limitation in form and decoration suggests that some restrictions in the production of the prestigious luxury wares persisted.

This new and enlarged production of prestigious silver vessels is probably best understood as a reflection of historical and social events within the Sasanian kingdom in the late fifth and sixth centuries. Following the social revolution led by Mazdak, new economic and social structures were established under Kavad I (r. 488–531) and Khusrau I (r. 531–579). The fall from power and authority of the old landed noble families and the rise of a new lesser nobility who owed allegiance to the king of kings coincided with a period of increasing prosperity within the Sasanian realm and of growing contacts with the lands east and west of Iran. The fifth century was a period in which natural disasters, internal dissensions, and a weakened central authority in the face of growing Hephthalite power east of Iran made a significant increase in the manufacture of luxury vessels—status symbols of a confident and prosperous elite—unlikely. Only late in the reign of Kavad I (499–531) and in the period of Khusrau I, his successor, did the

Sasanian kingdom regain its place among world empires, and as a symbol of this renaissance a massive production of gilded silver plate was again initiated.

Some of the new forms—ewers, vases, and high-footed bowls—again illustrate the influence on Iranian workshops of products made in the eastern Mediterranean world and in regions such as Bactria in the northeast, where Hellenized forms and motifs had persisted in the arts long after they had disappeared in Iran. But other forms, the polylobed elliptical bowl (Fig. 26) and the plain elliptical bowl (Fig. 51) have more complex histories. Increasing east Iranian and western Central Asian contacts may lie behind the adoption and development of these forms undocumented in the preceding Parthian period and in the early Sasanian corpus of vessels.

At the outset of any discussion of Sasanian silver vessels it must be acknowledged that there is still little or no evidence to suggest the workshops where the vessels were made. Few of the works preserved have a meaningful archaeological context. Only the silver vessels acquired with some degree of reliable documentation by the Iran Bastan Museum in Tehran can be said to have been found, in all probability, in Iran, as well as the few examples from controlled archaeological excavations on Iranian soil at Malyan, Qasr-i Abu Nasr, and Susa, now preserved in museums in Tehran and Paris. The majority of the silver vessels, loosely called Sasanian, that exist in public museums in America, Great Britain, Europe, and Asia are works that appeared on world art markets, particularly in the period from the 1960s through the 1980s, allegedly from Iran but probably, in at least some instances, from neighboring Afghanistan. Other Sasanian silver vessels and so-called Sasanian vessels were unearthed in the eighteenth and nineteenth centuries in Russia, chiefly but not exclusively along rivers

in the area west of the Ural Mountains. The various sites are adjacent to places where earlier Achaemenid silver vessels have been found. Since the Sasanian luxury wares reached the Ural Mountain region as booty and objects of trade or barter, their place of discovery has little significance in terms of the original place of manufacture. Most of the Sasanian vessels in this category, many of them bearing Middle Persian inscriptions, are in the collections of the Hermitage Museum in St. Petersburg, the Islamische Abteilung of the Staatliche Museen Preussischer Kulturbesitz in Berlin, and the Bibliothèque Nationale in Paris. A small number of additional pieces came to Great Britain as a result of colonial expansion in Asia in the nineteenth century, notably through the activities of British diplomatic and military personnel in Iran, India and Afghanistan. These silver vessels are in the British Museum.[40]

The elliptical lobed bowl is a late Sasanian silver vessel type that clearly illustrates the complexity of problems concerning the origin of certain popular Sasanian shapes. Referred to in later Persian texts as a *rekab*, the lobed elliptical bowl is a shape that was popular not only in the late Sasanian Near East but was also imitated in T'ang China (A.D. 618–906).[41] The form persists in the Islamic Near East as well as in early medieval Europe, where a twelfth-century example decorated with the figure of a Christian saint is preserved in the Treasury of St. Mark's in Venice.[42] There are three variations of Sasanian elliptical lobed vessels and none has an archaeological context that might suggest the original place and period of manufacture or a sequential development. The fact that examples of the commonest type, having both elongated lobes and smaller lateral lobes have been found on Iranian soil and are now in the archaeological museum (Muzeh Melli) in Tehran, and the appearance of the decoration on this type sup-

ports the attribution of these bowls to Sasanian workshops (Fig. 26). However, the question of the region in which the form first developed remains uncertain.

Another variation of the lobed elliptical bowl is formed entirely by small individual lobes radiating out from the center of the vessel (see, for example, Fig. 52). This type is the least well represented in the corpus of Sasanian luxury vessels. There are only a few examples preserved, and none has a meaningful provenance. The bowls differ slightly from the other lobed, elliptical bowls in shape and profile. They are narrow, compact vessels having vertical walls and a pronounced flattened rim beneath which is a concavity on the exterior and interior surfaces. The decoration of the vessels includes niello-filled designs and foil gilding, both features as well of contemporary Byzantine silver vessels. Foil gilding remains in use in the Byzantine world until the fifth century but is not usually found on Sasanian silver vessels after the third century A.D., when the technique is replaced by amalgam or mercury gilding. A bowl of this type in The Metropolitan Museum of Art has another unusual feature, otherwise unknown on Sasanian silver vessels, a stamped mark too deformed to identify precisely (Fig. 52).[43] The practice of stamping silver vessels is not Sasanian but in this period was utilized in the Byzantine world, where it is an indication of official controls. The presence of a stamp on the lobed bowl in the Metropolitan Museum suggests that the artisan who made this luxury vessel was familiar with practices at Byzantine centers and imitated what was perhaps considered to be a prestigious feature. The design of the stamp, however, is more similar to stamped ceramics made in Sasanian Mesopotamia than to any known Byzantine silver stamp. Another stamped silver vessel made outside the borders of the Byzantine empire is a silver jug made in western Central Asia in the seventh

to eighth century by a Sogdian craftsman.[44] The stamps on this vessel are in the form of simple crosses and are also unlike Byzantine silver stamps. Their presence on the Sogdian vessel is an indication that in some workshop in this region east of Iran, Byzantine practice was also known and imitated.

The evidence suggests that the four elliptical bowls having only discrete lobes may represent a local development in northwestern Mesopotamia, where artifacts having Byzantine and Sasanian features were produced and where traders from regions west and east of Iran met. However, a recent find in China at the Northern Wei capital of Pingcheng, near Datong, indicates that a variation of this particular vessel type was also made east of Iran in northwest India in the fifth century A.D. (Fig. 53). The elliptical lobed bowl found in China has discrete lobes and in the center of the interior is decorated with a curvilinear image described as a *makara*, an Indian sea monster, and a rearing feline who attacks the sea monster. The flattened surface of the rim is elaborated with cloudlike plant forms. In style as well as subject matter the lobed vessel appears to be a work made east of Iran and south of the Hindu Kush. There is nothing Sasanian about the decorative motifs, and the presence of the bowl in China in the late fifth century is probably to be explained by diplomatic and trade contacts between China and the Hephthalite lands in eastern Iran as well as in the regions bordering Iran in Bactria and India from the late fifth to the mid-sixth century. This hypothesis is supported by the recent publication of a Bactrian inscription on the bowl which gives the name of the owner as Khingila, a name known from 'Hunnish' coins and seals.[45] It is tempting to see this vessel as belonging to a class of luxury wares, now lost, that became known in Iran as a result of influences from and exchanges with the East in the Sasanian period. Although Indian influences

on Sasanian art are less apparent than formal, stylistic and icono-
graphic elements derived from the Greco-Roman West and the
Eastern Mediterranean world, the artifactual evidence is mislead-
ing in terms of actual exchanges between Iran and India. These ex-
changes can be traced in astronomical and astrological texts, in the
adoption by the Sasanians of board games—backgammon and
chess—from India, and in the translation into Persian of Indian
tales, the *Pancatantra* and Buddhist *Jataka* stories. A convincing ar-
gument has also been made that the horizontal-handled mirror, a
known Sasanian type and an object represented in Sasanian art,
was adopted in Iran from Kushan India and Central Asia.[46] The
fluid, curvilinear form of the lobes on the elliptical bowl found
in China may, therefore, be the prototype for the more abstract
Sasanian form of discrete lobed bowl in the sixth century.

The elliptical lobed bowl illustrates the complexity of identi-
fying the diverse cultural influences on the court silver made in
the late Sasanian period. Another difficult question concerns the
interpretation of the motifs and designs decorating these luxury
objects.[47] Undoubtedly the decoration of the precious works of
art had positive connotations for the followers of Zoroaster, but
there is no absolute evidence, in spite of what is often written, that
any of the figural subjects represent Zoroastrian divinities or illus-
trate Zoroastrian ritual practices. One common design on Sasan-
ian silver vessels is an inhabited vine scroll (Fig. 51), a subject that
also appears as an abbreviated vine sometimes with an animal on
late Sasanian seals.[48] The abbreviated vine on seal stones is often
accompanied by an inscription with the word *abzun,* which can be
translated "prosperity" or "increase." This generally beneficent
meaning was probably present as well in comparable images on
Sasanian silver vessels. But this same motif could have a variety of
meanings. It is used on a silver-gilt, hemispherical bowl executed

in standard Sasanian style and found in eastern Georgia. The bowl in this instance has a cross at the center of the interior and presumably was the possession of a Christian rather than a Zoroastrian.[49] On the stamped elliptical lobed bowl in the Metropolitan Museum mentioned above, there is a representation in the interior of a fish holding what may be a wafer in its mouth. If this interpretation is correct, then this bowl too may have been commissioned by a Christian (Fig. 54).[50]

Plain elliptical bowls without lobes are one of the few common shapes of Sasanian vessel for which the Middle Persian name is known (Fig. 51). An inscription on one bowl identifies the shape as *makog,* or boat-vessel. Judging by the decoration of examples having standard Sasanian imagery, this form of silver vessel is datable to the middle or late Sasanian period. No examples dating from the third or early fourth century can be positively identified and the type is not found in the corpus of Achaemenid and Parthian luxury vessels that has survived. While elliptical, boat-shaped vessels of a different type were made from silver and gold as early as the third millennium B.C. in the Near East, there is no evidence of a continuous development and use of the shape over the centuries. Phillippe Gignoux has cited Manichaean and Christian texts in which the conception of Jesus as the "pilot of the boat" is expressed, and this kind of literary symbolism might explain why this widely used type was also adopted, perhaps for sacramental use as a chalice, by the Christian population within the Sasanian realm.[51] A few of these elliptical bowls bear explicitly Christian imagery and are decorated in the interior with a Christian cross, often gilded.

Other motifs represented on Sasanian silver vessels are not such explicit reflections of the faith of the owner. On a silver-gilt dish found in the Urals and published when it was in the State

Historical Museum in Moscow, a central reclining female and the figures accompanying her are ultimately derived from Greco-Roman scenes of the Indian triumph of Dionysos (Fig. 55), a subject represented in the art of the Kushan realm east of Iran and in modified form appearing on a Sasanian silver vessel in the Freer and Sackler Galleries (Fig. 56). The figural style of the images on the plate in Moscow is provincial Sasanian, and it is unlikely that the vessel was made at one of the Sasanian court centers. The female figure wears a robe draped over her lower body and on this garment, at the level of her hip, is a cross enclosed within a roundel (Fig. 57). Dionysiac imagery is pervasive in early Christian, Byzantine, Parthian, and Sasanian art and does not in itself offer any clue to the identity of the persons who commissioned the plate in the Pushkin Museum. But the presence of a cross on the garment of the central figure does suggest that this adaptation and modification of the western Dionysiac motif may reflect the faith of the owner.[52]

More clearly and explicitly Christian are the images on a gilded silver plate of the sixth or seventh century found in northern Siberia in the Ob' basin and now in the Hermitage Museum. The plate is directly comparable to the most sophisticated Sasanian luxury wares in form and technique of manufacture. However, the iconography is specifically Christian: two angels flank an immense jeweled cross rising above a hill from which two rivers stream (Fig. 58). It has been suggested that the vessel was made in a Christian center, perhaps in Mesopotamia, where a sizable Christian population existed and a person of power and authority might commission such a prestigious and proclamatory work of Christian art.[53]

While the sources of the forms of Sasanian silver vessels and of the designs appearing on them are diverse, the Sasanian luxury

wares are modified and transformed so that the final product has a distinctive and unmistakable Sasanian appearance. A minor silver vessel type found in Iran and preserved in the Muzeh Melli in Tehran, as well as in European, Asian, and American collections, is a shallow hemispherical bowl having a small loop for suspension from a belt or harness strap attached near the rim (Fig. 26). Usually undecorated, a few examples display a simple plant or animal motif clearly executed in Sasanian style on the center of the interior. The horsemen who moved through the region north and east of Iran over the centuries carried such vessels. Herodotus describes the Scythians as having cups suspended from their belts, and, more than a millennium later, cups with buckles for attachment and suspension are part of the multicultural treasure found at Nagy Szent Miklos.[54] Presumably, Avar or Turkic mercenaries and allies of the Sasanians late in the period introduced this type of drinking vessel into Iran where the small bowls are distinctive reminders of the diverse populations and practices within the late Sasanian realm. Indications that the type was adopted by the higher levels of Sasanian society are the designs decorating the interior and the presence of a modification of the form, a substantial, half-elliptical, lobed bowl having a strap handle attached to one vertically truncated end (Fig. 59).

Some Sasanian figural motifs appear to combine features drawn from the Mediterranean West and the Indian subcontinent. Images of dancing females, regularly depicted on silver vases and ewers, are comparable in form to the maenads who are part of the entourage of the wine god Dionysos and, in those examples where the females hold a distinctive set of objects (Fig. 60), to images based on representations of the Seasons and the Months in the Roman West. In India a comparable dancing female figure is the *yakshi* (fertility nymph). Dancing females

appear in Sasanian art not only on silver vases and ewers but also in stucco reliefs, a medium utilized by court artists and architects (Fig. 61). The courtly associations of the dancing female motif led to its persistence not only in the Near East in early Islamic times but in the European West, where as late as the eleventh century dancing females, perhaps signifying the Graces or Virtues, decorate the eleventh-century Byzantine crown of Constantine IX Monomachos.[55]

More unusual on Sasanian silver vessels and more difficult to interpret are figural motifs derived from the art of the Greco-Roman world for which there are few or no other parallels in the corpus of Sasanian art. A good example is a unique silver-gilt plate in the Metropolitan Museum in New York dating from the middle or later Sasanian period on which two identical, almost nude, male figures stand, turned toward each other, statue-like, on a flat base. In one hand each figure holds a spear and in the other the reins of a winged horse bending his head to drink from a flowing vase supported by the half figure of a female (Fig. 62). This watery source rises from a row of half-palmette leaves. The nude twins are modeled on depictions of Castor and Pollux, the Dioscuroi in Hellenistic and Roman art. The western twins, whose horses are never winged, were a popular subject and they are represented on Roman coins as late as the fourth century. The subject passed as well into the Hellenized art of Bactria and Gandhara in the East. At Dilberjin at the end of the first millennium B.C. there was a temple, probably dedicated to the Dioscuroi (or Ashvins), in which a painted image of two almost nude males and their horses, without wings, appeared. On Seleucid, Greco-Bactrian, Indo-Scythian, and Indo-Parthian coins the motif of the twin horsemen occurs. The Sasanian interpretation of the Roman legend and imagery and the significance of this motif,

modified only by the addition of wings to the horses, is impossible to know with certainty. Some scholars have offered an alternate interpretation, claiming that this is a double image of Pegasus and Bellerophon. But in the Sasanian Near East the constellation Gemini is called *Do Paykar* (Two Figures) and it is perfectly possible that the elaborate scene on the prestigious Sasanian silver-gilt vessel illustrates this constellation, adapted from western pictorial imagery. The twelve zodiacal signs played an immensely important role in the life of the Zoroastrian believer. They were believed to be beneficent forces "on the side of Ohrmazd...that decided the fate of man in the universe."[56] A curious feature on this plate is the presence of a small lute player in the upper field between the heads of the twin horsemen. Apparently unrelated to the horsemen, this figure may provide a setting or context for the scene, a reference perhaps to a court banquet where minstrels related epic tales drawn from oral and literary traditions.

Abbreviated renditions of what may be the same subject appear on another silver plate and on Sasanian seal stones. On the silver vessel a pair of winged horses is depicted, their heads bent toward the ground.[57] On seals the motif is reduced to two confronted winged horse protomes in one case with a plant growing up between them. Whether all these images have the same meaning as the more complex scene on the Metropolitan Museum plate is impossible to tell but the seal stones are inscribed in Middle Persian with a legend naming an *aspbed*, or chief of cavalry, suggesting that the silver vessels might have belonged to elite persons of this rank or to persons incorporating the word *aspbed* in a family name.[58]

The diverse nature of the populations living within the boundaries of the Sasanian kingdom and of the influences that continued through the period to enter and be absorbed into the Sasanian

artistic *koine* is apparent at every level in the art of the Sasanian period, from simple artifacts used by common man to court luxury wares and dynastic rock sculptures. Minor works in nonperishable materials, chiefly ceramics and bronze, illustrate both the tenacity of diverse local traditions as well as the adoption, in the Sasanian lands, of many foreign modes and designs introduced by refugee artisans, merchants, and traders, and by the vast prisoner populations transported to Mesopotamia and Persia at various times. In contrast to this evidence from the lower levels of society are the more prestigious expressions of Sasanian authority in which foreign elements—subjects and compositions as well as the styles utilized for the depiction of significant images—are deliberately adopted and gradually modified by Sasanian craftsmen working under court controls. The resulting production of a distinctive and canonical court art was a royal policy initiated as early as the reign of the first Sasanian king, Ardashir I, and it continued, changing and developing over the centuries, through the Sasanian era. It is the influence of this imperial dynastic art, apparent in the regions bordering on and beyond the boundaries of the Sasanian kingdom, that is the subject of the next chapter.

1. Herodotus bk. I, ch. 135; Farkas 1980, pp. 15–21.
2. Whipple 1967.
3. Pigulevskaja 1963, pp. 159–161.
4. Fiey 1979b, ch. I, pp. 279–297; Fiey 1979c, ch. IX, p. 412; Widengren 1984, pp. 1–31; Garsoïan 1983, p. 578; Mango 1985, pp. 105–107; Frendo 2000, pp. 36–40; Curiel, Gyselen 1984, pp. 41–48.
5. Neusner 1970, p. 119; Tawil 1979, pp. 93–109; Kingsley 1992, pp. 39–346. For Zoroastrian concepts in the writings of the Hebrew prophet Ezekiel, see Russell 2003, pp. 1–15.
6. Whitcomb 1984; Whitcomb 1985.
7. Alden 1978, pl. 11b.
8. Balcer 1978, pp. 90–92.
9. For bibliography on the ceramics from Merv, see Herrmann et al. 2001, pp. 22–26; Whitcomb 1985; Simpson 1997, pp. 74–79; Boucharlat 1987.
10. Shaked 1995, pp. 239–256; Gyselen 1996a, pp. 240–252.
11. Lerner 1977; Gignoux 1980; Potts 1990, p. 243.
12. Göbl 1976, pl. 44, fig. 102, no. 565.
13. Bivar 1969, pl. 5, BE1; Widengren 1984, pp. 1–31.
14. Puech 1949, pp. 17–60; Porada 1967, pp. 99–120.
15. Bivar 1969, pl. 18, FC1; Simpson 1997, p. 76, fig. 3.
16. Harper, Skjaervø, Gorelick, Gwinnett 1992.
17. For this seal and Manichaean imagery in general, see Klimkeit 1982, pl. XXVIII; Russel 1990.
18. Trümpelmann 1984, pp. 317–329; Boucharlat 1989, pp. 675–712; Boucharlat 1991, pp. 71–78. For burial practices at Merv and bibliography, see Herrmann et al. 2001, pp. 19–20; Shahr-i Qumis: Hansman, Stronach 1970a, pp. 142–155; Luristan: Vanden Berghe 1972, pp. 4–12.
19. Hansman, Stronach 1970a,b, pp. 29–62, 142–155.
20. Bivar 1970, pp. 156–158.
21. Vanden Berghe 1970, pp. 18–21.
22. Huff 1989, pp. 713–729.
23. Rahbar 1999, pp. 62–65.
24. Kaim 2002, pp. 215–230.

25. Toynbee 1972, pp. 106–110; Ghirshman 1971, pl. XL,3, pp. 17–18, 195; Back 1978, pp. 378–383, 507.

26. Mackintosh 1973.

27. Kröger 1982a, pl. 12,3, pp. 47–48.

28. For a discussion of representations of Elijah at Dura Europos in one case in Parthian trousers and in another case in Greco-Roman dress, see Russell 2003, p. 12.

29. Mackintosh 1978.

30. For an alternate identification of this creature as the *xvarena* (heavenly glory), see chap. 1, n. 40.

31. Mathews 1982; Mathews 1993, pp. 118–119, fig. 88.

32. Eilers 1983; Bosworth 1983; Khoury 1993.

33. King 2002, pp. 144–150.

34. Rice 1932; Reuther 1938–39, p. 562; Meissner 1901, pp. 17–20; Musil 1927; Herzfeld 1920, pp. 102–103.

35. Keall 1995; Keall 1998; Potts 1997; Costa 1992; Shahid 1979.

36. Brisch 1988; Grabar 1996.

37. Harper, Meyers 1981.

38. Keall 1977, pp. 1–9, pl. IIIa; Azarnoush 1994, pls. VII–XII, XXXV.

39. Harper 1997, p. 49.

40. Harper 2000a, pp. 46–56.

41. Melikian-Chirvani 1995; Harper 2002b, pp. 113–127.

42. *The Treasury of San Marco, Venice* 1984, pp. 292–297, no. 43.

43. Harper 2002b, figs. 2, 8.

44. Marschak 1986, fig. 71, p. 431.

45. Watt 2004, p. 151, no. 61; Sims-Williams 2002, pp. 143–148.

46. Lerner 1996; Daryaee 2002.

47. Marshak 1998, pp. 84–92; Zeumal 1996, pp. 16–20.

48. Gropp 1974, pl. XXI, A3.

49. *National Treasures of Georgia* 1999, p. 201, no. 98.

50. Harper 2002b, pp. 113–127.

51. Gignoux 1993, p. 68.

52. Smirnov 1957; Gunter, Jett 1992, pp. 121–127, no. 16.

53. *Treasures from the Ob' Basin* 1996, p.70, no. 25.

54. Herodotus bk. IV, ch. 10; Daim, Stadler 1996, fig. 4,5.

55. Harper 2002a.

56. Harper 1965; Ettinghausen 1972, pp. 11–16; Ghirshman 1974; Kruglikova 1976, pp. 88–93; Gignoux 1988, pp. 299–304; Azarpay 1988; Daryaee 2002, p. 291.

57. Grabar 1967, p. 111, no. 24.

58. Gyselen 2001, pp. 24–27, 46: Seal A, B.

31

32

Fig. 31 Drawing of buckle element. Qasr-i Abu Nasr, Iran. Sasanian, 6th–7th century A.D. Whitcomb 1985, fig. 64h.

Fig. 32 Drawing of funerary vase. Merv, Turkmenistan. Sasanian, ca. 6th century A.D. F. Grenet, *Les pratiques funéraires dans l'Asie Centrale sédentaire.* CNRS 1984, pl. XLII, c.

Fig. 33 Drawings of modern seal impressions showing *lulav* and *etrog*, Sasanian. From Gyselen 1996a.

Fig. 34 Seal and modern impression of stamp seal, Sasanian. The British Museum, London, acc. no. 119393.

35

36

Fig. 35 Modern impression of stamp seal. Sasanian. The British Museum, London, acc. no. 119545.

Fig. 36 Rock crystal stamp seal with Mani inscription. Sasanian. Bibliothèque Nationale, Cabinet des médailles, Paris. From Klimkeit 1982, pl. XXXII.

Fig. 37 Drawing of stucco wall panels. Bandiyan, eastern Iran. ca. 5th century A.D. Rahbar 1998, fig.5, p. 238.

38

39

Fig. 38 Drawing of reconstructed stucco podium panel. Mele Hairam,
Turkmenistan. ca. 5th–6th century A.D. Kaim 2002, fig. 11.

Fig. 39 Drawing of stucco figure. Ctesiphon, Iraq, Sasanian, ca. 6th century A.D.
From Kröger 1982a, Taf. 12,3.

40

41

42

Fig. 40 Iwan of Khosro II (A.D. 591–628). Taq-i Bostan, Iran. Sasanian, 6th century A.D. Photo: L and C. Bier

Fig. 41 Drawing of stamp seal impression. Qasr-i Abu Nasr, Iran. Sasanian, 6th century A.D. *Sasanian Remains from Qasr-i Abu Nasr* 1973, D.72.

Fig. 42 Drawing of detail of apse mosaic. Church of Blessed David, Thessalonica, Greece. Byzantine, 5th century A.D. From Mathews 1993, fig. 88.

43

44

Fig. 43 Drawing of architrave block. Husn al-'Urr, Yemen. 6th century A.D. (?). Mukalla Museum. Keall 1998, p. 146, fig. 5.

Fig. 44 Drawings of capital. Husn al-'Urr, Yemen. 6th century A.D. (?). Aden Museum. Keall 1988, p. 144, figs. 1–4.

Fig. 45 Silver bowl with medallion portrait. Sasanian, early 4th century A.D. The
Metropolitan Museum of Art, acc. no. 55.57. Purchase, Dick Fund.

Fig. 46 Drawing of mural. Hajiabad, Iran. Sasanian, 3rd century A.D. Azarnoush 1994, pl. XXXV.

Fig. 47 Drawing of seal impression. Qasr-i Abu Nasr, Iran. Sasanian, 6th–7th century A.D. *Sasanian Remains from Qasr-i Abu Nasr* 1973, D.103.

Fig. 48 Drawing of central medallion in silver plate. Mtskheta, Georgia. Sasanian, 3rd century A.D. Museum of History, Tiflis, acc. no. 18-55:53.
A. M. Apakidze et al., *Mtskheta* I. Tbilisi 1958, p. 51, fig. 21.

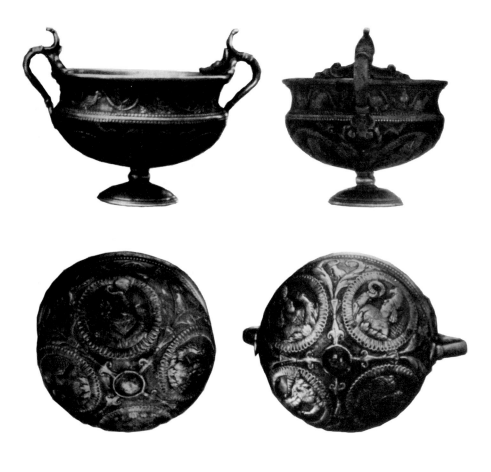

Fig. 49 Silver cup with image of Bahram II (A.D. 276–293). Sargveshi, Georgia.
Sasanian, 3rd century A.D. Museum of the Society for the History of Ethnography
of Georgia, Tiflis, acc. no. P134. Harper, Meyers 1981, pl. 2.

50

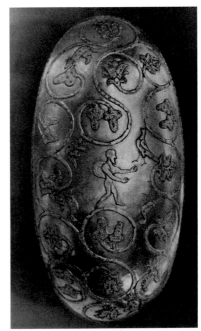

51

Fig. 50 Silver-gilt plate with image of Khosro I (A.D. 531–579). Sasanian,
6th century. Miho Museum, Shigaraki, Japan.

Fig. 51 Elliptical silver-gilt bowl. Sasanian, ca. 6th century A.D. The Metropolitan
Museum of Art, acc. no. 59.130.1. Fletcher Fund, 1959.

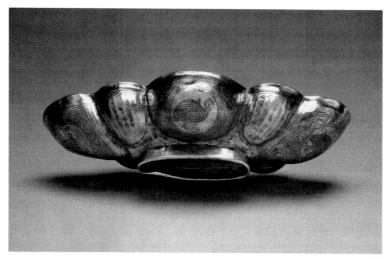

52

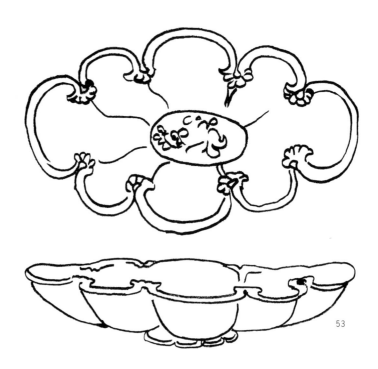

53

54

Fig. 52 (OPPOSITE) Silver lobed elliptical bowl decorated with gilding and niello. Sasanian, ca. 6th century A.D. The Metropolitan Museum of Art, acc. no. 1992.233. Anonymous Gift.

Fig. 53 (OPPOSITE) Drawing of silver lobed elliptical bowl. Datong, Shanxi Province, China. Ca. 5th century A.D. Datong City Museum. From *Cultural Relics Unearthed in China*, Peking 1972, Wen Wu Press. (Marcel C. Berard)

Fig. 54 Interior detail of Fig. 52.

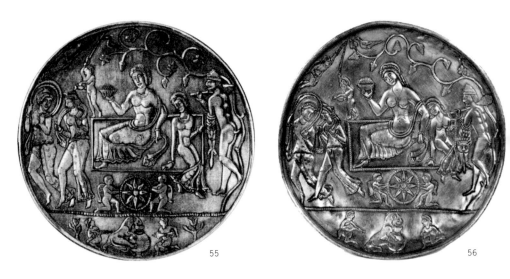

Fig. 55 Drawing of silver-gilt plate. Alkino station, Ural Mountain region, Russia. 6th–7th century A.D. Historical Museum, Moscow.

Fig. 56 Silver-gilt plate. Sasanian, 6th–7th century A.D. Freer Gallery of Art, acc. no. 64.10.

Fig. 57 Detail of design on hip of garment worn by reclining female in Fig. 55. Marschak 1986, fig. 174.

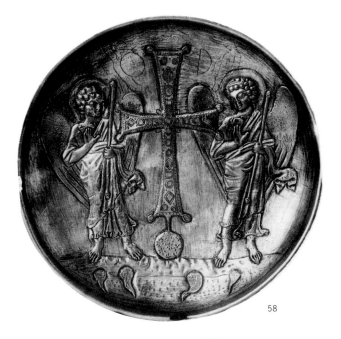

58

59

Fig. 58 Silver-gilt plate. Ob' River basin, Siberia, Russia. 6th century A.D. Hermitage Museum, St. Petersburg, acc. no. S-209.

Fig. 59 Silver lobed bowl. Sasanian, 6th–7th century A.D. Afghanistan or Iran. The Metropolitan Museum of Art, acc. no. 1991.73. Rogers Fund, 1991.

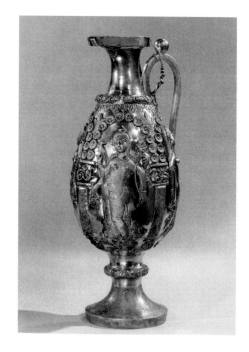

60

61

Fig. 60 Silver-gilt ewer. Sasanian, ca. 6th century A.D. The Metropolitan Museum of Art, acc. no. 67.10. Mr. and Mrs. C. Douglas Dillon Gift and Rogers Fund.

Fig. 61 Stucco relief. Ma'aridh I, Ctesiphon, Iraq. Sasanian, 6th century A.D. The Metropolitan Museum of Art. Excavated by the Expedition to Ctesiphon of The Metropolitan Museum of Art and the German State Museums 1931–1932.

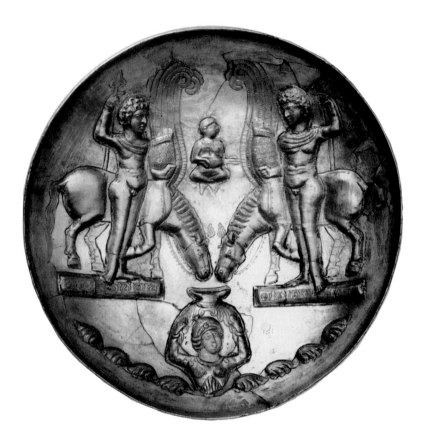

Fig. 62 Silver-gilt plate with twin spearmen and winged horses. Sasanian, 5th–6th
century A.D. The Metropolitan Museum of Art, acc. no. 63.152. Fletcher Fund, 1963.

DIFFUSION

During the four centuries of Sasanian rule in the Near East a variety of peoples, and the precious objects they carried with them, moved across great distances by land and sea routes connecting eastern Europe and the Near East to Central Asia, southeast Asia, and China.[1] The art and imagery of the Sasanian realm became widely known as objects of prestige and luxury—notably silver and glass vessels, textiles, seals, and coins—increasingly reached foreign lands. It is reasonable to suppose that only a tiny percentage of the whole, in terms of the original trade in precious items, has survived or been found. The greatest losses are the textiles, brightly colored, expertly woven, and decorated silks made in late Sasanian Iran and Mesopotamia. Unfavorable climatic and soil conditions caused the rapid decay of fabrics in this region, and the fragments preserved along the eastern and western trade routes and within China offer only a tantalizing glimpse of the skill and rich imagery of the products made in Sasanian workshops.

Sasanian silver coins were valued as currency in some regions, but in China coins as well as semiprecious seal stones appear to have been treasured for the materials of which they were made rather than as objects required for commercial transactions or as significant and meaningful works of art.[2] In contrast, a small hoard of fourth- to fifth-century Sasanian silver coins and jewelry found with five Byzantine gold *solidi* in the west, at Humeina (ancient Auara) in southern Jordan, provides an illustration, on a small scale, of the kind of commercial activity that led to the spread of Sasanian official icons on the routes between Rome and Persia.[3] In China, Sasanian seals made of semiprecious stones— lapis lazuli, agate, and carnelian—were incorporated into jewelry.

A necklace of western Central Asian or possibly Sasanian origin, unearthed in a tomb near the ancient Chinese capital city of Chang'an (modern Xian) in Shanxi Province, belonged to Li Jingxun, who died in A.D. 608 at the age of nine (Fig. 63). The clasp of the gold necklace is a lapis lazuli seal, probably a late Sasanian work, on which a simple figure of a stag is carved and the gold beads are decorated with pearls. Li Jingxun was the granddaughter of the eldest sister of the Sui emperor, a member of the court elite who treasured foreign exotica.[4]

The peoples who carried luxury products from Sasanian centers of production to the lands beyond the borders of the kingdom were a diverse group. Merchants and traders, many of them Nestorian Christians, brought Sasanian products to the provinces and to the states on the periphery. Cosmas Indicopleustes of Alexandria, who is thought to have been a Nestorian, reports in the sixth century that Persian traders lived in Sri Lanka, and Procopius, writing in the same century, speaks of Persians at all the ports along the coast of the Persian Gulf where the Indians stopped in their travels. Sasanian officials living in Armenia and eastern Georgia in the west and in Bactria in the east introduced into these regions the arts of Sasanian power and prestige. Refugees from religious persecution (Christians, Manichaeans, Jews) left the Mesopotamian river valleys and the Iranian highlands of the Sasanian kingdom for Arabia, Byzantium, and Central Asia. Political refugees, including members of the last Sasanian royal family and their court, settled finally in China. All these peoples carried with them cultural artifacts and traditions.[5]

Intermediaries also played a large role in the diffusion of Sasanian products. As commerce expanded in the hands of Sogdian merchants—and, later, Turkic rulers and traders—the silk routes crossing Asia were increasingly utilized, and Sasanian arti-

facts as well as locally made provincial Sasanian works spread eastward as far as China. In the west the movements of Alans, Avars, and Khazars along the northwestern borders of the Sasanian kingdom led to the introduction of Sasanian court products into the region of the Urals and eastern Europe.[6]

The influence of Sasanian imagery and manufacturing techniques is evident in works of art made in the western and eastern provinces of the Sasanian realm and in the lands on the periphery. During the millennium before the Sasanian period, luxury goods, notably silver vessels dating from the Achaemenid period, were objects of prestige and items of trade that reached the Urals, where they have been found at sites just south of the areas in which many later Sasanian and provincial Sasanian silver vessels were unearthed. Farther east, in northern China, non-Han Chinese kingdoms in the first millennium B.C. received a stream of foreign influences brought by peoples living along the borders and moving along the great routes of trade by land and sea. Materials excavated in fourth- to third-century B.C. tombs in Siberia at Pazyryk and at neighboring sites illustrate Achaemenid Persian iconographic influences, transmitted through the nomads on Iran's northeastern borders in the second half of the first millennium B.C. Other early exchanges between China and its borderlands and the West resulted from the travels of Buddhist monks, who left China for the Western Regions in search of the sources of their religion. Trade with the East increased in the second century B.C. and, with the discovery and utilization of the monsoon winds by western sailors navigating the waters between Arabia and India, there was an explosion of activity in the following century.[7]

With the unification of China under the Qin (221–210 B.C.) and Han (206 B.C.–A.D. 220) dynasties, the adaptation and sini-

cization of foreign forms and designs becomes apparent in a small group of luxury items. Silver and bronze lidded containers decoratively lobed in a derivative Achaemenid Iranian fashion were prized possessions placed in tombs at four different sites in early Han Dynasty (second century B.C.) China (Fig. 64). These beaten vessels, produced at some unknown metalworking center in the West, perhaps in Bactria or eastern Iran, have been found on the coast of China in the north and in the south as well as in the interior, in areas open to river and land trade. Adapted to become a familiar Chinese form, the *dou*, by the addition of cast feet and small animals in the round attached to the lid, the final product is an odd combination of Western and Chinese techniques, forms, and decorative styles. The circular lidded container is a form unknown in Iran in the corpus of surviving Achaemenid vessels, but the type is represented in the reliefs at Achaemenid Persepolis, where servants carry undecorated, circular, covered boxes. The distinctive egg-shaped lobing, which forms a curvilinear meander pattern on the containers and lids, betrays a familiarity with the decorative patterns on Achaemenid and Parthian hammered plates and bowls. Sarmatian discoveries of the first century A.D. in the north Black Sea region between the Volga and the Don also include a typologically similar vessel found in a grave near Kosika, a beaten hemispherical bowl having a lid on which there remain traces of the attachment of another element, perhaps a figure in the round. It is probable that the decorative lobing, an Achaemenid mode, as well as the precious lidded box type, became familiar north of Iran in peripheral lands to the east and west of the Achaemenid realm, passing eventually by land and water routes to China. In another Sarmatian grave in the same region as Kosika, at Kobyakovo, a Chinese Han Dynasty mirror of the first century B.C. or the first century A.D. was found

and provides evidence of the existence of cultural exchanges between these distant regions at this period.[8]

Uncertainty about the place of manufacture of the covered vessels found in China makes it difficult to understand the precise nature of the exchanges between Iran and the East, and this is also the case with works made in the later Sasanian period. Because so few Sasanian luxury objects have been found in a context that is meaningful, in terms of the place of manufacture, it is not always possible to categorize works of art as standard Sasanian court productions, provincial variations of court types, or adaptations made in peripheral areas farther from Sasanian court centers. As a result, caution must be exercised in using the artifacts found beyond the borders of the Sasanian kingdom, in the Caucasus and Georgia in the West and Bactria, Sogd, and China in the East, as evidence of direct contacts with Sasanian dynastic centers.

In his *Persian Wars,* Herodotus wrote of Achaemenid Persia: "Of nations [the Persians] honour most their nearest neighbors whom they esteem next to themselves; those who live beyond these they honour in the second degree; and so with the remainder, the further they are removed the less the esteem in which they hold them."[9] These varying degrees of relatedness to a Persian center are reflected in the cultural remains dating from the Sasanian era. Often a distinction between the products of central Sasanian workshops and those artifacts made by craftsmen living on the borders of the Sasanian Near East, perhaps the "nearest neighbors" in Herodotus' terms of reference, can be made on the basis of form, iconography, style, or technique of manufacture. The works of art providing the clearest illustrations of this phenomenon, because they are so numerous, are the silver vessels decorated with images of a king hunting wild animals (Fig. 27). As has

already been noted in chapter one, the central Sasanian court products were strictly regulated for centuries and followed certain iconographical and compositional patterns also established for dynastic works in other media: coins and rock reliefs. Moreover, the silver used for the manufacture of the royal vessels and certain non-decorative tool marks are distinctive. Provincial imitations of central Sasanian silver vessels adhere closely, though not absolutely, in iconography, composition, and manufacturing techniques to the Sasanian court originals (Fig. 65). More distinct are vessels in which Sasanian influence is less dominant in all categories: form, iconography, style, composition of the metal, and techniques of manufacture. Such works of art, made in regions further removed from the cultural and political centers of the Sasanian kingdom, were transformed by craftsmen vaguely familiar with and generally influenced by the prestigious Sasanian products but adhering to local artistic and craft traditions (Fig. 66).[10] The purposes of all these derivative productions and the significance of the images on the vessels do not necessarily relate to the central Sasanian court policy or ideology, and the objects themselves are not indications of direct Sasanian control or even of a Sasanian political presence.

However complex the problem, distinctions between the central Sasanian court silver vessels and those works made in centers on the borders of the kingdom or beyond are important to acknowledge as we attempt to define and understand cultural developments in the Sasanian Near East.[11]

Of the images appearing on Sasanian court silver vessels the most prestigious is the motif of an equestrian king who wears a crown, identifiable on Sasanian coins, hunting wild animals (Fig. 27).[12] Throughout the Sasanian period, in the corpus of luxury vessels, this theme appears on only one shape of vessel, an

open dish resting on a low foot ring. By the early fourth century no person other than the Sasanian monarch, wearing a crown known from Sasanian coin images, appears on any Sasanian silver vessel in a hunting scene. Moreover, the silver employed for the manufacture of the vessels decorated with royal images was drawn from a single ore source, a fact determined by neutron activation analysis of the metal. Details of the composition and design become standardized and with minor variations remain constant over the centuries of Sasanian rule in the Near East.

These canonical, central Sasanian scenes of royal hunts are static ideal images, abstract expressions of royalty and proclamatory icons rather than dynamic depictions of the pursuit of an elusive and often dangerous quarry. By the fourth century A.D., in the reign of Shapur II, the standardization of these royal images extends to the composition of the scene (vertically and horizontally balanced figures fitted carefully within the frame of the plate) and to a myriad of details in the design: the stylization of the folds of the drapery as paired lines, the shape of the royal beard, the animal's fur, and the form and decoration of the saddle and harness trappings. Mercury or amalgam gilding, first used to enhance most of the figural design, is applied only to the background shell of the vessel by the late fifth and early sixth century. In a few of the finest works of art, niello inlays fill parts of the decoration, and separate pieces fitted into slots cut in the background shell produce high-relief areas and actual elements in the round.

From almost the beginning of the Sasanian era, in the late third and early fourth centuries, another production of silver plates on which there are scenes of elite figures hunting is closely related to and derived from the Sasanian dynastic type.[13] On this second class of vessels, which often have a deep bowl-like form and a foot ring, the crowns or headdresses worn by the 'royal'

hunters do not follow the images on Sasanian coins. On one example in the Hermitage Museum the hunter wears a headdress decorated with a pair of ram's horns (Fig. 65).[14] The composition of the scenes on these vessels is also quite different, more dynamic and vigorous than the canonical works of the center, and the representations often include a narrative, epic or heroic, component. Analyses of the metal from which the vessels were made indicate the use of silver from different ore sources, none of them the same as the silver source used for the central Sasanian works. As with the central Sasanian plates, the composition of the scenes and the way many details of the design are depicted become standardized and are repeated with little variation, an indication that this related production was also subject to controls. Elements in the scene are cut off by the frame surrounding the design and the arrangement of the figures in a triangular composition creates a tension between the hunter and his quarry. The folds of the drapery are consistently depicted as a series of dense parallel lines in contrast to the paired line drapery style of the central Sasanian vessels. There are some parallels for this 'provincial' Sasanian style, in terms of the composition and details of the designs, in the corpus of Sasanian silver plates made in the third century A.D., before a canonical royal type was established (Fig. 30). So the 'provincial' works of art described above are not, in an art historical sense, entirely distinct from the official products made at centers within the Sasanian realm.

This alternative production of silver plates having scenes of 'royal' hunts and a parallel line drapery style appears at first to be a response to the prestigious Sasanian propaganda court silver, a distinct expression of an alternate but deliberately related authority. The most likely source of the production is in eastern Iran and in lands in present-day Turkmenistan and Afghanistan, where

Sasanian-Kushan and Kushano-Sasanian authorities, the latter increasingly independent of the Sasanian central court, ruled in the third and fourth centuries and minted coins. Further evidence of the cultural interaction between Kushans and Sasanians east of Iran is a wall painting found at Gulbiyan (northern Afghanistan) (Fig. 67).[15] The third- to fourth-century paintings at this site appear to include divine as well as elite figures and cult activities, religious subjects that are absent or severely restricted in the court arts of the Sasanian kingdom but that are present in eastern Iran at Kuh-e Khwaja in Sistan, where a few examples have survived in the South Gate and Painted Gallery and may be the expression of a similarly mixed Kushan and Sasanian culture.[16]

It is not clear when silver production in the east was initiated, at first perhaps under legitimate Sasanian prince-governors in the east and only later as a statement of independence from the Sasanian center by Kushano-Sasanian rulers. A third-century silver deep dish found in an early-sixth-century tomb in China was probably made in a provincial Sasanian center in the east Iranian world from which it eventually passed to China as a prestigious luxury item (Fig. 68).[17] On the dish a hunter on foot, wearing a headdress that is not a Sasanian crown, is depicted vigorously confronting two boars, who charge at him from behind a reed thicket, and fending off with a thrust of his bent leg a third boar, who approaches from behind. The scene, which seems to reflect some heroic narrative, is partially cut off by the fluted lines framing the scene, and the drapery appears in illustrations to have rather naturalistically depicted parallel-line folds. The tomb in which the vessel was found is located in Shanxi Province, just west of the Northern Wei capital at Datong. It belonged to Feng Hetu (438–502), a Northern Wei military official of Xianbei origin who was Commandant of Garrison Cavalry, a position that led to

contacts with the West. The vessel presumably reached China a century after it had been made not in a central Sasanian court workshop but in the eastern borderlands of Iran under early Sasanian control. Subsequently carried to China, the plate may have traveled in the hands of one of the trade or diplomatic missions to the Northern Wei kingdom in the fifth and early sixth centuries led by Hephthalites controlling this east Iranian realm.

It is evident that the third-century plate found in China remained above ground in the region where it was made, the precious possession of generations of owners, before it was finally carried to China and placed in the early-sixth-century tomb near Datong. This hypothesis is supported by the recent appearance on the antiquities market in Afghanistan of a second gilded silver dish, made almost a century later than the plate found in China but decorated with the same scene of a 'royal' hunter hunting wild boars (Fig. 69).[18] This vessel, originally published when it was in Kabul, has within the foot ring on the reverse a Middle Persian inscription giving a weight, as well as a Bactrian inscription giving a name, Tudak. The dish is closer in style and detail to canonical Sasanian works than to the earlier example found in China. The folds of the drapery are depicted as a series of paired lines, a notable feature of central Sasanian workmanship. However, the narrative theme, the elements of the design cut off by the border of the plate, and, most significantly, the depiction of a crown close but not identical to the Sasanian crown type of Ardashir II (r. 379–383), are indications that the Kabul plate is also a provincial work manufactured in eastern Iran, probably as a result of renewed Sasanian political and cultural influence in the region. For his subject, the artisan must have had at hand some prototype, such as the vessel that was later exported to China and buried in the tomb of Feng Hetu.

To interpret the unusual hunting scene depicted on these two plates is difficult, but the distinctive nature of the hunt and its appearance, unchanged, over a span of a century indicate that the heroic or mythological feat depicted on these vessels was a familiar and significant one in the region in which the vessel was produced. The boar hunt as an initiation for a young hero or prince is a theme that is widespread in legends in Europe and Asia. Odysseus and Meleager are two examples in the Greek world. In the *Shahnameh* the boar hunt is associated with the eastern borderlands between "Iran" and "Turan," as the tale of Bizhan demonstrates. It is possible that the boar hunts—as they appear on the elite silver plates made in the eastern part of the Sasanian realm—illustrate a general rather than a specific theme, and celebrate the attainment by a prince-king of manhood, power, and supremacy.

The Sasanian silver vessels decorated with scenes of an identifiable king hunting are standardized and hieratic statements of royal authority, as controlled in their production as the dynastic rock reliefs in Iran. The provincial silver vessels illustrating the parallel-line drapery style are another phenomenon and were directed at a different audience. The purposes of this alternative production must relate to changing historical events and reflect the movement of eastern territories in and out of Sasanian control. At Bandiyan, in northern Khorasan, recently discovered stucco reliefs attributed to the fifth century are unlike the stucco reliefs of central Sasanian Mesopotamia and Iran in style and subject matter, and illustrate a local provincial style that developed in this region disputed by Hephthalite and Sasanian armies in the fifth and sixth centuries (Fig. 37).[19]

There are other individual silver vessels decorated with images of royal hunts that are products of other provincial traditions, unrelated to the parallel-line drapery style but also distinct from

the products of the central Sasanian workshops. An example in the David Collection in Copenhagen is a small silver cup or bowl resting on a low foot ring (Fig. 66).[20] The walls of the deep vessel, which is an entirely local form unknown in the corpus of Sasanian silver vessels, are decorated on the exterior with three scenes of a similarly crowned, royal, equestrian figure hunting wild animals in a crowded and rather naturalistic landscape. The standard nature of the hunting scenes, including both live and dead animals, is close to the balanced compositions on central Sasanian silver plates, and the technique of manufacture, in which numerous added pieces are fitted into the background shell of the vessel to produce relief, is a standard Sasanian technique also used in Bactria on Kushan, Kidarite, and Hephthalite works. However, the crowns of the royal hunters are only roughly modeled on a Sasanian crown—that of Shapur III (r. 383–388)—and the landscape motifs in their fluidity and naturalism are more characteristic of works made in the east Iranian world, Bactria/Tokharistan. Commissioned, perhaps by a member of a local authority in a realm at least temporarily or nominally under the control of a Sasanian overlord, Shapur III, the bowl reflects the diffusion of both Sasanian and east Iranian influences significantly modified in accordance with local taste and usage. The person for whom the vessel was made wished to associate himself with the prestigious icon of Sasanian dynastic power, but the appearance of this icon is adapted to local traditions.

The vessels described above, having scenes of royal hunts, illustrate different aspects of the diffusion of Sasanian forms, imagery, and styles beyond the borders of the Sasanian kingdom. Another vessel, a silver-gilt ewer unearthed in China in a sixth-century tomb located near Guyuan in Ningxia Province, is also comparable to Sasanian works in form, but in iconography and

style it is quite unlike any Sasanian work of art (Fig. 70). The tomb in which the vessel was found belonged to the family of Li Xian, a Northern Chou (557–581) general of Toba (non-Han Chinese) ancestry who died in A.D. 569. At an early stage in his career Li Xian was governor of Dunhuang, guardian of the meeting place of routes along which embassies from the West passed into China. Buried with Li Xian was his wife; this ewer, as well as a typical Sasanian cut-glass bowl, were associated with her burial.[21]

The ewer found in China has precisely the same profile and dimensions as the distinctive Sasanian ewers and ultimately derives, as they do, from Late Antique models. What is notable and not at all comparable to the Sasanian works of art is the subject matter of the decoration, episodes from the *Iliad* of Homer and from Greek mythology, and the mannered Hellenizing style in which it is executed, a style that is characteristic of works made in Tokharistan, ancient Bactria, in the period between the fifth and sixth centuries. Boris Marshak has argued convincingly that an archaizing Greek style persisted in this region, remaining a traditional local form of artistic expression over a considerable period of time.[22]

The figural scenes on standard Sasanian silver ewers are also commonly derived from Greco-Roman images, and combine iconographic features associated with the cult of Dionysos and with the Seasons and Months, as mentioned in chapter two. Dancing, maenad-like females, often paired and holding a specific group of objects, were festal motifs appropriate for the decoration of vessels used at seasonal celebrations in the course of the Zoroastrian calendrical year. In apparent contrast, the paired figures on the ewer found in China are based on images of Greek epic heroes and divinities: Paris and Helen (the Rape of Helen), Paris and Aphrodite, Menelaus and Helen. Such paired figures,

drawn from the Trojan cycle, were a popular motif on late Hellen-
istic seals as illustrated by impressions excavated in a first-century
B.C. context at Delos in Greece.[23] Much later paired figures simply
interpreted as lovers are the subject of seventh- to eighth-century
paintings at Panjikent in Sogd, images that Marshak suggests may
be drawn from the repertory of illustrations of lyric songs or folk
tales.[24] The significance of the paired images in the art of Bactria
on the sixth century A.D. ewer found in China is unknown, but it
is possible the figures were no longer identified with a specific
Trojan narrative. Rather, they might have been viewed as gener-
ally erotic motifs, appropriate symbols of fruitfulness and pros-
perity. If this is the case, the decoration of the silver ewer found
in China, although it differs from Sasanian works in subject mat-
ter and style, may, in fact, have had a similar significance.

At Yuldus, in the governate of Perm, a somewhat later work of
art was found: a second silver ewer. This fragmentary vessel ap-
pears to have had the same distinctive form as Sasanian ewers, but
in this instance it is decorated with miniature hunting scenes that
cover the body of the vessel (Fig. 71).[25] As already noted, the pres-
tigious and exclusively royal motif of the hunt on central Sasan-
ian luxury vessels is represented only on silver dishes. In the
choice of imagery to decorate the Yuldus ewer, the artisan fol-
lowed Imperial Roman models, ewers having a different shape but
often decorated with vigorous hunting scenes. The motifs deco-
rating the Yuldus ewer and the mannered, classicizing poses of the
figures are indications that this vessel, probably made in the sev-
enth century, is another example of a luxury work incorporating
Sasanian elements as well as influences from the art of the Late
Antique world. Although somewhat later in date than the preced-
ing ewer found in China, this vessel is probably also a product of
a workshop in the region of Bactria/Tokharistan.

With the discovery in China of a Sasanian type of ewer dec-
orated in a foreign, non-Sasanian style, it became evident for the
first time that this distinctive vessel shape, the origin of which
lies in the Mediterranean world, was produced not only within
the Sasanian kingdom by the end of the fifth century but also in
workshops in at least one region east of the borders of Sasanian
Iran. In Bactria, the increasing presence of Sasanian cultural in-
fluences in the fourth and fifth centuries as its Hellenizing art
and culture degenerated has been discussed by Frantz Grenet,[26]
and it is probable that the adoption of this form of ewer is one
more sign of Persian influence in the region. In the absence of
absolute chronological data, however, the question of primacy,
Persia or Bactria, for the development of this type of ewer re-
mains open.

The focus of attention in the preceding pages has been on the
diffusion of Sasanian influences to lands east and north of Iran,
as it can be documented in the corpus of silver vessels dating
from the third to the seventh century A.D. and in occasional
works in other media, stucco reliefs and wall paintings. To balance
this Sasanian-centered picture and to provide a background or
context for the silver vessel production, it is important to remem-
ber that contemporary with the period of Sasanian rule in Iran
silver vessels were widely made and treasured by peoples living in
other lands: Bactrians, Sogdians, Hephthalites, Chorasmians,
Tibetans. These cultures produced silver vessels that were distinc-
tive and quite unlike the products of Sasanian workshops. A mid-
sixth-century (A.D. 547) Chinese record of life at the Northern
Wei court at Luoyang provides a description of the treasures of
the Prince of Ho-chien, Yuan Chen, who proudly displayed in his
residence at Luoyang "more than one hundred gold vessels and
silver jars, about the same amount of [gold or silver] bowls,

footed containers, plates and boxes. Among other drinking vessels were several scores of quartz bowls, agate cups, glass bowls, ruby goblets—such marvellous craftsmanship was not to be found in China. All came from the Western Regions."[27] Chinese texts also provide some idea of the wealth and taste for luxury that existed among the Hephthalites, describing the palatial setting of one ruler living in a "large felt tent...lined with [hanging] carpets on all sides. He wore a garment of brocade and sat in a golden chair supported by four phoenixes."[28]

It is evident that by the second half of the first millennium A.D. the Sasanian production of court silver vessels was only one of a number of distinctive local silver productions that existed in contemporary western Central Asia. Within one of these cultural centers, the world of Sogd, various schools of silver-working (defined in the studies of Boris Marshak) existed contemporane-ously, in contrast to the more centralized and standardized royal production within the Sasanian realm (Fig. 72). The cultural and artistic diversity illustrated by Sogdian silver vessels is under-standable in the context of a merchant, trade-oriented society where local polities operated with some independence and where a stream of cultural influences passed along the Silk Routes from lands to the east (eastern Asia and China) and the west (Bactria and Iran).[29] Frantz Grenet suggests that with the arrival of Hep-hthalites in the former Kushan/Sasanian realm, refugees from Bactria carried certain aspects of Sasanian culture to Sogd, a re-gion outside Sasanian or Kushano-Sasanian control. A hoard buried in Sogd near the modern town of Chilek (near Samar-kand) includes a provincial Sasanian plate with a 'royal' hunting scene, two Sogdian bowls, and a Hephthalite bowl, a multicul-tural collection of precious silverware that illustrates cultural diversity as well as the diffusion of Sasanian motifs and style.[30]

North of the Oxus River by the Aral Sea, in Chorasmia, an awareness of the prestige associated with the possession of luxury silver plate led to the creation of another distinctive local class of vessels decorated with various subjects, including divine figures (Fig. 73), and farther east in Tibet perhaps as early as the seventh century the newly independent monarchy gave expression to the concepts of royal power and authority by creating a class of local silver that illustrates stylistic and formal influences from Central Asia (Fig. 74).[31]

While the preceding discussion has been chiefly concerned with silver vessels from Iran and the lands east of Iran, it is also true that both east and west of Iran precious Sasanian glass vessels and semiprecious seal stones were frequent objects of trade (Fig. 75). However, these products are so standardized in form and decoration that there is no way to attribute them convincingly to regional workshops. The presence of such objects in China may be an indication of direct trade with Iran, or these products may have reached China as imports from local workshops in the Sasanian provinces or from peripheral regions in Central Asia.

Finally there is some evidence of the diffusion of Zoroastrian religious iconography to China, probably as a result of the travels of Sogdian merchants as well as by other peoples living in eastern Iran. Explicitly Zoroastrian illustrations of rituals are almost unknown in the court arts of the Sasanian Near East.[32] However, they appear in the art of eastern Iran, as the fifth-century stucco panels at Bandian mentioned above illustrate, and in the art of Sogd, in the sixth and seventh centuries, where temples and villas are decorated with wall paintings and clay ossuaries with reliefs including Zoroastrian divinities and cult scenes (Fig. 76). An unusual group of stone funerary reliefs found at different sites in

China and dating to the era just preceding the T'ang Dynasty (A.D. 618–906) has recently been found in tombs of Sogdians, indicating that these immigrants from the West brought with them a rich Zoroastrian religious iconography (Fig. 77).[33]

The same types of precious goods as those described above were traded or taken as booty to the provincial and peripheral regions west of Iran. Much has been written on the Sasanian presence in the culture of Byzantium by the mid-first millennium A.D., of orientalizing influences on court ceremonial and dynastic imagery as well as on luxury products such as textiles, stucco, and mosaic decoration. In the arts of Byzantium scholars have detected a break with the classicizing past and a renewal of the arts achieved through the 'creative' adoption of Sasanian formulae.[34] This phenomenon is comparable to the spread of Persian cultural influences at this time in the East, in Bactria, where a lingering Hellenism had persisted for centuries. In the Caucasus area on the northwest border of the Sasanian kingdom, local artistic styles assimilate and preserve Sasanian features. This is a cultural development that is apparent not only in luxury artifacts but also in architectural decoration. In a seventh-century church of Işhan in eastern Turkey (the ancient Georgian province of Tao-Klarjeti) the architecture is decorated in an orientalizing style incorporating Syrian and Iranian (Sasanian) features, notably an abstraction of plant forms, strong contrasts between light surfaces and dark background, and an equal emphasis on all parts of the design.[35] When the church at Işhan was rebuilt in the ninth century, the colonnade of the earlier seventh-century church built by Bishop Nerses (later *catholikos* of Armenia, A.D. 640–661) was preserved out of respect for the prestigious personage with whom it was associated, and the earlier style of architectural decoration was followed in many of the plant motifs on the later capitals and cornices.

The tenacity of Iranian artistic traditions in the art of the Caucasus is evident on a silver vessel made in eastern Georgia (Iberia) in the third century A.D.[36] The deep plate found at Ertso rests on a relatively high foot and is decorated in an Achaemenid Iranian style incorporating ovoid lobes (Fig. 78). Long after this type of embossed decoration had disappeared in Iran, the prestigious Achaemenid wares were apparently remembered and imitated west of Iran, in Georgia. Similarly, other variations of Achaemenid and Parthian types were still made as late as the sixth and seventh centuries A.D. in Sogd, east of Iran. In general, however, the silver excavated and probably made in Georgia follows east Roman and Byzantine prototypes rather than Iranian models, and the strongest artistic influences in this region in the early centuries A.D. are from the West. Some of the earliest official Sasanian silver vessels of the third and early fourth centuries have been found in Georgia at Mtskheta, the burial place of the military aristocracy, *eristavi* (Fig. 48), and at Sargveshi (Fig. 49).[37] It is evident from the decoration of the pieces—medallion portraits of an official and of the royal family—and from the shape of the Sargveshi cup that this early Sasanian dynastic silver production was stimulated by political and cultural interaction with Rome and her intermediaries on the western borders of the Sasanian kingdom. Viewed from a Greco-Roman 'center' the earliest Sasanian works could be, and have been, considered provincial Roman works. When parts of eastern Georgia returned to direct Sasanian control in the sixth century A.D., western modes reasserted their influence on Sasanian silver production. The Hellenizing medallion portrait image, infrequently used in Iran for royal images after the fourth century, reappears as a dynastic icon on a late Sasanian silver plate described in chapter two, a work that probably was made in celebration of renewed Sasanian authority

within Georgia under Khusrau I (r. 531–579) (Fig. 50).[38] Another purely Sasanian silver vessel found in eastern Georgia, likely of sixth-century date, is the small hemispherical bowl mentioned in chapter two. Decorated on the exterior with a typical Sasanian vintage scene and populated floral scroll, the interior has the image of a gilded cross, presumably an indication of the Christian faith of the owner.[39] Whether the piece was made in a Sasanian workshop in Georgia or exported to that region from Iran and later modified there is unknown.

Roads through the Caucasus led to eastern Europe, where there is also evidence of the diffusion of Sasanian precious goods and artistic influences. Immediately north of the Caucasus, in the area of the river Terek, a small silver hemispherical bowl was found some time before 1896 and subsequently acquired by the Hermitage Museum (Fig. 79).[40] The bowl illustrates the spread of prestigious Sasanian imagery in this area west and north of Iran's borders in the seventh century. From a Sasanian viewpoint the vessel is a work made in a region beyond the Sasanian centers by an artisan who was commissioned to decorate the simple drinking bowl (a minor form in the Sasanian corpus) with the most significant images: hunting scenes. In the center of the exterior decoration, a roundel encircles the image of a *senmurw*, a motif associated in Sasanian art with the king of kings. Often classified with central Sasanian vessels because of the hemispherical shape and details of the design, the decoration of the bowl incorporates many features unparalleled on central Sasanian works of art. The physical appearance and the dress of the hunters (short tunic, pants, and headgear) are at variance with Sasanian court images and indicate that the persons depicted belong to another culture. Parallels for the physiognomy of the hunters and their costume are to be found in the art of the Avar

world of the seventh and eighth centuries, and it is probable that this vessel is a work influenced by that cultural environment at the end of or just following the Sasanian period.[41] Thomas Noonan describes the expanded Sasanian presence in Darband in the sixth century, and this presence may have left its mark on local artistic productions such as the Terek bowl.[42] One detail of its decoration, the scalloped pattern along the outlines of the neck of the *senmurw*, recurs on other images on silver vessels made in other workshops, illustrating different styles: a late Sasanian silver-gilt ewer found at Pavlovka in the Ukraine on which the scallops along the *senmurw* neck clearly depict a feather pattern (Fig. 80); and a peripheral lobed bowl of seventh- or eighth-century date found in eastern Europe, near the river Dniester, at Khomiakovo (Fig. 81).[43] In the latter example the scallops are more abstract and geometric and elaborate the necks of griffins.

The iconographic and stylistic features described above are indications that the Terek bowl was made by craftsmen in a workshop where Sasanian court wares were known and where there was some prosperity, probably associated with the cross-Caspian trade. Following the Byzantine/Turkic alliance of the late sixth century, merchants from the East traveled through the Caucasus to Byzantium, bypassing Iran and avoiding exorbitant taxes. This trade route brought commerce and wealth, as well as precious goods, to the region.

The artisan who made the Terek bowl was familiar with Sasanian court motifs through such luxurious works of art as the silk textiles and silver vessels that reached the region in the late Sasanian and early Islamic periods as objects of trade or booty. But the craftsman who made the bowl was responding to the taste of another people and culture. Writing of the wealth of the Caucasus in the seventh century, Noonan mentions the treasure of gold

and silver vessels and embroidered and encrusted robes captured by the Khazars at the time of their invasion into Georgia, Armenia, and Albania. Rich in metals, the Caucasus Mountains had a long tradition of distinctive and skillful metalworking, a tradition that persisted in the late Sasanian era.[44]

The treasured silk fabrics woven in Byzantium, the Near East, and Central Asia are an important medium, now largely lost, through which Sasanian and Late Antique motifs and iconographic details must have been transmitted to regions far beyond the borders of Iran.[45] The impact of these precious silk textiles on the decoration of the silver vessels made in Iran and elsewhere is evident on a late Sasanian silver-gilt vase, also found in the Caucasus, in Daghestan (Fig. 82).[46] This vessel is, in a sense, wrapped in a silk textile on which a lozenge or diaper pattern encloses images of real and fantastic animals.

Farther west of Iran, central Sasanian gold and silver vessels are also found in the valleys of the rivers Don, Dniester, and Dnieper. The late Sasanian or early Islamic silver-gilt ewer found in this area near Pavlovka is, as noted above, decorated with the image of a *senmurw* whose neck is bordered by a scalloped feathered band (Fig. 80), a detail noted above in the description of the same motif on the Terek bowl.[47] Although the style of the decoration on the two vessels is quite distinct—and clearly they were not made in the same workshop—this detail suggests a common source for the iconography, perhaps a work in another medium.

Another find, near Malaya Pereshchepina in the Ukraine, includes diverse works of art—Sasanian, Byzantine, and Turco-Sogdian (Fig. 83).[48] It is similar in its multicultural composition to the hoard, mentioned above, of a prosperous merchant of Sogd found buried at Chilek in western Central Asia. The Sasanian gold ewer and elliptical lobed bowl in the Malaya Pereshchepina

hoard, the only central Sasanian gold vessels known, are believed to be booty taken from some Iranian royal treasury, perhaps at Dastagird, by the victorious armies of the Byzantine emperor Heraclius in the early seventh century, later to be passed on to his Khazar and Bulgar allies. Scholars have suggested that the hoard was buried in the early eighth century and belonged to a Khazar leader or the Bulgar ruler Kuvrat, whose name appears on some objects. The proportionately narrow form and upright walls of the Sasanian gold elliptical bowl in this treasure may point to the west Sasanian realm as its place of origin, since these same features characterize the small class of elliptical bowls having discrete lobes for which a west Sasanian provenance was suggested in chapter two (Fig. 52).

One of the silver vessels in the Malaya Pereshchepina hoard, a shallow circular bowl resting on a rather pronounced foot, is a form unrepresented in the Sasanian silver corpus and may be the product of a workshop in the western provinces of the Sasanian kingdom (Fig. 84).[49] Both Sasanian and non-Sasanian decorative motifs adorn its exterior and interior surfaces, which have an abstract embossed form vaguely reminiscent of Achaemenid plates and bowls. In this respect, and in the presence of a moderately high foot, the bowl is comparable to the third-century A.D. lobed, circular vessel described above, which was found in Georgia at Ertso (Fig. 78). The bowl in the Malaya Pereshchepina hoard appears to be the work of a craftsman who drew upon stylistic and iconographic features from the Sasanian center but was at home in another cultural environment.[50]

Some central Sasanian vessels reached Europe indirectly from Central Asia, as the presence of both a Middle Persian and a Sogdian inscription on a vase from Limarovka between the rivers Don and Dniester indicates.[51] The place of manufacture of other

precious artifacts found in eastern Europe is unknown, but stylis-
tic details suggest a familiarity with Central Asian works of art.
An identical pair of vessels in the shape of an antelope head were
found north and west of Iran at Khomiakovo, in the Ukraine near
the river Dnieper (Figs. 81, 85).[52] These works of art have only a
single parallel in the corpus of central Sasanian works—an ante-
lope head vessel, formerly in the Guennol Collection, that has a
Middle Persian inscription and a back plate which is decorated
with four heart-shaped petals (Figs. 86a,b).[53] Stylistically the
elongated linear treatment of the eyes of the animal in the Guen-
nol Collection resembles animals represented on Sogdian silver
vessels of the eighth century, a region in which vessels in the shape
of animal heads and bodies appear in the spectacular seventh- and
eighth-century wall paintings at Panjikent. A common western
Central Asian prototype may, therefore, lie behind both the
Sasanian antelope-head vessel in the Guennol Collection and the
pair of heads found at Khomiakovo, which cannot be called
Sasanian on the basis of style.

With the two antelope heads found at Khomiakovo was a sil-
ver, elliptical bowl having three elongated lobes and two small
lobes on the lateral axis (Fig. 81).[54] The decoration of the exterior
of this vessel includes the Sasanian and more ancient Near East-
ern motif of two rearing animals confronting a tree, images of
griffins (a particularly popular subject in the art of Byzantium and
the Avars), and a recumbent lion in a marshy landscape of water
and reeds.[55] As noted above, the griffins display the same dec-
orative, scalloped neck border seen on the *senmurw* images on the
Terek bowl and on the Pavlovka ewer (Figs. 79, 80). Sasanian
influence is apparent on the Khomiakovo vessel in the number of
lobes and in the open flaring form of the vessel, but the style and
subject matter of the exterior decoration suggest that it is a

peripheral work of art, derived from Sasanian and other models.[56] The motifs grouped together on the bowl are not found on Sasanian bowls, and lions in Sasanian art invariably appear in a mountainous landscape not among reeds, a landscape associated with wild boar. In workshops north and west of Iran in the Sasanian period Byzantine, Central Asian, and Sasanian designs were known and copied by artisans working for the Alans, the Avars, and the Khazars. The lobed bowl from Khomiakovo appears to be the result of such cultural interaction.

Another, more elaborate elliptical lobed bowl has five elongated lobes and two small lobes on the lateral axis. This vessel was found in Poland, northeast of Cracow, and is decorated in a more standard Sasanian fashion with dancing female figures, plants, an inhabited vine scroll, and guinea fowl (Fig. 87).[57] Six-petaled rosettes on the exterior of the bowl may be derived from textile designs. The profile of the vessel, the steep upright walls, and the greater number of lobes are features also seen on the gold elliptical lobed bowl in the Malaya Pereshchepina hoard for which a west Sasanian workshop was suggested above.

One of the best known but still enigmatic 'Sasanian' luxury vessels is the unique gold, rock crystal, and colored glass dish in the Cabinet des Médailles of the Bibliothèque Nationale, Paris (Fig. 88). Some vague memory of its past history may be reflected in the legend that it was a gift from Harun al-Rashid to Charlemagne.[58] On the reverse of the dish is a Middle Persian inscription giving the weight of the piece. Depicted on the central rock crystal medallion is a relief-carved image of an enthroned king wearing a crown and a form of dress generally modeled on late Sasanian images of the time of Khusrau I (r. 531–579) and Khusrau II (r. 591–628). However, details of the royal dress, including the sharp pointed cut of the robe, have parallels not on Sasanian

works of art but in the art of Sogd and western Central Asia. The colored glass inlays surrounding the central rock crystal medallion are carved into four-petaled rosettes, a ubiquitous Late Antique motif commonly found on textiles and also decorating the patterned back plate on the silver antelope-head rhyton described above. Unusual and not typical of the Sasanian works of art that have survived is the mixture of brightly colored materials inlaid into the gold vessel, and it is this feature that has led to comparisons between the Bibliothèque Nationale plate and the art of the peoples living in the steppe world—Scythians, Sarmatians, Parthians, and Huns. A deep electrum bowl found at Nagy Szeksos in Hungary in a rich, fifth-century Hunnish tomb may originally have had an appearance similar to the Bibliothèque Nationale dish as the walls of the vessel found in Hungary have circular cutouts which once held inlays.[59]

It is possible that the golden "Cup of Solomon" decorated with a Sasanian type of royal enthronement scene represents a class, as yet unknown, of late Sasanian precious vessels in which Iranian imagery is modified by influences from Central Asia and the steppes of Eurasia. Alternatively, the unique piece may be viewed as a provincial Sasanian work made in a region having contacts and interchanges with both the northern steppe world and the Persian realm.

One of the conclusions that can be drawn from this excursion beyond the Sasanian kingdom is that the stages of cultural diffusion from the Sasanian centers to the East and to the West were similar, and that the passage of precious works was stimulated in both regions by a recognition of the prestige associated with the Sasanian dynasty and by the unceasing movement throughout the Sasanian period of peoples both within and beyond the borders of the Iranian kingdom along expanding routes of trade. Central

Sasanian silver vessels reached eastern Europe, but no central Sasanian silver wares have yet been found as far east as China, only works derived to a greater or lesser degree from Sasanian models.

The prestigious Sasanian luxury works left their mark most prominently on local cultures on the borders of Iran. From there a Sasanian presence—modified but still recognizable—spread farther abroad. The varied composition of the Chilek treasure, buried in Sogd on the northeastern periphery, has a counterpart in the group of gold and silver vessels in the culturally diverse hoard unearthed at Malaya Pereshchepina in the Ukraine on the western periphery.

There is always a danger in attempting to categorize and define too precisely distinctions apparent in the arts, and to interpret degrees of relatedness too rigidly in cultural and political terms. Art historical and technical criteria indicate that there existed dynastic silver workshops operating from controlled Sasanian centers where specific forms and icons prevailed. It is also evident that derivative productions developed in the early Sasanian period on and beyond the borders of Iran in response to local political and cultural demands. The corpus of silver vessels of Sasanian date is sufficiently large and varied to provide illustrations of these phenomena. As we move now to a review of the Sasanian cultural identity, the existence of provincial and peripheral work-shops where Sasanian artistic influences were present underscores the need to exercise caution in utilizing artifacts from sources removed from the Persian center to achieve an understanding of Sasanian culture.

1. For bibliography on the subject of diffusion and the opinion of Rudolph Wittkower that "in art historical controversies the degree and character of diffusion may be disputed but not the principle of diffusionism," see *Selected Lectures* 1989, p. 6.

2. Thierry 1993, pp. 89–140.

3. de Bruijn, Dudley 1995, pp. 683–697.

4. *Wenwu* 1987, p. 77; Xiong, Laing 1991, pp. 163–173.

5. Whitehouse 1971, pp. 262–267; Miller 1969; Loewe 1971, pp. 166–179; Forte 1996, pp. 187–197.

6. Jeroussalimskaja 1989, pp. 897–916.

7. Watson 1983, pp. 537–558; Bunker 1991, pp. 20–24; So, Bunker 1995, pp. 70, 149–151.

8. Harper 2000a, pp. 95–113.

9. Herodotus bk. 1, chap. 134.

10. Harper 1989, pp. 847–866.

11. Marcus 1990, pp. 129–150.

12. For a more detailed discussion, see Harper, Meyers 1981.

13. Marshak, Krikis 1969, pp. 55–81; Marschak 1986.

14. Harper and Meyers 1981, pl. 23.

15. Grenet, Lee, Pinder-Wilson 1980, pp. 69–104; Lee, Grenet 1998, pp. 75–85; Grenet 1999, pp. 66–67.

16. Kawami 1987b, pp. 13–51.

17. *Wen Wu* 1983, p. 8; Harper 1990.

18. *Glories of the Past* 1990, pp. 58–59.

19. Rahbar 1998, pp. 213–250; Gignoux 1998, pp. 251–258.

20. Harper 1989, pp. 847–866.

21. Carpino, James 1989, pp. 71–76; Harper 1991, pp. 67–84; Juliano, Lerner 2001, pp. 98–100.

22. For the spread of Greek literature in the East, see Derrett 1992, pp. 47–57.

23. Hatzi-Vallianou 1996, pp. 209–229.

24. Marshak 2002, pp. 99–101.

25. Marschak 1986, p. 275, fig. 192.

26. Grenet 1996, pp. 367–390.

27. Yang Hsuan-chih 1984, p. 193.

28. Ibid., pp. 225–226.

29. Marshak 1996, pp. 425–438.

30. Marshak, Krikis 1969, pp. 55–81.

31. Marschak 1986.

32. Boyce 1995, pp. 93–111; Zeumal 1996, pp. 16–20.

33. Russell 1996, 1997, pp. 9–10, 17–19; Grenet 1993, pp. 149–160.

34. Speiser 1984; Levi c. 1947. See also excavation reports of the sixth-century church of St. Polyeuktos in Istanbul, *Dumbarton Oaks Papers* 1965–1972.

35. Piquet-Panayatova 1989, pp. 166–212; Piquet-Panayatova 1991, pp. 198–253. See also the orientalizing style of the tenth century in the Monastery of Constantine Lips, Mango, Hawkins 1964, pp. 299–315.

36. Machabeli 1983, p. 112, no. 57.

37. Harper, Meyers 1981, pp. 24–39, pls. 1–7.

38. *Miho Museum* 1997, pp. 106–107, no. 49.

39. *National Treasures of Georgia* 1999, p. 201, no. 98.

40. Trever, Lukonin 1987, p. 87, no. 26, figs. 73–78.

41. Bálint 1989, p. 191, no. 2; Daim 1996, pp. 300, 354, no. 5.283.

42. Noonan 1984, pp. 268–269.

43. Trever, Lukonin 1987, nos. 21, 33, figs. 56, 101.

44. Noonan 1982, pp. 279–280.

45. For the continuing trade in textiles and a historical résumé, see Ierusalimskaia 1996; Knauer 2001, pp. 125–154.

46. Trever, Lukonin 1987, no. 30, figs. 90–95; Gonosova 1987, pp. 227–237.

47. Trever, Lukonin 1987, no. 21.

48. Werner 1984; *Treasure of Khan Kubrat* 1989, p. 42.

49. Trever, Lukonin 1987, no. 25.

50. For a different opinion, see Marshak in Daim 1996, p. 216.

51. Trever, Lukonin 1987, no. 19.

52. Bálint 1989, p. 106.

53. Miho Museum, Japan, acc. no. 551623. *Splendeur des Sassanides* 1993, pp. 250–251.

54. Bálint 1989, p. 106.

55. Daim 1990, pp. 273–303.

56. For a different opinion, see Marshak 1998, p. 87.
57. Smirnov 1909, pl. XLIX, no. 77.
58. Harper, Meyers 1981, p. 115, pl. 33; Shalem 1994, pp. 77–81.
59. Daim 1996, pp. 160–162.

63

64

Fig. 63 Gold necklace of Li Jingxun (d. A.D. 608). Near Xian, Shaanxi Province, China. 6th century A.D. National Museum of China. *Wen Wu* 10, 1987, fig. 77.

Fig. 64 Drawing of covered box. Yunnan Province, China. 2nd century B.C. Yunnan Provincial Museum. Harper 2000b, p. 97, fig. 1 (after *Yunnan Jinning Shizhaishan gumqun fajue baogao* [Beijing 1959], vol. 1, p. 69, fig. 21).

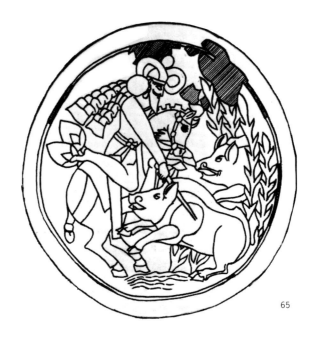

65

66

Fig. 65 Drawing of silver-gilt plate. Provincial Sasanian, 4th century A.D. Hermitage Museum, St. Petersburg, acc. no. s-24. Drawing by A. Koh.

Fig. 66 Drawing of silver bowl; ca. 4th century A.D. The David Collection, Copenhagen, acc. no. 2/1984. From: Harper 1989, p. 862, pl. IIb.

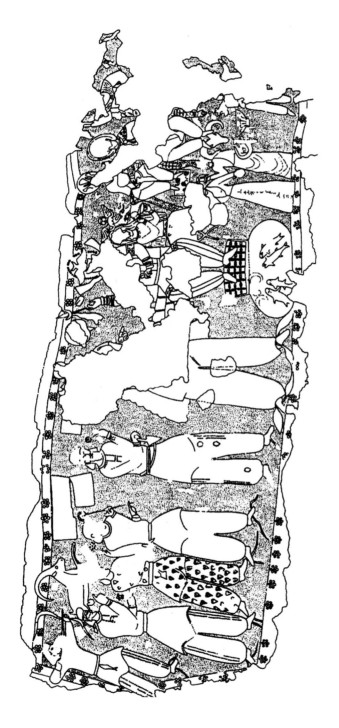

Fig. 67 Drawing of painting at Ghulbiyan, Faryab Province, Afghanistan. Kushano–Sasanian (?), 4th century A.D. Grenet 1999. p. 67. Drawing by A. Searight.

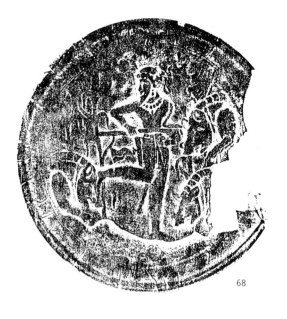

68

69

Fig. 68 Rubbing from silver plate from tomb of Feng Hetu. Datong, Shanxi Province, China; ca. 4th century A.D. Datong City Museum. Harper 1990, p. 52, fig. 2 (from *Wen Wu* 1983.8).

Fig. 69 Silver-gilt plate. Provincial Sasanian, Afghanistan, late fourth–early fifth century A.D. Shelby White and Leon Levy Collection.

Fig. 70 Drawing of silver-gilt ewer. Guyuan, Ningxia Autonomous Region, China. Bactrian, ca. 6th century A.D. Guyuan Museum. Harper 1991, p. 83, fig.4 (from *Cultura Antiqua* 41/4, fig. 3).

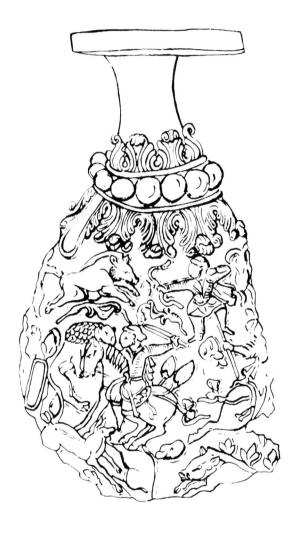

Fig. 71 Drawing of silver ewer. Yuldus, Perm, Russia. 6th–7th century A.D.
Marschak 1986, no. 192.

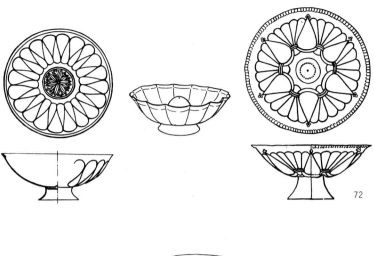

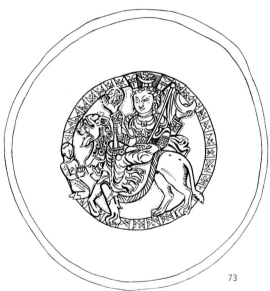

Fig. 72 Early Sogdian silver vessel shapes. 6th–7th century A.D.
B.I. Marshak, *Sogdiiskoe Serebro*, Moscow 1971. Table.

Fig. 73 Drawing of silver vessel. Bartym, Perm, Russia. Khoresmian,
8th century A.D. District Museum, Perm. Marschak 1986, fig. 170.

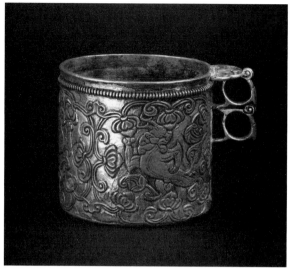

74

75

Fig. 74 Silver beaker. Tibetan, mid-7th century A.D. The Cleveland Museum of Art, acc. no. 88.69. Severance and Greta Milliken Purchase Fund.

Fig. 75 Glass bowl. Sasanian, 6th–7th century A.D. The Metropolitan Museum of Art, acc. no. 59.34. Purchase. Rogers Fund 1959.

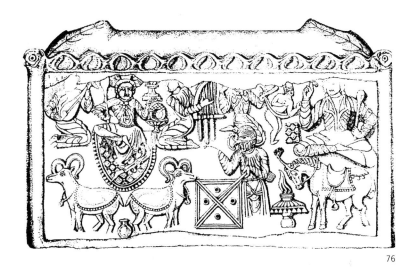

76

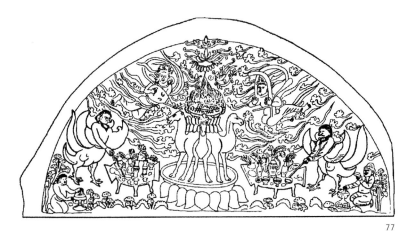

77

Fig. 76 Drawing of clay ossuary. Sivaz, Uzbekistan. Sogdian, 6th–7th century A.D. F. Grenet in *Studia Iranica* 22, 1993, Pl. IV.

Fig. 77 Drawing of stone relief in tomb of An Jia (d. A.D. 579). Xian, China. H. Sugaya in *Bulletin of the Miho Museum* 4, 2004, pl. 10.

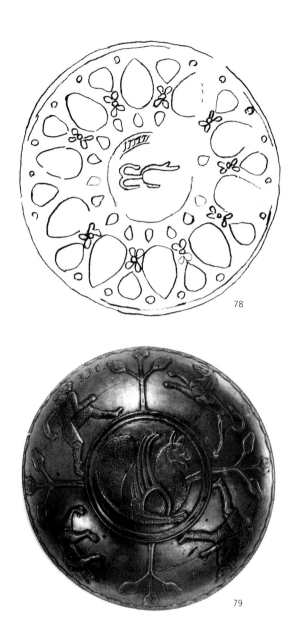

78

79

Fig. 78 Drawing of silver bowl. Ertso, Georgia. 3rd century A.D.
From: Machabeli 1983, p. 112, no. 57.

Fig. 79 Silver-gilt bowl. Terek river region. Caucasus, ca. 6th century A.D.
Hermitage Museum, St. Petersburg, acc. no. S-57.

80

81

Fig. 80 Silver-gilt ewer. Pavlovka, Ukraine. Sasanian, 6th–7th century A.D. Hermitage Museum, St. Petersburg, acc. no. s-61.

Fig. 81 Finds from Khomiakovo. 6th–7th century A.D. Lobed bowl: Hermitage Museum, St. Petersburg, acc. no. s-285. Bálint 1989, p. 106, Abb. 51.

Fig. 82 Silver-gilt vase, Daghestan, Caucasus. Sasanian, 6th–7th century A.D. Hermitage Museum, St. Petersburg, acc. no. S-70.

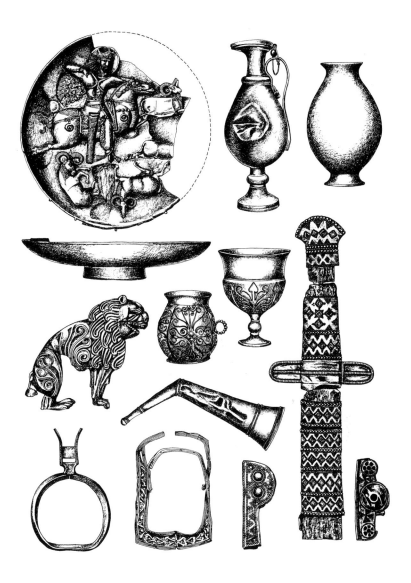

Fig. 83 Drawing of selected finds in Malaya Pereshchepina hoard. Ukraine. Bálint
1989, p. 97, fig. 42.

Fig. 84 Circular lobed silver-gilt bowl. Malaya Pereshchepina, Ukraine. 6th–7th century A.D. Hermitage Museum, St. Petersburg, acc. no. S-271.

Fig. 85 Silver-gilt antelope head rhyton. Khomiakovo. 6th–7th century A.D. The Metropolitan Museum of Art, acc. no. 47.100.82. Purchase, Rogers Fund 1947.

86a

86b

Fig. 86 a,b Silver-gilt antelope head. Sasanian (?) 6th–7th century A.D. Formerly in the Guennol Collection, New York.

87a

87b

Fig. 87 a,b Drawing of silver elliptical lobed bowl. Poland; ca. 6th century A.D.
From: Smirnov 1909, pl. XLIX, no. 77.

Fig. 88 Gold, rock crystal, and glass bowl. Sasanian (?), ca. 7th century A.D.
Bibliothèque Nationale, Cabinet des médailles, Paris, acc. no. 379.

REFLECTIONS
on a Sasanian Cultural Identity

The works of art and artifacts reviewed in the preceding chapters present a complex picture of the cultural environment and cultural developments in the Sasanian Near East. This complexity is hardly surprising since the territories under Sasanian control were geographically widespread and peoples of diverse backgrounds lived at vastly different levels of wealth and prosperity. Primary sources available are official and dynastic, the didactic court arts of the Sasanian center. These are the most conspicuous and well-known remains, and while they illustrate developments over the centuries, they share a relatively uniform and distinctive appearance. Fortunately, the dynastic works are supplemented by a growing body of material that provides another view—objects of daily life found in excavations of urban sites and centers along trade routes where peoples and products from many lands contributed to the cultural identity of the Sasanian world. These minor works (ceramics, seals, beads, bronze and iron implements) provide evidence of cultural diversity, a diversity that existed among the native populations of Mesopotamia and Iran and included, as well, foreign peoples, colonists, prisoners, and traders who came or were transported to the Near East. In this sense the Sasanian era is comparable to the period of Achaemenid rule in the Near East when the presence of different cultures and peoples was celebrated in royal inscriptions as part of the dynastic identity. Shaul Shaked has commented on the

open and eclectic character of the Sasanian literary tradition, and this observation, it is becoming evident, is true of the material remains as well.[1]

In the dynastic arts continuity with past traditions is a significant feature throughout the period. From the beginning of the era, under Ardashir I (r. 226–241), the presence of and familiarity with ancient monuments influenced the formation of a dynastic imagery.[2] New motifs, forms, and styles were drawn from many sources over time, but traditional concepts of significant imagery, composition, and design persisted. As in past millennia, official state controls affected the organization and productions of artisans, a fact that is evident from existing texts defining the classes of society (priests, warriors, scribes and bureaucrats, artisans and peasants) as well as from the appearance of dynastic monuments: rock reliefs, court silver vessels, coin images, and seals.[3]

Inherent in the use of the words *dynastic* and *official* in a Sasanian context is a recognition of the primary role of the Zoroastrian religion in society. The doctrines of the state religion governed the actions of the king and his court, and the priests (*mog, mogbed*) also served as judges and officials of the state government, enforcing the laws of the land and creating a particular cultural, social, and economic environment.[4] The Zoroastrian presence is both explicit and implicit in the works of art. Inherent in images of the king is the presence of Ohrmazd, and even in the presentation of figural and ornamental designs in the dynastic works of art, the emphasis on balance and order corresponds to Zoroastrian beliefs of what is right and good in the world and in a rigidly hierarchical society. As Boris Marshak has observed, most of the subjects used in the decoration of the court silver vessels produced in such quantity in the late Sasanian period can be understood as prayers, benedictions, or invocations in pictorial form.[5] The close relation-

ship between artistic expression and religious belief also resulted in the absence of certain forms and themes. Statues in the round of divinities and explicit renditions of Zoroastrian cult activities are not part of the central Sasanian cultural identity, exceptions being images on coins.[6] Only on works of art made on the eastern borders of Iran, where cultural developments follow traditions deeply influenced by the Hellenism of Bactria and Sogd, do Zoroastrian divinities and religious cult practices regularly appear in the arts (Figs. 67, 76, 77).

A dynastic imagery was established in the reign of the first king, Ardashir I (r. 226–241), and is evident in his official art, on the reliefs and coins. The initial search for a dynastic language of images drew on Achaemenid and Parthian prototypes as well as on contemporary Roman forms, motifs and compositions introduced into Iran by populations transported from northern Mesopotamia and the eastern Mediterranean world. On the earliest Sasanian reliefs there is a notable correspondence between image and text: in the investiture relief of Ardashir I at Naqsh-i Rustam a traditional royal icon is employed, the trampling of a dead enemy, but the figures of the god and king are labeled in Greek and Middle Persian inscriptions (Fig. 8); the rock sculptures of Shapur I mirror the historical events recorded on the Ka'ba of Zoroaster, and the relief of Kirder at Sar Meshed can be read as an illustration of his neighboring rock inscription (Fig. 9). In this respect the early Sasanian reliefs are similar both to official monuments in the Late Antique world, where image and text are closely related, and to Achaemenid Bisitun. Over time, this individual, historical statement is modified and the emphasis shifts to the concept of dynasty. Continuity with dynastic predecessors is emphasized rather than historical specificity by the repetition of crown types on the coinage with little variation. When the

medium of rock relief sculpture is once again used at the end of the period as a vehicle for the expression of the resumption of dynastic rule and legitimacy under Khusrau II (r. 591–628) at Taq-i Bostan, the identity of the king represented is not clear from the appearance of his crown or from any accompanying inscription. The royal monument expresses an imperial ideology and illustrates concepts of royalty rather than specific historical events. In this sense it is comparable to the contemporary, seventh-century Great Palace mosaic in Constantinople attributed by Trilling to the reign of Heraclius (r. 610–641). Trilling writes that the mosaic "is political art that transcends propaganda: it is an uncompromising reminder of the basis of civilization and the responsibilities of imperial rule."[7] A similar concept lies behind Taq-i Bostan.

Political and social developments led to other modifications in the production of state workshops over time. Following the Mazdakite revolution in the late fifth and early sixth century the production of silver plates bearing royal images illustrates a greater variety in iconography and style and the corpus of court silver vessels expanded to include new forms and designs. This development late in the reign of Kavad I (r. 499–531) and under Khusrau I (r. 531–579) may reflect the increasing status of a class of high civil and military officials, the *azadan*, at the expense of the powerful old noble families of Iran.[8] Members of this lesser nobility, free landowners, owed their rank to the king and were probably granted rights of production and ownership. However, even this expanded production continues to be regulated and standardized. Certain motifs appear only on certain shapes of vessels: royal hunts decorate open plates not bowls or ewers; festal motifs, including sets of dancing females, decorate vases and ewers; animals are represented against typical geographical backgrounds—boars

in reeds, lions on mountainous terrain. Some subjects remain rare or absent, notably banqueting and cult/religious scenes.

Standardization in the production of silver vessels is evident not only in the forms and motifs appearing on silver vessels but in the weights of the pieces as well, at times recorded in dotted Middle Persian inscriptions on the vessels themselves. As in the Seleucid and Parthian periods in the Near East the weights follow the Attic standard and correspond to the Sasanian coin (*drahm*) weights.[9] Sasanian silver vessels, were in a sense, a medium of exchange, able to be used as collateral for loans, a fact that is evident from their use as recorded in the Sasanian Law Book.[10] The different shapes fall generally into categories according to weight: ewers range from approximately 1,300 to 1,500 grams (300–400 *drahms*); most vases weigh from 480–630 grams (120–160 *drahms*); plates range from 400–550 grams (100–135 *drahms*); hemispherical bowls weigh from 230–480 grams (60–120 *drahms*); elliptical bowls range from 150–330 grams (40–85 *drahms*). To put these figures into some perspective in terms of the Sasanian economy, we know from texts referring to the Middle Iranian period that a sheep was worth 12 *drahms*; an ox, 48 *drahms*; a woman (slave) or a woman's dowry, 2,000 *drahms*.[11]

Another cultural development during the centuries of Sasanian rule is the use of an increasingly inclusive iconography in the arts culminating in the great iwan of Khusrau II at Taq-i Bostan. The images depicted come from ancient Near Eastern, Late Antique, Zoroastrian, and Christian sources, and, depending on the background of the viewer, were open to different interpretations. There is no use of text or any explicit articulation of the imagery.

The challenge of interpreting Sasanian monuments is considerable. Contemporary Middle Persian texts do not always correspond to the appearance of the monuments. Edith Porada once

observed that in the art of the Achaemenid period the "pictorial renderings seem to indicate a more elevated position of the king than the one suggested by the inscriptions in which he presents himself as gratefully dependent upon the help of Ahura Mazda."[12] In the texts of the Sasanian era the Mazda-worshiping king is similarly obedient and subservient to the god, but the images of god and king in the monumental dynastic reliefs are usually the same size. The role of the king as an extension of the great god Ohrmazd on earth is translated into a visual image of equality rather than subservience. Harder to understand is the image of Khusrau at Taq-i Bostan, larger than the divinities by his side.

Utilizing contemporary foreign texts in an attempt to understand the Sasanian imagery is also not necessarily productive, as the distinctions between reality, *topos,* and tradition are blurred. Greek and Latin writers provide remarkably similar descriptions of Near Eastern palaces and villas in pre-Sasanian and Sasanian times, a standard feature being the decoration of the buildings with scenes of combat and hunting (*Diodorus of Sicily* II, 8, 6–7; *Ammianus Marcellinus* XXIV, 6.3).[13] Another theme repeated in texts over the centuries is the destruction of the paradise or game park of the enemy, the cutting of trees, and the killing or dispersal of the animals. In the Near East this is an ancient metaphor for domination, an action taken by Assyrian and Achaemenid kings in the first millennium B.C. (*Diodorus of Sicily* XVI, 4.5) and, much later, by the army of Julian invading Mesopotamia.[14]

Some images frequently repeated in western literary sources are depicted on Sasanian works of art as Gignoux has observed.[15] *Ammianus Marcellinus* (XXIV, 5.2) describes a game park with "lions with flowing manes, boars with bristling shoulders and bears savage beyond all manner of madness," images that appear on central and provincial Sasanian silver vessels in Berlin, Cleveland,

and St. Petersburg.[16] In the art of the Assyrian and Achaemenid periods in the first millennium B.C. and in works of the Sasanian period in the first millennium A.D., royal and heroic figures grapple with wild animals seizing them by the ear.[17] This motif had appeared in Assyrian texts and in Armenian literature of the first millennium A.D. and it is difficult to know whether the writers are repeating familiar phrases or drawing on images they had seen on works of art.[18] Alternatively the artist may be illustrating a familiar literary or oral text. The movement between art and text must have been constant and have gone both ways.

Two major written sources of the Sasanian period are the canonical religious texts, the Pahlavi Books, and the Iranian national history, the book of kings, *Xwadaynamag*, compiled by the time of Khusrau I and added to by Khusrau II.[19] Firdausi, the late tenth- and early eleventh-century Persian epic poet, claims a Pahlavi text of the *Xwadaynamag* as one source for his *Shahnameh*, and he adds that another source was available to him in tales told by *mobads* (priests) and *dehqans* (landowners), Iranian oral traditions that ran parallel to the written record. Even if this statement is only a literary device, it is of some interest. Oral sources have been said to preserve memories, beliefs, and ideologies over the centuries rather than historical or chronological facts. They have been described as an additive analysis of the world, aggregative rather than analytic, conservative and traditional.[20] This is an important source in the Sasanian world of the first millennium A.D. but it is one that is difficult to trace in the arts. One example in court luxury objects of the interaction between orally transmitted tales and the visual arts may be the tale of a heroic hunt attributed in the *Shahnameh* to the Sasanian ruler Bahram V (r. 420–438). In preserved Sasanian and post-Sasanian representations of this tale there appears to be a development or progression in the imagery

with new features added over time, as if the story itself has ex-
panded in many retellings.

The story of Bahram Gur's hunt with a female companion is
known in the literature only as early as the tenth century but the
earliest representation of a central theme in this narrative appears
on a late fifth-century or early sixth-century silver-gilt plate in the
Metropolitan Museum (Fig. 89). Two other post-Sasanian plates
of the seventh or possibly early eighth century in the Hermitage
Museum, St. Petersburg (Figs. 90, 91), also illustrate the tale, as
do stucco reliefs of the late seventh to early eighth century exca-
vated in the villa of a noble at Chal Tarkhan/Eshqabad near Rayy
in northern Iran (Fig. 92).[21]

On the Metropolitan Museum plate the king hunting animals
wears a Sasanian type of royal headdress with a ball of hair drawn
up above the head and a long diadem around the base of the
headdress. This crown cannot be identified from the images of
kings on Sasanian coins, although a late Sasanian queen, Buran
(r. 630–31), has discs rising above the double beading on the base
of her crown. On the plate in New York the 'king' sits astride a
running camel moving to the viewer's right, and is accompanied
by a small female companion who holds his quiver and an arrow
drawn from it. In this detail the scene resembles the representa-
tion of a figure accompanying and assisting the hunting king on
the side wall at Taq-i Bostan. The camel-riding lady is a person of
some importance, since she wears a long diadem around her head
and has a carefully depicted hairstyle including a long braid. In
the field are the quarry, but instead of the usual pair or pairs in
which one animal is alive and the other (probably the same one)
is dead, on this plate the gazelle in one pair is transformed from
a male to a 'female' by the shot of an arrow, which removes both
horns; in the second pair, the female animal becomes a 'male'

when two arrows pierce her head and appear to be horns. This narrative scene deviates significantly from the canonical Sasanian royal hunts that are depicted on court silver plates, and it is the earliest example in central Sasanian style of a theme drawn from some divine, heroic, or princely legend rather than from an iconic royal hunt model. On eastern Iranian, provincial Sasanian, silver vessels heroic hunting narratives appear as early as the fourth century A.D., and it is probable that the adoption of a royal narrative motif by the central Sasanian artisans who made this vessel is due to cultural interactions and exchanges with the east Iranian world. Boris Marshak has suggested that the representation on the Metropolitan Museum silver plate—and on the other related works of art described below—is influenced by images in the art of Sogd where the Zoroastrian god Verethragna, one of whose avatars is a camel, is accompanied by a female associate. Since this god and the Sasanian king share the same name (Bahram), eastern images of Verethragna may well have served as models for the Sasanian artist.[22] However, it is also true that in later Iranian literary works, allegedly drawing on ancient sources, feats of hunting prowess in archery as well as the taunting of a heroic king by a beauteous lady are recurring motifs. The source and setting of these tales, which were recorded in the eleventh century by Firdausi and Asadi the Younger, is the east Iranian world, "the home of the heroic tradition as we possess it."[23]

Whatever sources lie behind the original image on the Metropolitan Museum's plate it is evident that over time the imagery changes. On one of the silver-gilt plates in the Hermitage Museum (Fig. 90), made perhaps a century later but still closely resembling a Sasanian work, the scene is slightly modified. The female who holds arrows has a hair arrangement similar in detail to the female on the Metropolitan Museum plate but now a ball

of hair rises above her head, a symbol of royalty or divinity. In contrast, the function of the female companion on the second plate in the Hermitage Museum is no longer understood (Fig. 91). She simply gestures with her right hand and grasps a handhold with her left hand. This female is a less significant figure in the scene since she neither holds arrows nor has anything about her hair arrangement to suggest she is a member of the elite. In style this plate is further removed from any central Sasanian original. The crowns worn by the 'kings' on the Hermitage Museum plates are typologically similar and are related but not identical to the crown of Bahram V as it appears on his coins. It seems, therefore, that the story being illustrated may be concerned with events associated, at this stage, with the life of the fifth-century king.

The next significant development in the story is illustrated on the fragmentary molded reliefs from Chal Tarkhan, part of the architectural decoration in the reconstruction of the last Sasanian small palace or villa (Fig. 92). Under such circumstances it is easy to imagine that modifications to the form and design of the original stucco decoration may have occurred as the subject of the tale developed and the stucco panels were from time to time restored. At Chal Tarkhan one change is the depiction of an animal having a leg pinned by an arrow to the head. In the tale of Bahram Gur as it appears in the *Shahnameh* this second feat is part of the story. The female companion challenges the king not only to change the sex of his quarry but also to pin the head, foot, and shoulder together with a single shot. The king achieves this goal by throwing a pebble to tickle the animal's head so that it raises its leg to scratch its ear. Then, loosing his shot, the ruler pins the foot and the ear together. Occasionally ungulates are depicted on Sasanian seals with a hind leg raised, apparently to scratch the ear or head. The significance of this motif is unknown but the image was

evidently a meaningful one in Sasanian times, and this fact may have led to its adoption and reinterpretation in the Bahram Gur tale of Firdausi.

In the stucco panels at Chal Tarkhan another significant change concerns the role of the small female who is now shown playing a musical instrument. The actions of the females on these plates, holding quiver and arrow and playing a musical instrument, are the same as the actions of attendants in the Taq-i Bostan boar hunt reliefs. On all the surviving stucco panels from Chal Tarkhan there is much damage and restoration, and the 'king' headdress is not well preserved. However, it is not the same as the headdresses worn by the king on the Metropolitan Museum plate, the two hunters on the Hermitage Museum vessels, or Bahram V on his coins. In fact, the hair and headdress of the figure are more similar to the hunter's low flat cap as it appears on the side walls of Taq-i Bostan than to any other representation of a Sasanian royal crown.

In what was probably the latest addition to the story, the bold female musician, having taunted the hunter once too often, is trampled under the hooves of his camel. This addition to the theme does not appear in the arts until the late twelfth or early thirteenth century and at this point in time the hunter no longer wears any type of Sasanian royal headdress. This same scene appears on a unique seal formerly in the Ackerman Collection that is probably also of Islamic date since the scene moves to the viewer's left and the two camel riders are placed back to back, typical features of the Islamic representations.[24]

The images of a camel-riding heroic or divine figure have been traced in the monuments described above in some detail because the depictions of this subject vary as additions are made and changes occur in the iconography. In this sense the pictorial imagery is a phenomenon that is comparable to developments in an

oral tradition. Undoubtedly the interaction between the oral tradition and the visual arts went both ways: well-known visual images were adopted and reinterpreted by the "singers of songs" to elaborate and give life to their tales, and familiar, well-loved tales of prowess were naturally chosen for display by princely and noble patrons for the decoration of their palaces and villas as well as of their precious gilded-silver plates.

An interesting illustration of the nature of oral accounts, drawn from relatively recent times, is provided by the late American anthropologist Louis Dupree, who in 1967 traveled along the route of the British army's 1842 retreat from Kabul to Jalalabad, speaking with the local people about the history of the region.[25] What Dupree found was chronological confusion, events occurring in the First Anglo-Afghan War interchanged with those of the Second War and no reliable knowledge of the sequence of historical events. On the other hand he heard tales that reinforced and articulated social values and beliefs, defended tribal honor, and emphasized the bravery of local heroes. Consistently, the best storytellers were those whose fathers and grandfathers had been storytellers. The hereditary aspect of folk telling was impressed upon him and is reminiscent of the ancient Babylonian *asipu* priests, whose genealogies were recorded and are preserved.

To give a sense of the rank and prestige of those persons who preserved and fostered oral traditions in Sasanian Iran there is Barbad, a minstrel in the court of Khusrau II, and, from earlier periods in the history of the Iranian peoples, the poets and instrumentalists of the Achaemenid, Median, and Parthian courts. It has been suggested that oral sources explain the use of formulas and the existence of narrative inconsistencies in earlier times, in the Sumerian literature of early Mesopotamia.[26] An analysis of the text of Dumuzi's dream reveals the formulaic and traditional

structure of Sumerian poetry, an indication that the literary form draws on an oral tradition. In Sumer, the most important cult performer sang lamentations to the gods in various rituals; his office was an inherited office, *kalu,* and he had the "ear of the gods."[27] Samuel Kramer once wrote that "the biblical Book of Lamentations owes no little of its form and content to Mesopotamian forerunners.... The modern orthodox Jew who utters his mournful lament at the western wall of 'Solomon's' long destroyed Temple is carrying on a tradition begun in Sumer 4000 years ago...."[28]

A first-millennium B.C. Neo-Babylonian representation of a *kalu* priest, Ibni Ishtar, on the stela of Marduk-zakir-shumi shows a beardless figure.[29] The text refers to his role "to appease the heart of the god." An earlier singer of the Early Dynastic period in the third millennium B.C. was Ur-Nanshe (Fig. 93). A small statue in the Musée du Louvre is one of two dedicated by this singer *(naru),* as he is identified in the inscription.[30] The appearance of Ur-Nanshe, seated cross-legged and wearing an oddly bulging, sheepskin lower garment, is distinctive. He too has no beard and his long hair falling in strands is an unusual hairdo.

Musicians are depicted on two Akkadian seals of the late third millennium B.C. published by Dominique Collon and Anne Kilmer (Figs. 94, 95).[31] Ur-ur, the musician, is named in the inscription on one of the seals. The scenes illustrate Ea, the patron of music and of the *kalu* priests, in a mythological scene that, one supposes, is typically the subject of such singers and their songs. On both seals a small lute player is inserted into the scenes. A parallel for this phenomenon in Sasanian art may be the representation of a small, cross-legged poet-musician on the silver gilt plate in the Metropolitan Museum, described above as having a representation of the Heavenly Twins (Fig. 62).

The late third-millennium B.C. southern Mesopotamian ruler Shulgi prided himself as a musician, claiming mastery of various instruments and, perhaps by implication, of the subjects of songs expressing the values of society. A text from Nimrud in Assyria refers to the chief singer (*naru*) hung from a stake, a symbol of the physical destruction not just of a significant person but of national memories and ideologies handed down for generations.[32]

This digression from our principal subject is intended to provide a sense of an environment that had existed through the millennia in the Near Eastern lands where cultural traditions, beliefs, and ideologies were preserved and modified over time and passed on by respected and prestigious members of society through oral as well as literary techniques.

In contrast to the progression apparent in illustrations of the tale of Bahram Gur and Azadeh, the treatment of foreign—notably Greek—images in the art of the Sasanian and wider Iranian world is relatively static. The foreign themes and motifs are standardized. Because they are not part of a native, Sasanian, Bactrian, or Sogdian pictorial repertory, they do not develop over time. A Labor of Heracles represented on a fourth-century A.D. east Iranian silver plate is, in subject matter and composition, essentially the same as the image painted on a fifth-century B.C. Greek vase.[33] Subjects drawn from the plays of Euripides and the works of Homer are recognizable on vessels made in Bactria in the mid and late first millennium A.D. There is little variation from much earlier Greek models transmitted eastward through such imported media as the ceramic Megarian bowls of the third to first century B.C. and plaster molds that served as artists' models.[34] A boar-hunting scene on the east Iranian plate found in a Chinese tomb is almost exactly repeated on a second east Iranian plate made a century later (Figs. 68, 69).[35] The narrative scene

illustrated on these two plates has not developed and this fact may be an indication that the original model for the scene depicted was a subject drawn from a foreign rather than an Iranian source. In the later Sasanian arts, dancing females depicted on ewers and vintage scenes are based on earlier Late Antique prototypes (Figs. 60, 51). The motifs are not significantly modified over the centuries. To interpret these adopted or adapted motifs is difficult, but it is probable that their original significance was lost and that the images assumed a new significance meaningful in the culture that had adopted them.

Our sense of a Sasanian identity is distorted by a number of factors. There is an absence of contemporary texts that might help in the interpretation of the iconography and provide us with a sense of the audience for whom the images were intended. In addition, the loss of a vast body of material, most notably paintings on the walls of buildings, in books or scrolls—works that could provide a broader illustration of common subjects and themes and reduce the impression that Sasanian art is overwhelmingly official and dynastic, ornamental and decorative in purpose—and textiles (with paintings, a medium that would illustrate the significant role of color in daily life and the arts). As Ann Farkas observed years ago, textiles may be the "one truly Persian art," a medium that from Achaemenid times onward is reflected in wall ornamentation.[36] The primary focus of art historians has necessarily been on works of art made of durable materials, chiefly stone and metal—official, canonical works of art of the court often without a known place of manufacture. Even these more durable materials are not comprehensively represented. One thinks also of glass and rock crystal, the former represented only by a few hardy standard types and the latter by isolated examples. Kurt Erdmann hypothesized in the 1950s that Sasanian prototypes

lay behind the eighth- and ninth-century relief-cut glass industry in Iraq and Iran. Citing the shapes of the later glass and rock-crystal vessels and the motifs represented in relief, he suggested that the Abbasid artists were familiar with Sasanian luxury silver vessels and probably were following a tradition of glass and crystal manufacture already established in Sasanian times.[37]

Fortunately in recent years our view of the arts of the Sasanian Near East has been expanded by evidence drawn from archaeological investigations of secular and religious structures, of centers of trade, and of graves, as well as from analyses of minor artifacts such as ceramics, coins, seals, and beads.[38] The result is a clearer awareness of the diversity that existed within the Sasanian kingdom. Geographical, ethnic, and religious factors all contributed to distinct cultural developments within Sasanian Iran and Mesopotamia. As in Achaemenid times the official, dynastic arts follow patterns and conventions that had been familiar and meaningful in the art of Mesopotamia for millennia, whereas alternate, perhaps more specifically Iranian, traditions apparent in the art of the borderlands and of neighboring regions to the north and east are less evident in the products of central court workshops. Only in the mid and late Sasanian period is there some evidence that certain heroic tales and narrative details, aspects of east Iranian culture, penetrate the workshops of the Sasanian center. In an era of increasing interaction and exchange, the rulers of Sasanian Iran played a central role, a concept mirrored in the tale, probably drawn from a Pahlevi book, of the golden seats set up in his audience hall by the Sasanian king Khusrau I. To the left and to the right and behind his own throne were seats permanently reserved for the kings of Byzantium China and the "Khazars."[39]

The popular culture of the Sasanian kingdom was always less homogeneous and less restricted than the court culture. It was a complex and changing phenomenon that influenced developments in the dynastic arts. One manifestation of this popular culture may exist in the glyptic art. In unusual representations on personal seals one feels the presence of other traditions, of motifs drawn from lyric songs and folk tales—the ox and stag whose legs are entwined by a serpent (Fig. 35), the ungulate represented in an ear-scratching pose, the equestrian dragon-slayer (Fig. 96), the giant bird lifting a female toward the heavens (Fig. 97). These motifs and many others may provide illustrations of popular subjects otherwise invisible or rarely seen in the pictorial arts of Sasanian Iran that have survived.

To ignore either aspect of Sasanian culture, dynastic or popular, is to offer a false and partial view of the Sasanian world. Admittedly, the evidence for a detailed understanding of Sasanian cultural developments is incomplete. However, archaeological finds within the Sasanian kingdom and far beyond its borders to the east and the west are beginning to remedy this situation, and, with the aid of continuing studies focused on dynastic monuments and minor works of art, the culture of this period before the advent of Islam will become increasingly well defined. A review of scholarship in this field in the last five or six decades leads to optimism and to a sense that this central, if still imperfectly understood, presence is gradually assuming a proper place in the "family of nations" that existed in the Late Antique and early medieval world.

1. Shaked 1984, pp. 31–67.
2. C. Bier 1993, pp. 172–194.
3. Taffazoli 1974, pp. 191–196; Kröger 1982b, p. 18.
4. For recent bibliography on this subject, see Daryaee 2003, pp. 193–204.
5. Marshak 1998, p. 84.
6. On seals the image of a person and fire altar is often simply a reflection of the person's name incorporating the word for fire; this image is not, therefore, primarily a cult image. Gyselen 1990, pp. 253–265.
7. Trilling 1989, p.60.
8. Gyselen 1996b, p. 209.
9. Vickers 1995, pp. 163–184.
10. Perikhanian 1997, p. 404.
11. Shaki 1993, pp. 222–224.
12. Porada 1965, p. 159.
13. Briant 1996, pp. 220–222; *Letters of Sidonius* 1915, p. XCIX; *Ammianus Marcellinus* 1937, p. 449.
14. Briant 1996, pp. 249–250; Glassner 1991, pp. 9–17.
15. Gignoux 1983, p. 106.
16. Shepherd 1964, pp. 90–91, figs 30–31; Harper, Meyers 1981, pl. 20; Trever, Lukonin 1987, nos. 1, 26, 28.
17. Harper, Meyers 1981, p. 74, pl. 24; *Art and Empire* 1995, p. 188.
18. Gignoux 1985–88, pp. 53–65.
19. Shahbazi 1990, pp. 208–229.
20. Lord 1991; Lord 1995; Culley 1972, pp. 102–116.
21. Harper, Meyers 1981, pl. 38; Orbeli, Trever 1935, pls. 11, 12; Thompson 1976, pl. 11, figs. 3, 4; Ettinghausen 1979, pp. 25–32.
22. Marshak, Raspopova 1990, pp. 140–143.
23. Boyce 1954, p. 49, n. 2.
24. Ettinghausen 1979, pls. IIIa, Vb, VIa, VIIa,b.
25. Dupree 1967, pp. 50–74.
26. Alster 1972.
27. *The Assyrian Dictionary* 1971, vol. 8, pp. 91–94.
28. Kramer 1969, pp. 89–93.
29. Thureau-Dangin 1919, pl. 1.
30. Spycket 1981, pp. 92–93, pl. 60.

31. Collon, Kilmer 1980, pp. 13–23.
32. *The Assyrian Dictionary* 1980, vol. 11, pt. 1, p. 378.
33. Ortiz 1994, no. 243.
34. Brilliant 1984, p. 43.
35. See above, pp. 124, 125.
36. Farkas 1980, p. 21.
37. Erdmann 1953, p. 198.
38. Recently on beads, see Simpson 2003, pp. 59–78.
39. Christensen 1944, pp. 411–412.

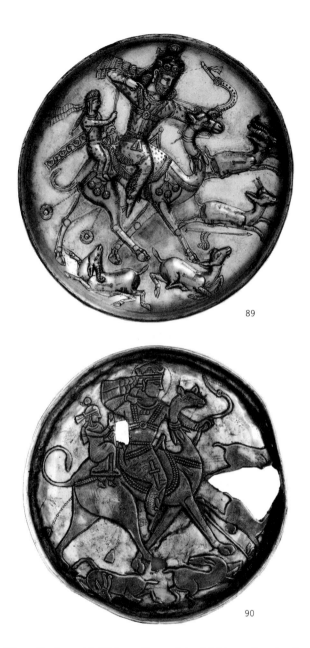

Fig. 89 Silver-gilt plate with "Bahram Gur and Azadeh" hunt. Sasanian, late 5th–6th century A.D. The Metropolitan Museum of Art, acc. no. 1994.402. Purchase, Lila Acheson Wallace Gift, 1994.

Fig. 90 Silver-gilt plate with "Bahram Gur and Azadeh" hunt. Ca. 7th century A.D. Hermitage Museum, St. Petersburg, acc. no. s-43.

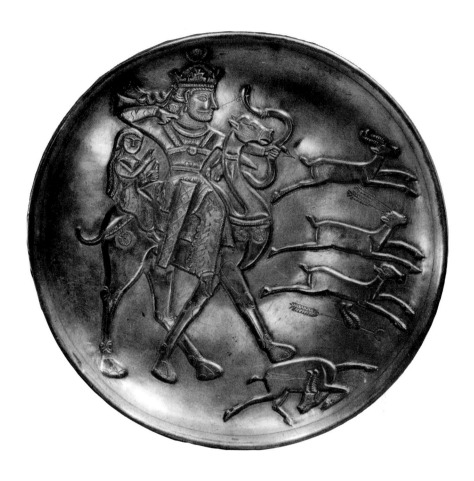

Fig. 91 Silver-gilt plate with "Bahram Gur and Azadeh" hunt. Hermitage Museum, St. Petersburg, acc. no. s-252.

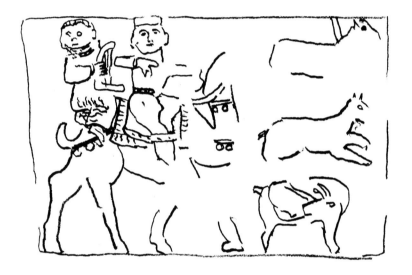

Fig. 92 Drawing of stucco panel with "Bahram Gur and Azadeh" hunt. Chal Tarkhan-Eshqabad, Iran. 7th–8th century A.D. Museum of Fine Arts, Boston, acc. no. 39.4.85. From Thompson 1976, pl. II, fig. 3.

93

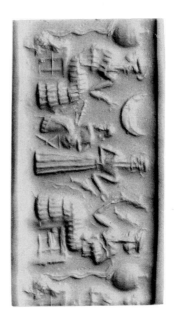

94

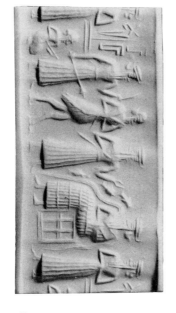

95

Fig. 93 Drawing of statue of Ur-Nanshe. Mari, Syria. Sumerian, 3rd millennium B.C. Damascus Museum. From Spycket 1981, pl. 60.
Fig. 94 Modern impression of cylinder seal. Mesopotamia. Akkadian period, 3rd millennium B.C. The British Museum, London, acc. no. 28809.
Fig. 95 Modern impression of cylinder seal. Mesopotamia. Akkadian period, 3rd millennium B.C. The British Museum, London, acc. no. 89096.

185

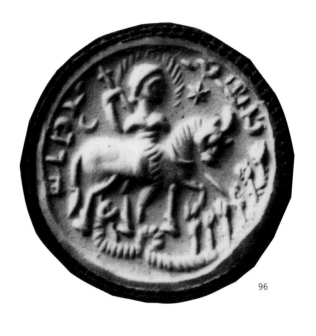

96

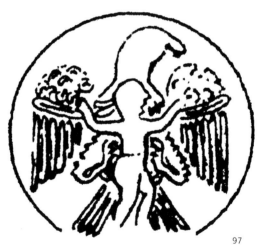

97

Fig. 96 Modern impression of stamp seal with equestrian dragon-slayer motif. Sasanian, 6th–7th century A.D. The British Museum, London, acc. no. 119387.

Fig. 97 Drawing of stamp seal impression showing eagle and female. Sasanian, 6th–7th century A.D. Bibliothèque Nationale, Cabinet des médailles, Paris. R. Gyselen, *Catalogue des sceaux, camées et bulles sassanides de la Bibliothèque Nationale et du Musée du Louvre I. Collection générale*, Paris 1993, p. 233, no. 31.1.

Bibliography

The Age of Spirituality. 1979. Edited by K. Weitzmann. New York.

Alden, J. R. 1978. "Excavations at Tal-i Malyan. Part I. A Sasanian kiln." *Iran* 16: 79–86.

Alster, B. 1972. *Dumuzi's Dream.* Copenhagen (Mesopotamia 1).

Ammianus Marcellinus. 1935, 1937, 1939. Trans. J. C. Rolfe. 3 vols. London, Cambridge, Mass.

Ancient Persia: The Art of an Empire. 1980. Edited by D. Schmandt-Besserat. Undena.

Anderson, J. K. 1961. *Ancient Greek Horsemanship.* Berkeley, Los Angeles.

André-Salvini, B. 2003. "The Rediscovery of Gudea Statuary in the Hellenistic Period." In *Art of the First Cities*, pp. 424–425. New York.

Arabie orientale, Mésopotamie et Iran méridional: de l'âge du fer au début de la période islamique. 1984. Edited by R. Boucharlat, J-F. Salles. Paris.

Archaeologia Iranica et Orientalis: Miscellanea in honorem Louis Vanden Berghe. 1989. Edited by L. de Meyer, E. Haerinck. Gent.

Archives et sceaux du monde hellénistique. Bulletin de correspondence hellénique, Suppl. 29. 1996. Edited by M-F. Boussac, A. Invernizzi. Paris.

Aro, J. 1976. "Anzu and Sīmurg." In *Cuneiform Studies in Honor of Samuel Noah Kramer*, pp. 25–29. Neukirchen-Vluyn.

The Art and Archaeology of Ancient Persia. 1998. Edited by V. S. Curtis, R. Hillenbrand, J. M. Rogers. London, New York.

Art and Empire, Treasures from Assyria in the British Museum. 1995. Edited by J. E. Curtis, J. E. Reade. New York.

Art of the First Cities. 2003. Edited by J. Aruz. The Metropolitan Museum of Art, New York.

The Assyrian Dictionary. 1971. Edited by A. Leo Oppenheim. Vol. 8. Chicago.

The Assyrian Dictionary. 1980. Edited by E. Reiner. Vol. 11. Chicago.

Azarnoush, M. 1994. *The Sasanian Manor House at Hājiābād, Iran* (Mesopotamia 3). Firenze.

Azarpay, G. 1981. *Sogdian Painting*. Berkeley, Los Angeles, London.

Azarpay, G. 1988. "The Roman Twins." *Iranica Antiqua* 23: 349–364.

Back, M. 1978. *Die sassanidischen Staatsinschriften*. Acta Iranica, 3rd series. Textes et Memoires VIII. Leiden.

Balcer, J. M. 1978. "Excavations at Tal-i Malyan: Part 2, Parthian and Sasanian Coins and Burials (1976)." *Iran* 16: 86–92.

Bálint, C. 1989. *Die Archäologie der Steppe*. Wien, Köln.

Baltrusaitis, J. 1929. *Études sur l'art médiéval en Georgie et Arménie*. Paris.

Bier, C. 1993. "Piety and Power in Early Sasanian Art." In *Official Cult and Popular Religion in the Ancient Near East*, pp. 172–194. Heidelberg.

Bier, L. 1993. "The Sasanian Palaces and Their Influence in Early Islam." *Ars Orientalis* 23: 57–66.

Bivar, A.D.H. 1969. *Catalogue of the Western Asiatic Seals in the British Museum. Stamp Seals II: The Sassanian Dynasty*. London.

Bivar, A.D.H. 1970. "Appendix: The Sasanian Coin from Qūmis." *Journal of the Royal Asiatic Society*: 156–158.

Bosworth, C. E. 1983. "Iran and the Arabs before Islam." In *Cambridge History of Iran*. Vol. 3(1), pp. 593–612.

Boucharlat, R. 1987. *Fouilles de Tureng Tepe*. Paris.

Boucharlat, R. 1989. "Cairns et pseudo-cairns du Fars." In *Archaeologia Iranica et Orientalis: Miscellanea in honorem Louis Vanden Berghe*, pp. 675–712. Gent.

Boucharlat, R. 1991. "Pratiques funéraires à l'époque sasanide dans le sud de l'Iran." In *Histoire et cultes de l'Asie centrale pré-islamique*, pp. 71–78. Paris (CNRS).

Boyce, M. 1954. "Some Remarks on the transmission of the Kayanian Heroic Cycle." In *Serta cantabrigiensia* (F. Steiner), pp. 45–52. Wiesbaden.

Boyce, M. 1957. "The Parthian *Gōsān* and the Iranian Minstrel Tradition." *Journal of the Royal Asiatic Society*: 10–45.

Boyce, M. 1990. "Some Further Reflections on Zurvanism." *Acta Iranica* 30, 3rd series: 20–29.

Boyce, M. 1995. "Iconoclasm among the Zoroastrians." In *Christianity, Judaism and Other Greco-Roman Cults; Studies for Morton Smith at Sixty*, pp. 93–111. Leiden.

Briant, P. 1988. "Le nomadisme du grand roi." *Iranica Antiqua* 23: 253–273.

Briant, P. 1996. *Histoire de l'empire Perse de Cyrus à Alexandre*. Paris.

Brilliant, R. 1963. *Gesture and Rank in Roman Art*. Memoirs of the Connecticut Academy of Arts and Sciences 14. New Haven.

Brilliant, R. 1984. *Visual Narratives*. Ithaca, London.

Brisch, K. 1967. "Das parthische Relief mit dem Sonnengott aus Hatra." *Jahrbuch preussischer Kulturbesitz* 5: 237–249.

Brisch, K. 1988. "Observations on the Iconography of the Mosaics in the Great Mosque at Damascus." In *Content and Context of Visual Arts in the Islamic World*, pp. 13–20. University Park and London.

de Bruijn, E., and D. Dudley. 1995. "The Humeina Hoard." *American Journal of Archaeology* 99: 683–697.

Bunker, E. C. 1991. "The Chinese Artifacts among the Pazyryk Finds." *Source* 10: 20–24.

Burstein, S. M. 1978. *The Babyloniaca of Berossus*. Malibu.

Cairo to Kabul: Afghan and Islamic Studies presented to Ralph Pinder-Wilson. 2002. Edited by W. Ball, L. Harrow. London.

Carpino, A., and J. M. James. 1989. "Commentary on the Li Xian Silver Ewer." *Bulletin of the Asia Institute* 2: 71–76.

Christensen, A. 1944. *L'Iran sous les Sasanides*. Copenhagen.

Christianity, Judaism and Other Greco-Roman Cults: Studies for Morton Smith at Sixty. Studies in Judaism in Late Antiquity 12. 1995. Edited by Jacob Neusner. Leiden.

The Collapse of Ancient States and Civilizations. 1995. Edited by N. Yoffee, G. L. Cowgill. Tucson, London.

Collectanea Orientalia. Etudes offerts en hommage à Agnès Spycket. Civilisations du Proche-Orient. Série I. Archéologie et Environnement, vol. 3. 1996. Edited by H. Gasche, B. Hrouda.

Collon, D., and A. D. Kilmer. 1980. "The Lute in Ancient Mesopotamia." *British Museum Yearbook* 4: 13–23.

Content and Context of Visual Arts in the Islamic World: Papers in Memory of Richard Ettinghausen. 1988. Edited by P. Soucek. University Park, Pa.

Contribution à l'histoire de l'Iran: Mélanges offerts à Jean Perrot. 1990. Edited by F. Vallat. Paris.

Costa, P. M. 1992. "Problems of Style and Iconography in the South-Arabian Sculpture." *Yemen* 1: 19–39.

Creswell, K.A.C. 1989. Ed. J.W. Allen, revised and supplemented edition. *A Short Account of Early Muslim Architecture.* Aldershot: Scolar Press.

Culley, R. C. 1972. "Oral Tradition and Historicity." In *Studies on the Ancient Palestinian World*, pp. 102–116. Toronto.

Curiel, R., and R. Gyselen. 1984. "Monnaies byzantino-sasanides à la croix sur degrés." *Studia Iranica* 13: 41–48.

Daim, F. 1990. "Der awarische Greif und die byzantinische Antike." *Typen der Ethnogenese unter besonderer Berücksichtigung der Bayern* II: 273–304.

Daim, F. 1996. *Reitervölker aus dem Osten: Hunnen und Awaren.* Bad Vöslau.

Daim, F., and P. Stadler. 1995. "Der Goldschatz von Sînnicolaul Mare (Nagyszentmiklós)." In *Reitervölker aus dem Osten: Hunnen und Awaren*, pp. 439–444. Bad Vöslau.

Dalley, S. 1991. "Gilgamesh in the Arabian Nights." *Journal of the Royal Asiatic Society:* 1–17.

Dalley, S. 1998a. "Occasions and Opportunities." In *The Legacy of Mesopotamia*, pp. 35–55. Oxford.

Dalley, S. 1998b. "The Sassanian Period and Early Islam c. A.D. 224–651." In *The Legacy of Mesopotamia*, pp. 163–181. Oxford.

Daryaee, T. 2002. "Mind, Body and Cosmos: Chess and Backgammon in Ancient Persia." *Iranian Studies* 35: 281–312.

Daryaee, T. 2003. "The Effect of the Arab Muslim Conquest on the Administrative Division of Sasanian Persis/Fars." *Iran* 41: 193–204.

Derrett, J.D.M. 1992. "Homer in India: The Birth of the Buddha." *Journal of the Royal Asiatic Society:* 47–57.

Diodorus of Sicily. Translated by C. H. Oldfather. Cambridge, Mass.

Downey, S. 1988. *Mesopotamian Religious Architecture; Alexander through the Parthians*. Princeton.

Dupree, L. 1967. "The Retreat of the British Army from Kabul to Jalalabad in 1842: History and Folklore." *Journal of the Folklore Institute* 4: 50–74.

East of Byzantium: Syria and Armenia in the Formative Period. 1982. Edited by N. Garsoïan, T. F. Mathews, R. W. Thomson. Dumbarton Oaks.

Eilers, W. 1983. "Iran and Mesopotamia." In *Cambridge History of Iran*. Vol. 3(1), pp. 481–504.

Erdmann, K. 1953. "Die fatimidischen Bergkristall-Kannen." *Forschungen zur Kunstgeschichte und christlichen Archäologie* 2: 189–205.

Ettinghausen, R. 1972. *From Byzantium to Sasanian Iran and the Islamic World*. Leiden.

Ettinghausen, R. 1979. "Bahram Gur's Hunting Feats or the Problem of Identification." *Iran* 17: 25–32.

Farkas, A. 1980. "Is There Anything Persian in Persian Art?" In *Ancient Persia: The Art of an Empire*, pp. 15–21. Malibu.

Fiey, J. M. 1979a. *Communautés syriaques en Iran et Irak des origines à 1552*. London (Variorum Reprints).

Fiey, J. M. 1979b. "Les communautes syriaques en Iran des premiers siècles à 1552." In J. M. Fiey, *Communautés syriaques en Irak et Iran*, ch. 1, pp. 279–297. London.

Fiey, J. M. 1979c. "Topographie chrétienne de Mahozé." In J. M. Fiey, *Communautés syriaques en Iran et Irak*, ch. 10, pp. 397–420. London.

Forte, A. 1996. "On the Identity of Aluohan (617–710); A Persian Aristocrat at the Chinese Court." In *La Persia e l'Asia Centrale da Alessandro al X secolo*, pp. 187–197. Rome.

Frankfort, H. 1934. "A Tammuz Ritual in Kurdistan(?)." *Iraq* 1: 137–145.

Frendo, D. 2000. "Byzantine-Iranian Relations before and after the Death of Khusrau II." *Bulletin of the Asia Institute* 14: 27–45.

Gabra, G. 2002. *Coptic Monasteries*. Cairo, New York.

von Gall, H. 1979. "Die Qajarischen Felsreliefs als archäologisches Problem." *Archaeologische Mitteilungen aus Iran*, Ergänzungsband 6: 617–618.

von Gall, H. 1990. *Das Reiterkampfbild in der iranischen und iranisch beeinflussten Kunst parthischer und sasanidischer Zeit.* Berlin.

Garrison, M. B. 1991. "Seals and the Elite at Persepolis: Some Observations on Early Achaemenid Persian Art." *Ars Orientalis* 21: 1–29.

Garsoïan, N. 1973. "Le rôle de l'hiérarchie chrétienne dans les rapports diplomatiques entre Byzance et les Sassanides." *Revue des études arméniennes*: 119–138.

Garsoïan, N. 1983. "Byzantium and the Sasanians." In *Cambridge History of Iran.* Vol. 3(1), pp. 568–592. Cambridge.

Garsoïan, N. 1988–89. "Les residences royales des arsacides arméniens." *Revue des études arméniennes* 21: 251–269.

Geller, M. J. 1997. "The Last Wedge." *Zeitschrift für Assyriologie* 87: 43–95.

Ghirshman, R. 1962. *Persian Art.* New York.

Ghirshman, R. 1971. *Fouilles du Bîchâpour.* Vol. 1. Paris.

Ghirshman, R. 1974. "Les Dioscures ou Bellerophon?" In *Mémorial Jean de Menasce*, pp. 163–167. Louvain.

Ghirshman, R. 1976. *Terrasses sacrées de Bard-è Néchandeh et Masjid-i Solaiman* (MDAI XLV).

Gignoux, Ph. 1980. "Sceaux chrétiens d'époque sassanide." *Iranica Antiqua* 15: 299–314.

Gignoux, Ph. 1983. "La chasse dans l'Iran sassanide." *Orientalia Romana, Essays and Lectures 5. Iranian Studies*, 101–118.

Gignoux, Ph. 1985–88. "Pour une evaluation de la contribution des sources arméniennes à l'histoire sassanide." *Acta Antiqua Academiae Scientiarum Hungaricae* 31: 53–65.

Gignoux, Ph. 1988. "Les noms des signes du Zodiaque en syriaque et leurs correspondants en Moyen-Perse et en Mandéen." In *Mélanges Antoine Guillaumont*, pp. 299–304. Geneva.

Gignoux, Ph. 1993. "Contacts culturels entre Manichéisme et Mazdéisme: Quelques exemples significatifs." *Studia Orientalia (Helsinki)* 70: 65–73.

Gignoux, Ph. 1998. "Les inscriptions en moyen-perse de Bandiān." *Studia Iranica* 27: 251–258.

Gignoux, Ph. 1999. "Sur quelques relations entre chrétiens et mazdéens d'après sources syriaques." *Studia Iranica* 28: 83–94.

Glassner, J. J. 1991. "A propos des jardins mésopotamiens." *Res Orientalis* 3: 9–17.

Glories of the Past. 1990. Edited by D. von Bothmer. New York.

Göbl, R. 1976. *Die Tonbullen vom Tacht-e Suleiman*. Berlin.

Gonosová, A. 1987. "The Formation and Sources of Early Byzantine Floral Semis." *Dumbarton Oaks Papers* 41: 227–237.

Grabar, O. 1967. *Sasanian Silver*. Ann Arbor.

Grabar, O. 1996. *The Shape of the Holy*. Princeton.

Grenet, F., J. Lee, and R. Pinder Wilson. 1980. "Les monuments anciens de Gorzivân." *Studia Iranica* 9: 69–104.

Grenet, F. 1993. "Znaniye yashtov Avesti v Sogde i Baktrii po dannim ikonografii." *Vestnik Drevnei Istorii* 207, 4: 149–160.

Grenet, F. 1996. "Crise et sortie de crise en Bactriane-Sogdiane aux IVe–Ve siècles: De l'héritage antique à la adoption de modèles sassanides." In *La Persia e l'Asia Centrale da Alessandro al X secolo*, pp. 367–390. Rome.

Grenet, F. 1999. "La peinture sassanide de Ghulbian (Afghanistan)." *Dossiers d'archéologie* 243: 66–67.

Gropp, G. 1974. "Some Sasanian Clay Bullae and Seal Stones." *American Numismatic Society Museum Notes* 19: 119–144.

Gunter, A. C., and P. Jett. 1992. *Ancient Iranian Metalwork in The Arthur M. Sackler Gallery and the Freer Gallery of Art*. Washington D.C.

Gunter, A. C., and M. C. Root. 1998. "Replicating, Inscribing, Giving. Ernst Herzfeld and Artaxerxes' Silver Phiale in the Freer Gallery of Art." *Ars Orientalis* 28: 3–40.

Gyselen, R. 1990. "Quelques éléments d'iconographie religieuse." In *Contribution à l'histoire de l'Iran*, pp. 253–265. Paris.

Gyselen, R. 1995. *Sceaux magiques en Iran sassanide* (Studia Iranica, Cahiers 17). Paris.

Gyselen, R. 1996a. "Notes de glyptique sassanide 5. Un sceau sassanide à l'iconographie juive." *Studia Iranica* 25: 249–250.

Gyselen, R. 1996b. "Review of M. Zakeri, *Sasanid Soldiers in Early Muslim Society*." *Studia Iranica* 25: 209.

Gyselen, R. 2001. *The Four Generals of the Sasanian Empire: Some Sigillographic Evidence*. Rome.

Hansman, J., and D. Stronach. 1970a. "A Sasanian Repository at Shahr-i Qūmis." *Journal of the Royal Asiatic Society*: 142–155.

Hansman, J., and D. Stronach. 1970b. "Excavations at Shahr-i Qūmis 1967." *Journal of the Royal Asiatic Society*: 29–62.

Harper, P. O. 1965. "The Heavenly Twins." *Bulletin of The Metropolitan Museum of Art*: 186–195.

Harper, P. O. 1989. "A Kushano-Sasanian Silver Bowl." In *Archaeologia Iranica et Orientalis*. Vol. 2, pp. 847–866. Gent.

Harper, P. O. 1990. "An Iranian Silver Vessel from the Tomb of Feng Hetu." *Bulletin of the Asia Institute* 4: 51–60.

Harper, P. O. 1991. "The Sasanian Ewer: Questions of Origin and Influence." In *Near Eastern Studies Dedicated to H.I.H. Takahito Mikasa on the Occasion of His Seventy-fifth Birthday*, pp. 67–84. Wiesbaden.

Harper, P. O. 1996. "Taq-i Bostan and Mesopotamian Palatial Traditions." In *Collectanea Orientalia*, pp. 119–127.

Harper, P. O. 1997. "Plate with the Bust of a King." In *Miho Museum Catalogue*, p. 106.

Harper, P. O. 2000a. "Sasanian Silver Vessels: The Formation and Study of Early Museum Collections." In *Mesopotamia and Iran in the Parthian and Sasanian Periods*, pp. 46–56. British Museum, London.

Harper, P. O. 2002a. "Iranian Luxury Vessels in China from the Late First Millennium B.C.E. to the Second Half of the First Millennium C.E." In *Nomads, Traders and Holy Men along China's Silk Road*, pp. 95–113. Brepols, Belgium.

Harper, P. O. 2002b. "A Gilded Silver Vessel: Iran and Byzantium in the Sixth and Seventh Centuries." In *Of Pots and Pans*, pp. 113–127. Nabu Publications.

Harper, P. O., and P. Meyers. 1981. *Silver Vessels of the Sasanian Period.* Princeton and New York.

Harper, P. O., P. O. Skjaervø, L. Gorelick, and A. J. Gwinnett. 1992. "A Seal-Amulet of the Sasanian Era: Imagery and Typology, the Inscription and Technical Comments." *Bulletin of the Asia Institute* 6: 43–58.

Hatzi-Vallianou, D. 1996. "Thèmes homériques sur les sceaux de Délos." In *Archives et sceaux du monde Hellénistique*, pp. 205–229.

Herodotus. 1942. *The Persian Wars.* Translated by G. Rawlinson. New York.

Herrmann, G. 1981. "Early Sasanian Stoneworking." *Iranica Antiqua* 16: 151–160.

Herrmann, G. et al. 2001. "The International Merv Project: Preliminary Report on the Ninth Year (2000)." *Iran* 39: 9–52.

Herzfeld, E. 1920. *Am Tor von Asien.* Berlin.

Histoire et cultes de l'Asie centrale préislamique (CNRS). 1991. Edited by P. Bernard, F. Grenet. Paris.

Huff, D. 1989. "Ein christliches Felsgrab bei Istakhr." In *Archaeologia Iranica et Orientalis*, pp. 713–729. Gent.

Huyse, P. 1990. "Noch einmal zu Parallelen zwischen Achaimeniden- und Sāsāniden- Inschriften." *Archaeologische Mitteilungen aus Iran.* 23: 177–183.

Ierusalimskaja, A. A. 1996. *Die Gräber der Moščevaja Balka: Frühmittelalterliche Funde an der nordkaukasischen Seidenstrasse.* Munich.

Incontro di religioni in Asia tra il III e il X secolo d. C. 1984. Edited by L. Lancioti. Firenze.

Jeroussalimskaja, A. 1989. "A propos de l'influence sassanide sur l'art des tribus alains." In *Archaeologia Iranica et Orientalis*, pp. 897–916. Gent.

Juliano, A. L., and J. A. Lerner. 2001. *Monks and Merchants.* The Asia Society, New York.

Kaim, B. 2002. "Un temple de feu sassanide découvert à Mele Hairam." *Studia Iranica* 31: 215–230.

Kawami, T. S. 1987a. *Monumental Art of the Parthian Period in Iran* (Acta Iranica 26). Leiden.

Kawami, T. S. 1987b. "Kuh-e Khwaja, Iran and Its Wall Paintings: The Records of Ernst Herzfeld.: *Journal of The Metropolitan Museum of Art* 22: 13–51.

Keall, E. J. 1977. "Qal'eh-i Yazdigird: The Question of Its Date." *Iran* 15: 1–9.

Keall, E. J. 1995. "Forerunners of Umayyad Art. Sculptural Stone from the Hadramawt." *Muqarnas* 12: 11–23.

Keall, E. J. 1998. "Carved Stonework from the Hadramawt in Yemen. Is It Sasanian?" In *The Art and Archaeology of Ancient Persia; New Light on the Parthian and Sasanian Empires*, pp. 141–149. London.

Khoury, N.N.N. 1993. "The Dome of the Rock, the Ka^cba, and Ghumdan." *Muqarnas* 10: 57–66.

King, G.R.D. 2002. "The Sculptures of the Pre-Islamic Haram at Makka." In *Cairo to Kabul*, pp. 144–150. Melisende.

Kingsley, P. 1992. "Ezekiel by the Grand Canal: Between Jewish and Babylonian Tradition." *Journal of the Royal Asiatic Society*: 339–346.

Kitzinger, E. 1954. "The Cult of Images in the Age before Iconoclasm." *Dumbarton Oaks Papers* 8: 83–150.

Klimkeit, H. J. 1982. *Manichean Art and Calligraphy*. Iconography of Religions XX. Leiden.

Knauer, E. R. 2001. "A Man's Caftan and Leggings from the North Caucasus of the Eighth to Tenth Century: A Genealogical Study." *Journal of The Metropolitan Museum of Art* 36: 125–154.

Kramer, S. N. 1969. "Lamentation over the Destruction of Nippur." *Eretz-Israel* 9: 89–93.

Kröger, J. 1982a. *Sasanidischer Stuckdekor*. Mainz am Rhein.

Kröger, J. 1982b. "Werkstattfragen iranisch-mesopotamischen Baudekors in sasanidisch-frühlislamischer Zeit." In *Künstler und Werkstatt in den orientalischen Gesellschaften*, pp. 17–29. Graz.

Kruglikova, I. T. 1976. "Nastenniye rospisi Dilberdzhina." In *Drevnyaya Bactriya*: 87–110. Moscow.

Kuhrt, A. 1987. "Berossus's *Babyloniaka* and Seleucid Rule in Babylonia." In *Hellenism in the East*, pp. 32–56. Berkeley, Los Angeles.

Kuhrt, A. 1990. "Achaemenid Babylonia: Sources and Problems." *Achaemenid History* 4: 177–194.

Künstler und Werkstaat in der orientalischen Gesellschaften. 1982. Edited by A. J. Gail. Graz.

La Persia e l'Asia Centrale da Alessandro al X secolo. 1996. Accadenia Nazionale dei Lincei 127. Roma.

La Persia nel Medioevo. 1971. Accademia Nazionale dei Lincei 160. Roma.

Langdon, S. 1934. "Excavations at Kish and Barghuthiat 1933." *Iraq* 1: 113–136.

Lee, J., and F. Grenet. 1998. "New Light on Sasanid Painting at Ghulbiyan, Faryab Province." *South Asian Studies* 14: 75–85.

The Legacy of Mesopotamia. 1998. Edited by S. Dalley. Oxford.

Lerner, J. A. 1977. *Christian Seals of the Sasanian Period.* Istanbul.

Lerner, J. 1991. "A Rock Relief of Fatḥ ᶜAlī Shāh in Shiraz." *Ars Orientalis* 21: 31–43.

Lerner, J. 1996. "Horizontal-handled Mirrors: East and West." *Journal of The Metropolitan Museum of Art* 31: 11–40.

Letters of Sidonius. 1915. Translated by O. M. Dalton. Oxford.

Levi, D. c. 1947. *Antioch Mosaic Pavements.* Princeton, London.

Loewe, M. 1971. "Spices and Silk: Aspects of World Trade in the First Seven Centuries of the Christian era." *Journal of the Royal Asiatic Society*: 166–179.

Lord, A. B. 1991. *Epic Singers and Oral Tradition.* Ithaca, London.

Lord, A. B. 1995. *The Singer Resumes the Tale.* Ithaca, London.

Luft, J. P. 2001. "The Qajar Rock Reliefs." *Iranian Studies* 34: 31–49.

Luschey, H. 1979. "Das Qadjarische Palais am Taq-i Bostan." *Archaeologische Mitteilungen aus Iran* 12: 395–411.

Machabéli, K. 1983. *Argenterie de l'ancienne Géorgie.* Tbilisi.

Mackintosh, M. C. 1973. "Roman Influences on the Victory Reliefs of Shapur I of Persia." *California Studies in Classical Antiquity* 6: 181–203.

Mackintosh, M. C. 1978. "Taq-i Bustan and Byzantine Art." *Iranica Antiqua* 13: 149–177.

Maguire, H. 1990. "Garments Pleasing to God: The Significance of Domestic Textile Designs in the Early Byzantine Period," *Dumbarton Oaks Papers* 44: 215–224.

Mango, C. 1985. "Deux études sur Byzance et la Perse sassanide." *Travaux et mémoires*: 105–117.

Mango, C., and E.J.W. Hawkins. 1964. "The Monastery of Lips (Fenari Isa Camii): Additional Notes." *Dumbarton Oaks Papers* 18: 299–315.

Mango, M. M. 1982. "The Continuity of the Classical Tradition in the Art and Architecture of Northern Mesopotamia." In *East of Byzantium*, pp. 115–134.

Marcus, M. 1990. "Centre, *Province* and Periphery: A New Paradigm from Iron-Age Iran." *Art History* 13: 129–150.

Marschak, B. I. 1986. *Silberschätze des Orients*. Leipzig.

Marshak, B. I. 1996. "New Discoveries in Piandjikent and a Problem of Comparative Study of Sasanian and Sogdian Art." In *La Persia e l'Asia Centrale da Alessandro al X secolo*, pp. 425–438. Roma.

Marshak, B. I. 1998. "The Decoration of Some Late Sasanian Silver Vessels and Its Subject-Matter." In *Art and Archaeology of Ancient Persia*, pp. 84–102. London, New York.

Marshak, B. I. 2002. *Legends, Tales and Fables in the Art of Sogdiana*. New York.

Marshak, B. I., and Y. K. Krikis. 1969. "Chilekskiye Chashi." *Trudy Gosudarstven-nogo Ermitazha* 10: 55–81.

Marshak, B. I., and V. I. Raspopova. 1990. "Wall Paintings from a House with a Granary, Panjikent, First Quarter of the Eighth Century A.D." *Silk Road Art and Archaeology* 1: 123–176.

Mathews, T. F. 1982. "The Early Armenian Iconographic Program of the Ējmiacin Gospel." In *East of Byzantium*, pp. 199–215.

Mathews, T. F. 1993. *The Clash of Gods*. Princeton.

Meissner, B. 1901. *Von Babylon nach den ruinen von Ḥira und Ḫuarnaq*. Leipzig.

Mélanges Antoine Guillaumont (Cahiers d'orientalisme XX). 1988. Geneva.

Melikian-Chirvani, A. S. 1995. "Rekab: The Polylobed Wine Boat from Sassanian to Seljuk Times." *Res Orientalis* 7: 187–204.

Mesopotamia and Iran in the Parthian and Sasanian Periods: Rejection and Revival c. 238 B.C.– A.D. 642. 2000. Edited by J. Curtis. British Museum Press.

Michalak, M. 1987. "The Origins and Development of Sassanian Heavy Cavalry." *Folia Orientalia* 24: 73–86.

Miho Museum, South Wing. 1997. Nissha Printing Co. Ltd.

Miller, J. I. 1969. *The Spice Trade of the Roman Empire 29 B.C. to A.D. 641.* Oxford.

Montgomery, J. A. 1913. *Aramaic Incantation Texts from Nippur.* Philadelphia.

Moorey, R. 1988. "The Technique of Gold-Figure Decoration on Achaemenid Silver Vessels and Its Antecedents." *Iranica Antiqua* 23: 231–246.

Moorey, R. 1993. "High Relief Decoration on Ancient Iranian Metal Vessels." *Bulletin of the Asia Institute* 7: 131–139.

Morier, J. 1818. *A Second Journey through Persia, Armenia and Asia Minor to Constantinople.* London.

Mundell, M. 1975. "Monophysite Church Decoration." In *Iconoclasm.* Edited by A. Bryer, J. Harris. Birmingham.

Musil, A. 1927. *The Middle Euphrates.* New York.

National Treasures of Georgia. 1999. Edited by O. Z. Soltes. New York.

Near Eastern Studies, Dedicated to H.I.H. Prince Takahito Mikasa. 1991. Edited by M. Mori et al. Wiesbaden.

Neusner, J. 1970. *A History of the Jews in Babylonia: Later Sasanian Times.* Vol. 5. Leiden.

Nomads, Traders and Holy Men along China's Silk Road (Silk Road Studies 7). 2002. Edited by A. L. Juliano, J. A. Lerner. Brepols.

Noonan, Th. S. 1982. "Russia, the Near East and the Steppe." *Archivum Eruasiae Medii Aevi*: 269–302.

Noonan, Th. S. 1984. "Why Dirhems First Reached Russia." *Archivum Eurasiae Medii Aevi* 4: 151–282.

Oates, D. 1968. *Studies in the Ancient History of Northern Iraq.* The British Academy, London.

Of Pots and Pans. Presented to David Oates in Honour of his 75th Birthday. 2002. Edited by L. Al-Gailani Werr et al. Nabu Publications.

Official Cult and Popular Religion in the ancient Near East. 1993. Edited by E. Matsushima. Heidelberg.

Orbeli, I. A., and C. V. Trever. 1935. *Orfèvrerie sasanide.* Moscow, Leningrad.

Ornaments from the Past: Bead Studies after Beck. 2003. Edited by K. Glover et al. London Bead Study Trust.

Ortiz, G. 1994. *In Pursuit of the Absolute. Art of the Ancient World; from the George Ortiz Collection.* Royal Academy of Arts, London.

Oxford Dictionary of Byzantium. 1991. Edited by A. P. Kazhdan. New York, Oxford.

Özgüç, T. 1988. *İnandiktepe.* Ankara.

Parrot, A. 1948. *Tello. Vingt campagnes de fouilles (1877–1933).* Paris

Perikhanian, A. (trans.) 1997. *The Book of a Thousand Judgments (A Sasanian Law-Book).* Trans. from the Russian by N. Garsoïan. Costa Mesa, California, New York (Persian Heritage Foundation).

Pfrommer, M. 1990. "Ein Achämenidisches Amphorenrhyton mit Ägyptischem Dekor." *Archaeologische Mitteilungen aus Iran* 23: 191–209.

Pigulevskaja, N. 1963. *Les villes de l'état iranien.* Paris, The Hague.

Piquet-Panayotova, D. 1989. "Recherches sur les tetraconques à déambulatoire et leur decor en Transcaucasie au VIIe siècle." *Oriens Christianus* 73: 166–212.

Piquet-Panayotova, D. 1991. "L'église d'Iškhani: patrimoine culturel et création architecturale." *Oriens Christianus* 75: 198–253.

Porada, E. 1965. *The Art of Ancient Iran.* New York.

Porada, E. 1967. "Of Deer, Bells and Pomegranates." *Iranica Antiqua* 7: 99–120.

Pottery in the Making. 1997. Edited by I. Freestone, D. Gaimster. The British Museum.

Potts, D. T. 1990. *The Arabian Gulf in Antiquity II: From Alexander the Great to the Coming of Islam.* New York, Oxford.

Potts, D. T. 1997. "Late Sasanian Armament from Southern Arabia." *Electrum* 1: 127–137.

Puech, H.-C. 1949. "Le cerf et le serpent." *Cahiers archéologiques* 4: 17–60.

Rabbat, N. 1993. "Mamluk Throne Halls." *Ars Orientalis* 23: 201–218.

Rahbar, M. 1998. "Découverte d'un monument d'époque sassanide à Bandian, Dargaz (Nord Khorasan)." *Studia Iranica* 27: 213–250.

Rahbar, M. 1999. "A Dargaz (Khorassan); Découverte de panneaux de stucs sassanides." *Dossiers d'archéologie* 243: 62–65.

Rashid, M. 1996. "Die Bedeutung der Jagd für die Herrscherdarstellungen bei den Achämeniden, Parthern und Sasaniden." In *Vom Halys zum Euphrat,* pp. 241–255.

Reade, J. 1979. In *Power and Propaganda* (Mesopotamia 7). Edited by M. T. Larsen.

Reuther, O. 1938–39. "Sāsānian Architecture." In *A Survey of Persian Art.* Vol 1, pp. 493–578.

Rice, D. T. 1932. "The Oxford Excavations at Hira, 1931." *Antiquity* 6: 276–291.

Rome and India: The Ancient Sea Trade. 1991. Edited by V. Begley, R. D. DePuma. Madison, Wisconsin.

Root, M. C. 1985. "The Parthenon Frieze and the Apadana Reliefs at Persepolis." *American Journal of Archaeology* 89: 103–120.

Root, M. C. 1990. *Crowning Glories; Persian Kingship and the Power of Creative Continuity.* University of Michigan (Kelsey Museum of Archaeology). Ann Arbor.

Root, M. C. 1994. "Lifting the Veil: Artistic Transmission beyond the Boundaries of Historical Periodization." *Achaemenid History* 8: 9–37.

Russel (misspelled in publication), J. R. 1990. "Kartīr and Mānī: A Shamanistic Model of Their Conflict." *Acta Iranica* 30: 180–193.

Russell, J. R. 1996, 1997. "Zoroastrianism and the Northern Qi Panels." *Ushta (A Zoroastrian Studies Publication, Newsletter* XVII, no. 4; XVIII, no. 1): 9–10; 17–19.

Russell, J. R. 2003. "Ezekiel and Iran." *Irano-Judaica* 5: 1–15.

Sancisi-Weedenburg, H. 1985. "The Death of Cyrus: Xenophon's *Cyropaedia* as a Source for Iranian History." *Acta Iranica 25, Hommages* II: 459–471.

Sasanian Remains from Qasr-i Abu Nasr. 1973. Edited by R. N. Frye. Cambridge, Mass.

Schmidt, H. P. 1980. "The Sēnmurw." *Persica* 9.

Schwartz, M. 2000. "Revelations, Theology and Poetics in the Gathas." *Bulletin of the Asia Institute* 14: 1–18.

Selected Lectures of Rudolph Wittkower. 1989. Edited by D. M. Reynolds. Cambridge.

Shabazi, A. Sh. 1977. "From Pārsa to Taxt-e Jamšid." *Archaeologische Mitteilungen aus Iran* 10: 197–207.

Shabazi, A. Sh. 1987. "Asb, Horse." In Pre-Islamic Iran." In *Encyclopaedia Iranica.* Vol. 2, pp. 724–730.

Shabazi, A. Sh. 1990. "On the Xᵂadāy-nāmag." *Acta Iranica* 30: 208–229.

Shahid, I. 1979. "Byzantium in South Arabia." *Dumbarton Oaks Papers* 33: 27–87.

Shaked, S. 1971. "The Notions of the *menog* and *getig* in the Pahlavi Zoroastrian Texts and Their Relation to Eschatology." *Acta Orientalia* 33: 59–107.

Shaked, S. 1984. "From Iran to Islam; Notes on Some Themes in Transmission." *Jerusalem Studies in Arabic and Islam* 4: 31–67.

Shaked, S. 1994. *Dualism in Transformation: Varieties of Religion in Sasanian Iran.* London (School of Oriental and African Studies).

Shaked, S. 1995. "Jewish Sasanian Sigillography." *Res Orientalis* 7: 239–256.

Shaki, M. 1993. "Contracts II: In the Middle Persian Period." In *Encyclopaedia Iranica.* Vol. 6, pp. 222–224.

Shalem A. 1994. "The Fall of al-Mādain: Some Literary References Concerning Sasanian Spoils of War in Medieval Islamic Treasuries." *Iran* 32: 77–82.

Shepherd, D. 1964. "Sasanian Art in Cleveland." *The Bulletin of the Cleveland Museum of Art* 51: 66–95.

Simpson, St. J. 1997. "Partho-Sasanian Ceramic Industries in Mesopotamia." In *Pottery in the Making,* pp. 74–79.

Simpson, St. J. 2003. "Sasanian beads: The Evidence of Art, Texts and Archaeology." In *Ornaments from the Past: Bead Studies after Beck,* pp. 59–78.

Sims-Williams, N. 2002. "The Bactrian Inscription on a Seal of Khiṅgila." *Silk Road Art and Archaeology* 8: 143–148.

Skjaervø, P. O. 1983. "Kirdir's Vision: Translation and Analysis." *Archaeologische Mitteilungen aus Iran* 16: 269–306.

Skjaervø, P. O. 1985. "Thematic and Linguistic Parallels in the Achaemenian and Sassanian Inscriptions." *Acta Iranica 25, Homages* 11: 593–603.

Skjaervø, P. O. 1992. "L'Inscription d'Abnūn et l'imparfait en Moyen-Perse," *Studia Iranica* 21: 153–160.

Skjaervø, P. O. 1993. "Review of Ph. Gignoux, Les quatres inscriptions de mage Kirder." *Bibliotheca Orientalis*: 690–700.

Skjaervø, P. O. 1995. "Iranian Elements in Manichaeism: A Comparative Contrastive Approach. Irano-Manichaica I." *Res Orientalis* 7: 263–284.

Smirnov, A. P. 1957. *Novaya nakhodka vostochnogo serebra v priuralye.* Moscow (Trudy Gosudarstvennogo istoricheskogo Muzeia).

So, J. F., and E. C. Bunker. 1995. *Traders and Raiders on China's Northern Frontier.* Seattle and London.

Soucek, P. P. 1993. "Solomon's Throne/Solomon's Bath: Model or Metaphor." *Ars Orientalis* 23: 109–134.

Speiser, J.-M. 1984. *Thessalonique et ses monuments du IV au VI siècle.* Paris.

Splendeur des Sassanides. 1993. Brussels (Musées Royaux d'Art et d'Histoire).

Sprengling, M. 1953. *Third Century Iran.* Chicago.

Spycket, A. 1981. *La statuaire du proche-orient ancien.* Leiden/Köln.

Stronach, D. 1989. "The Royal Garden at Pasargadae: Evolution and Legacy." In *Archaeologia Iranica et Orientalis*, pp. 475–502. Gent.

Stronach, D. 1994. "Parterres and Stone Watercourses at Pasargadae: Notes on the Achaemenid Contribution to Garden Design." *Journal of Garden History* 14: 3–12.

Stronach, D. 1997. "Anshan and Parsa: Early Achaemenid History, Art and Architecture on the Iranian Plateau." In *Mesopotamia and Iran in the Persian Period*, pp. 35–53. London.

Studies on the Ancient Palestinian World. 1972. Edited by J. W. Wevers, D. B. Redford. Toronto, Buffalo.

Taffazoli, A. 1974. "A List of Trades and Crafts in the Sassanian Period." *Archaeologische Mitteilungen aus Iran* 7: 191–196.

Tawil, D. 1979. "The Purim Panel at Dura in the Light of Parthian and Sasanian Art." *Journal of Near Eastern Studies* 38: 93–109.

Tavoosi, M. 1989. "An Inscribed Capital Dating from the Time of Shapur I." *Bulletin of the Asia Institute* 3: 25–38.

Thierry, F. 1993. "Sur les monnaies sassanides trouvées en Chine," *Res Orientalis* 5: 89–140.

Thompson, D. 1976. *Stucco from Chal Tarkhan-Eshqabad near Rayy*. Warminster.

Thureau-Dangin, F. 1919. "Un acte de donation de Marduk-zâkir-šumi." *Revue assyriologie et d'archéologie orientale* 16: 117–156.

Toynbee, J.M.C. 1972. "Some Problems of Romano-Parthian Sculptures at Hatra." *Journal of Roman Studies* 62: 106–110.

Treasures from the Ob' Basin. 1996. Edited by B. I. Marshak et al. St. Petersburg.

Treasure of Khan Kubrat (Culture of Bulgars, Khazars, Slavs). 1989. Exhibition Catalogue, National Museum of History. Sofia.

The Treasury of San Marco, Venice. 1984. The British Museum, Milan.

Treister, M. Yu. 1994. "Sarmatskaya shkola khudozhestvennoi torevtiki." *Vestnik Drevei Istorii*: 172–203.

Treister, M. Yu. 1997. "New Discoveries of Sarmatian Complexes of the First Century A.D." *Ancient Civilizations from Scythia to Siberia* 4: 35–100.

Trever, K. V., V. G. Lukonin. 1987. *Sasanidskoe Serebro*. Moscow.

Trilling, J. 1989. "The Soul of the Empire: Style and Meaning in the Mosaic Pavement of the Byzantine Imperial Palace in Constantinople." *Dumbarton Oaks Papers* 43: 27–72.

Trümpelmann, L. 1984. "Sasanian Graves and Burial Customs." In *Arabie orientale, Mésopotamie et Iran méridional*, pp. 317–329. Paris.

Vanden Berghe, L. 1970. "Luristan. Prospections archéologiques dans la région de Badr." *Archeologia* 36: 10–21.

Vanden Berghe, L. 1972. "Recherches archéologiques dans le Luristan." *Iranica Antiqua* 9: 4–48.

Vickers, M. 1995. "Metrological Reflections: Attic, Persian, Hellenistic, Roman and Sasanian Gold and Silver Plates." *Studia Iranica* 24: 163–184.

Vom Halys zum Euphrat: Thomas Beran zu Ehren. 1996. Edited by U. Magen, M. Rashad. Munster.

Watson, W. 1983. "Iran and China." In *Cambridge History of Iran*. Vol. 3(1), pp. 537–558.

Wenwu. 1987 (10): 17.

Watt, J.C.Y. 2004. *China. Dawn of a Golden Age 200–750 A.D.* The Metropolitan Museum of Art, New York.

Werner, J. 1984. *Der Grabfund von Malaja Pereščepina*. Munich.

Whipple, A. O. 1967. *The Role of the Nestorians and Muslims in the History of Medicine*. Princeton.

Whitcomb, D. S. 1984. "Qasr-i Abu Nasr and the Gulf." In *Arabie orientale, Mésopotamie et Iran méridional*, pp. 331–337. Paris.

Whitcomb, D. S. 1985. *Before the Roses and Nightingales*. New York.

Whitehouse, D. 1971. "Sīrāf: A Sasanian Port." *Antiquity* 45: 262–267.

Widengren, G. 1984. "The Nestorian Church in Sasanian and Early Post-Sasanian Iran." In *Incontro di religioni in Asia tra il III e il X secolo d.C.*, pp. 1–31. Firenze.

Wiesehöfer, J. 1996. *Ancient Persia*. London, New York.

Wiesehöfer, J. 2002. "Review: Die sportlichen Qualifikationen der altiranischen Fürsten." *Iranian Studies* 35: 429–432.

Wiggerman, F.A.W. 1992. *Mesopotamian Protective Spirits*. Groningen.

Wilkinson, C. K. 1965. "The Achaemenian Remains at Qasr-i-Abu Nasr." *Journal of Near Eastern Studies* 24: 341–345.

Winter, I. J. 1992. "Idols of the King: Royal Images as Recipients of Ritual Action in Ancient Mesopotamia." *Journal of Ritual Studies* 6: 13–42.

Winter, I. J. 1993. "Seat of Kingship" / "A Wonder to Behold." *Ars Orientalis* 23: 27–55.

Wiseman, D. J. 1952. "A New Stela of Aššurnasirpal II." *Iraq* 14: 24–39.

Wittkower, R. 1938–9. "Eagle and Serpent. A Study in the Migration of Symbols." *Journal of the Warburg and Courtauld Institutes* 2: 293–325.

Xiong, V. C., and E. J. Laing. 1991. "Foreign Jewelry in Ancient China." *Bulletin of the Asia Institute* 5: 163–173.

Yang, Hsuan-chih. 1984. *A Record of Buddhist Monasteries in Lo-yang*, p. 206. Princeton.

Yarshater, E. 1971. "Were the Sasanians Heirs to the Achaemenids?" In *La Persia nel Medioevo*, pp. 517–531. Roma.

Yoffee, N. 1988. "The Collapse of Ancient Mesopotamian States and Civilization." In *The Collapse of Ancient States and Civilzations*, pp. 44–68. Tucson, London.

Zeumal, E. V. 1996. "K siuzhetu na bliude iz Lukovki." In *Nauchnaya Konferentsia Alisi Vladimirovni Bank*, pp. 16–20. Saint Petersburg.

Index

WITHDRAWN